YES
WE
CAN

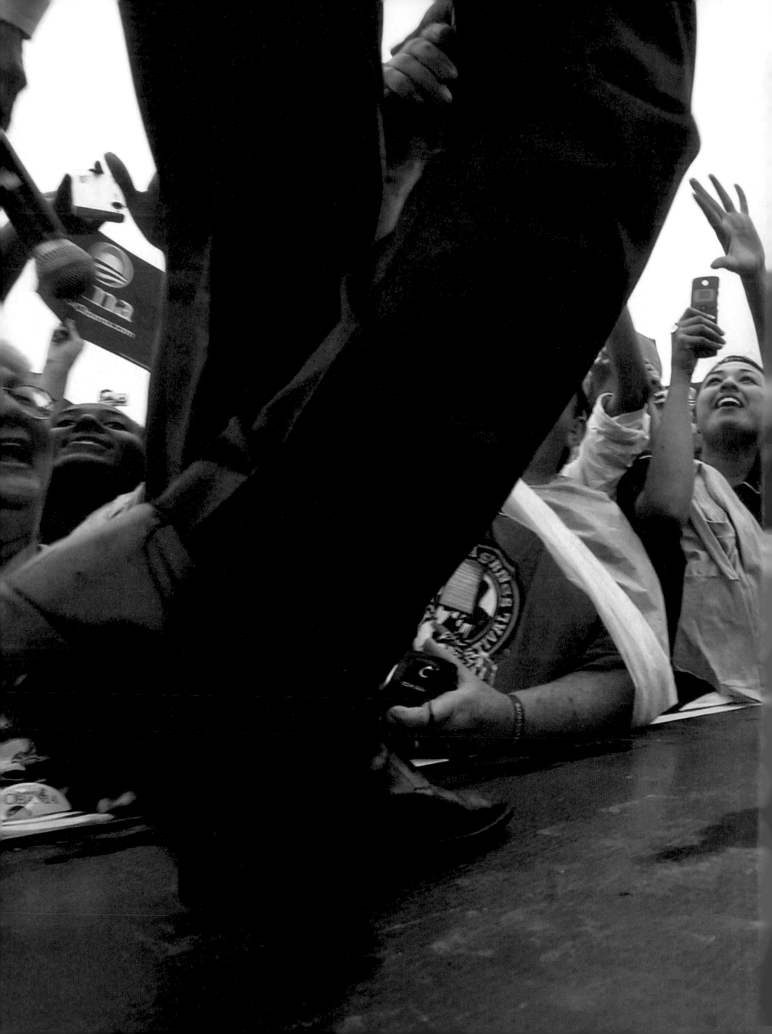

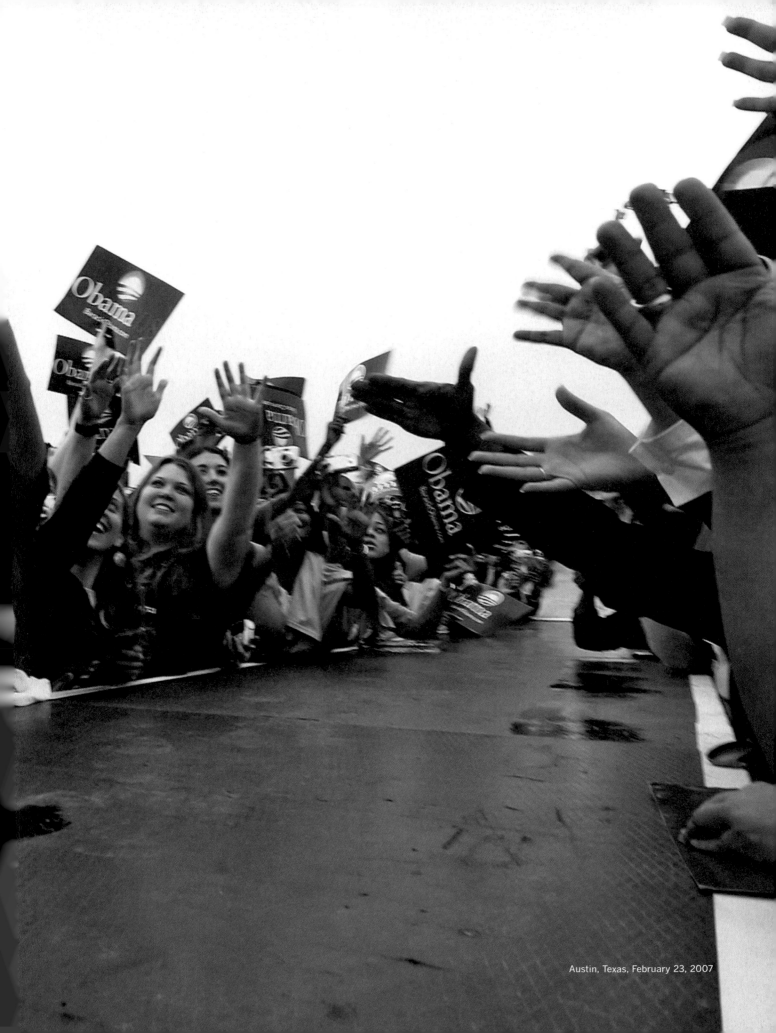

Austin, Texas, February 23, 2007

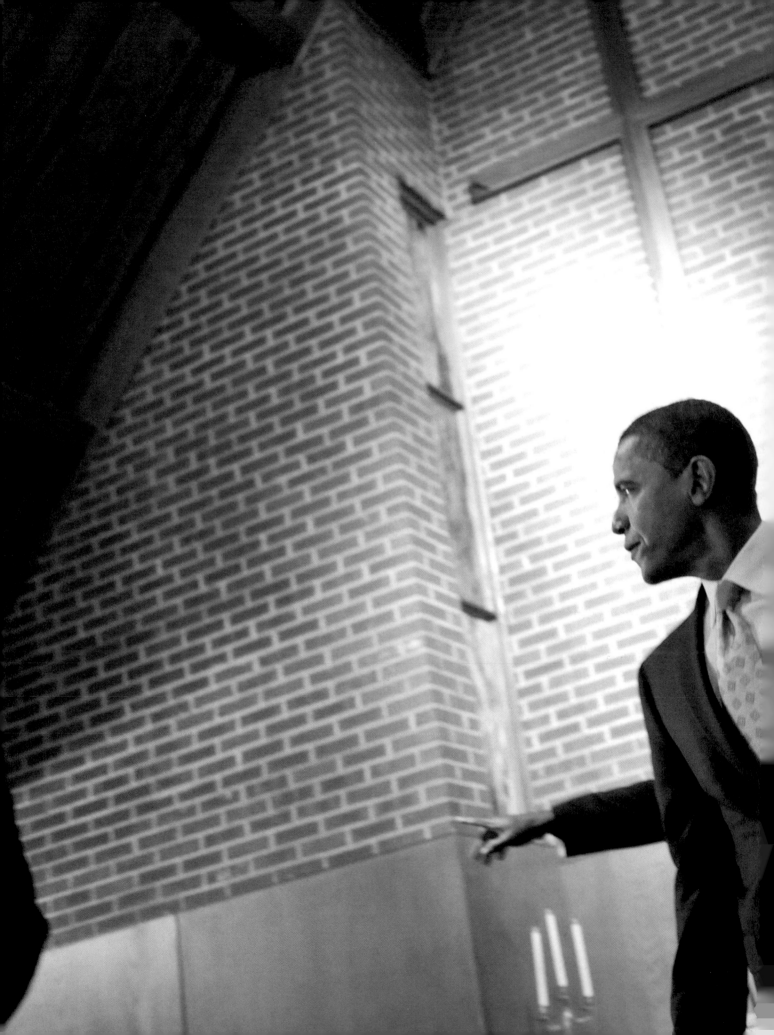

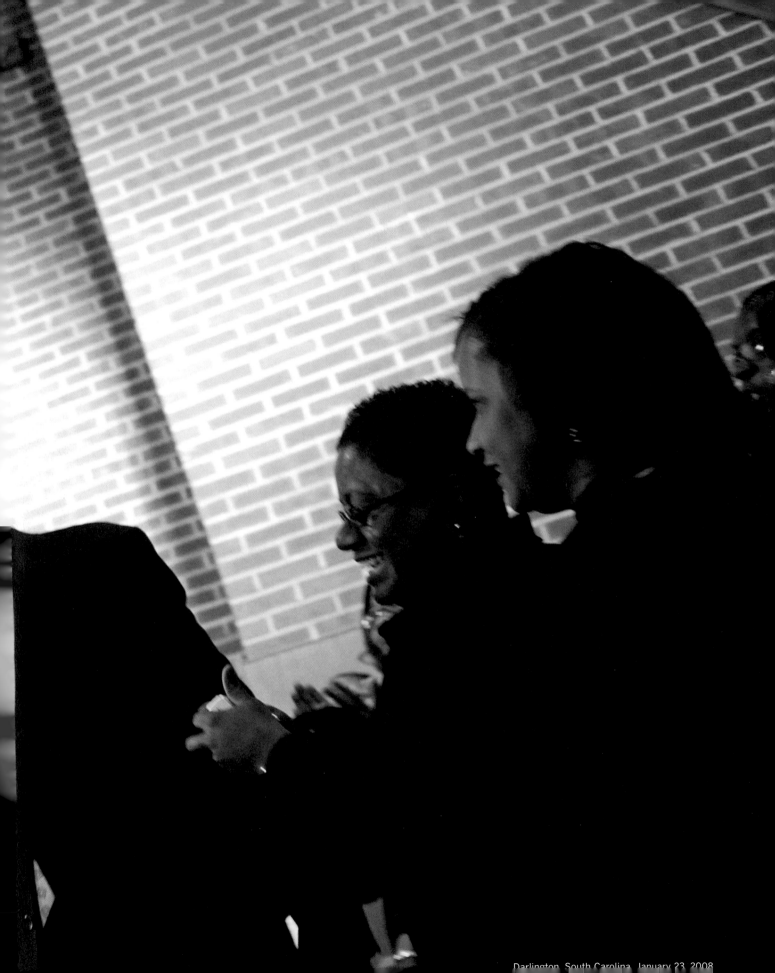

Darlington, South Carolina, January 23, 2008

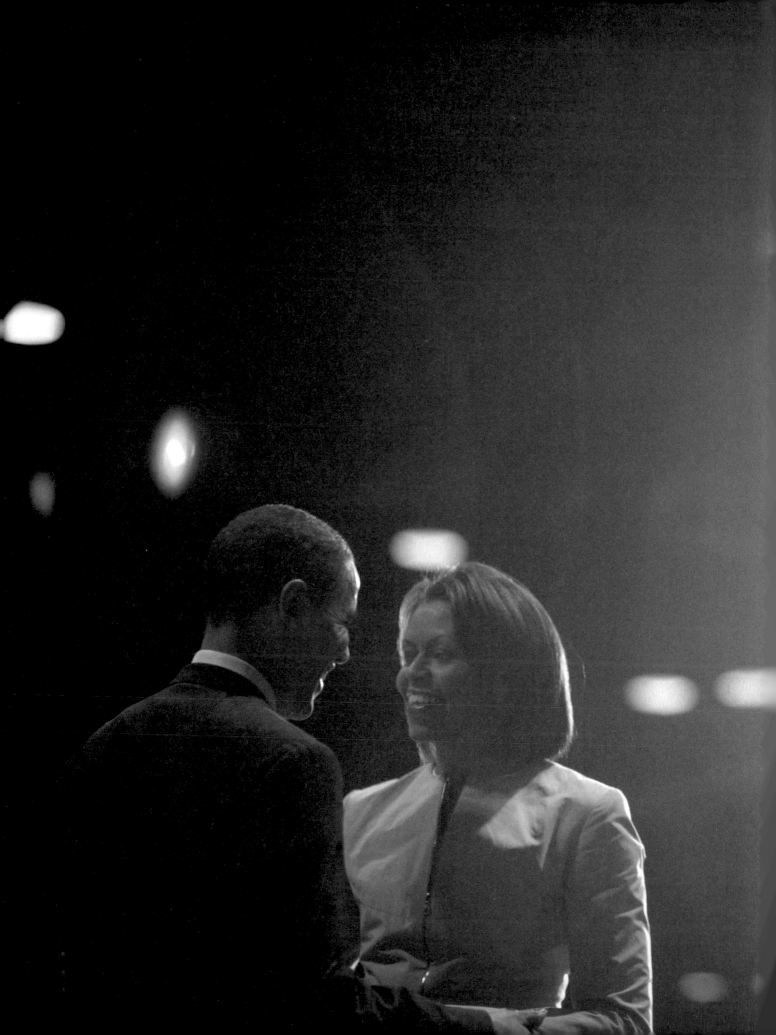

Houston, Texas, March 3, 2008

Norfolk, Virginia, October 28, 2008

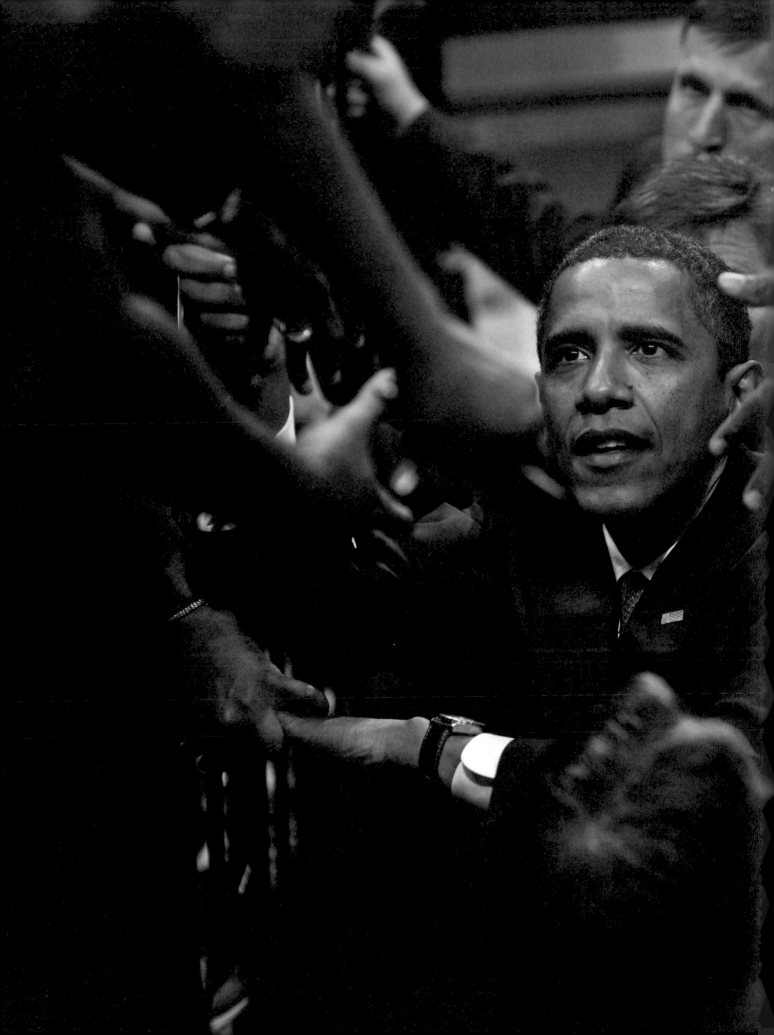

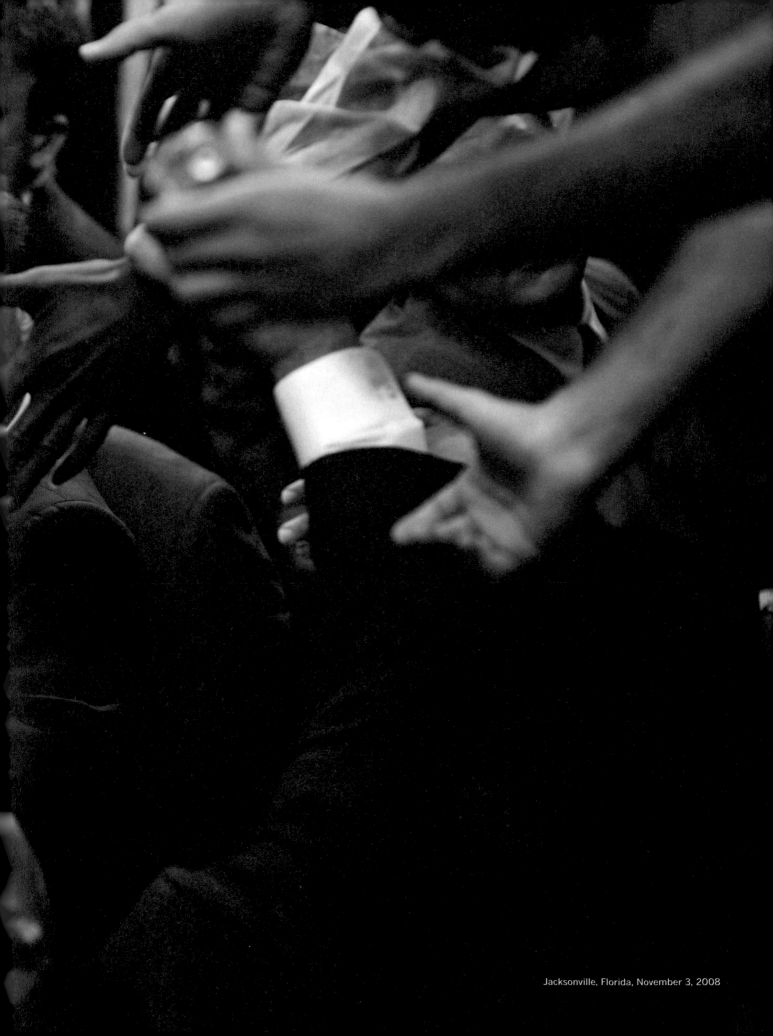

Jacksonville, Florida, November 3, 2008

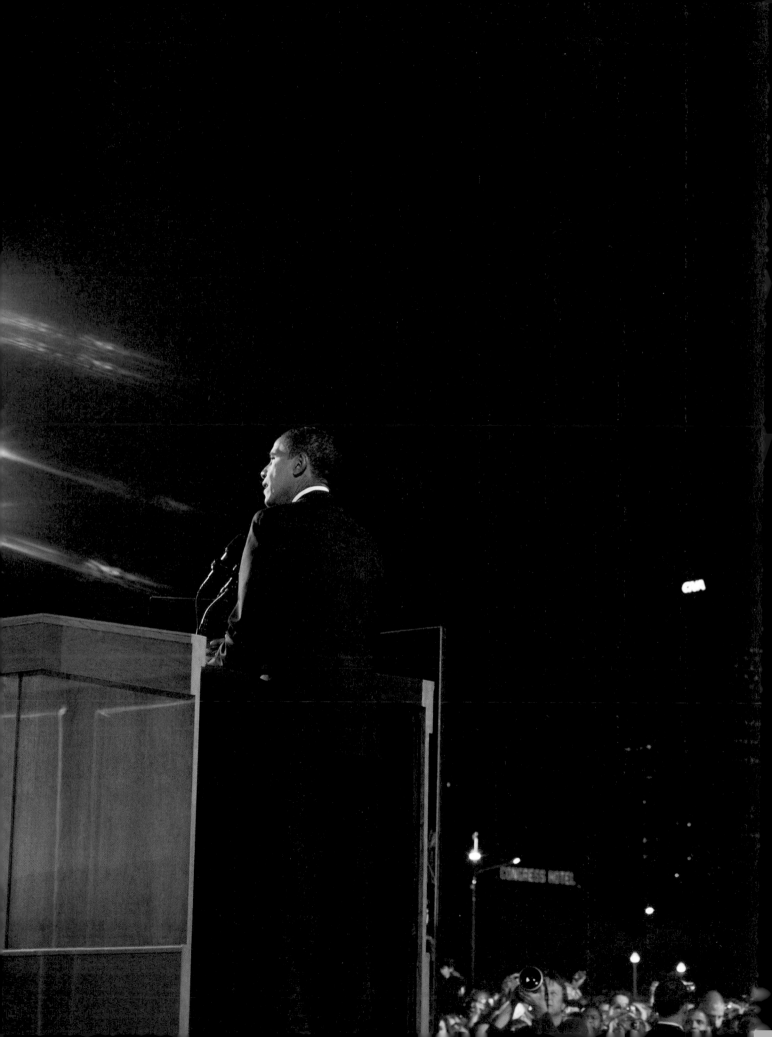

YES
WE
CAN

BARACK OBAMA'S HISTORY-MAKING
PRESIDENTIAL CAMPAIGN

PHOTOGRAPHS BY SCOUT TUFANKJIAN

MELCHER
MEDIA

pH powerHouse Books

Published in the United States by powerHouse Books,
a division of powerHouse Cultural Entertainment, Inc.

 powerHouse Books

37 Main Street
Brooklyn, NY 11201-1021
www.powerHouseBooks.com

CEO: Daniel Power
Executive Publisher: Craig Cohen
Marketing Director: Sara Rosen
Sales Director: Wes Del Val
Web Master: Chaz Requina
PR Coordinator: Tami Mnoian

Produced by Melcher Media

 **MELCHER
MEDIA**

124 West 13th Street
New York, NY 10011
www.melcher.com

Publisher: Charles Melcher
Associate Publisher: Bonnie Eldon
Editor in Chief: Duncan Bock
Production Director: Kurt Andrews
Project Editor: David E. Brown
Associate Editor: Lindsey Stanberry

Book design by Naomi Mizusaki and Chika Azuma

Library of Congress Control Number: 2008940765

ISBN 978-1-57687-504-9

A complete catalog of powerHouse Books and Limited Editions is
available upon request; please call, write, or visit our website.

First edition

11 10 09 08 10 9 8 7 6 5 4 3 2

Printed and bound in the United States

Mixed Sources
Product group from well-managed
forests, controlled sources and
recycled wood or fiber
www.fsc.org Cert no. SW-COC-002550
© 1996 Forest Stewardship Council

TABLE OF CONTENTS

INTRODUCTION / 16

1. **FIRED UP AND READY TO GO:** THE EARLY DAYS / 18

2. **THEY SAID THIS DAY WOULD NEVER COME:** THE LEAD-UP TO IOWA / 34

3. **YES WE CAN:** NEW HAMPSHIRE TO SOUTH CAROLINA / 56

4. **WE ARE THE ONES WE'VE BEEN WAITING FOR:** SUPER TUESDAY TO TEXAS / 72

5. **ARE YOU GOING TO GO ALONG WITH THE PAST OR ARE YOU GOING TO GO TOWARDS THE FUTURE?:** MISSISSIPPI TO PENNSYLVANIA / 88

6. **THIS IS OUR MOMENT:** NORTH CAROLINA TO THE NOMINATION / 104

7. **AMERICA, WE CAN NOT TURN BACK:** THE ROAD TO THE CONVENTION / 120

8. **THE PROMISE WE MUST KEEP:** TOWARD THE FINISH / 138

9. **NOW IT FALLS TO US:** THE LAST DAYS OF THE GENERAL ELECTION / 154

10. **TONIGHT IS YOUR ANSWER:** THE PRESIDENT-ELECT / 176

ACKNOWLEDGMENTS / 190

INTRODUCTION

I STILL CAN'T BE

I still can't believe it. It hasn't sunk in that Barack Obama is now the President-Elect of the United States. I can't believe that the long-shot candidate I started following almost two years ago actually won. I can't believe the American people elected a man named Barack Obama. I can't believe that the guy who spent two years making faces into my camera is going to be the leader of the free world.

Even when I think about all of the people who have made up his movement—the teenagers who defied all stereotypes about the unreliability of the youth vote; the adults who, despite a long experience with disappointment, let themselves believe again; the older white farmers who painted the symbol of a young black politician on their barns and hung signs on their tractors; the young girls who exploded in joy when he walked on stage in Dillon, South Carolina; the hundreds of people in Harlem who ran alongside his motorcade grinning from ear to ear and shouting his name; the small-town Iowans who asked careful questions and not only caucused for this newcomer, but volunteered and convinced their neighbors—even when I remember the joy and determination in their eyes, I still can't believe it.

And to think, the first time I photographed Barack Obama, I didn't want to go. I was interested in him, but I had plans that weekend that did not involve driving to New Hampshire to photograph what I assumed would be a deadly, dull book signing (at far right).

But when Kelly Price, my editor at Polaris Images, told me that the German newsmagazine *Stern* would pay me to make that five-hour drive, I canceled my plans, climbed into my Camry, and drove up to Portsmouth. It was probably the best decision I ever made.

I had been right about a few things. The event was in a building that was dark, cavernous, and impossible to find. I showed up late and in a panic. Looking around at the space, I wondered why I had even bothered.

But when Obama walked into the room, my concerns became irrelevant. The crowd was transfixed. Hell, some of the other news photographers were transfixed. And this was New Hampshire! New Hampshire photographers are not impressed by politicians. Ever. Immediately after the event ended, even before filing my pictures, I called Kelly and told her that I was going to cover the Obama presidential campaign. I did not offer her a choice. The fact that he wasn't technically running yet was immaterial. I knew that this was

going to be important, and I wanted to be there.

Despite my complete lack of "on-the-bus" experience, the national editor at *Newsweek* took a huge risk and assigned me to cover Barack Obama's announcement tour. For the first two days of the campaign, I would be a part of the traveling press corps. I would have to learn fast.

For the next twenty-three months, I followed Obama from event to event, only heading home for quick breaks to meet with editors and remind my boyfriend what I looked like. I followed Obama into coffee shops and diners, auto manufacturing plants and bowling alleys. I followed him in a rental car, and I flew in his charter jet. I photographed him wooing potential voters in expensive houses and on poverty-stricken Indian reservations. I covered small events where I was the only photographer present, and I covered massive rallies with more than 75,000 people.

Even as the campaign stretched from one year to two, and as I marked my third winter photographing the Senator, I never lost interest in documenting this campaign and the people who have supported it. The crowd's reaction to the Senator and his campaign has fueled my work, whether the audience included

a skeptical old farmer from Tama, Iowa, who was surprised to slowly realize that he had something in common with this young black politician from Hawaii, or an eight-year-old boy from L.A. who couldn't stop saying, "He is going to be President! He looks like me and he is going to be President!" The looks on people's faces, the questions on their lips, and the way they hung on his every word were constant reminders of the importance of Obama's campaign.

As a friend said on election night, we are now living in a different world than the one we woke up in. I will be forever grateful that I had the opportunity to witness this moment in history.

Scout Tufankjian
November 2008

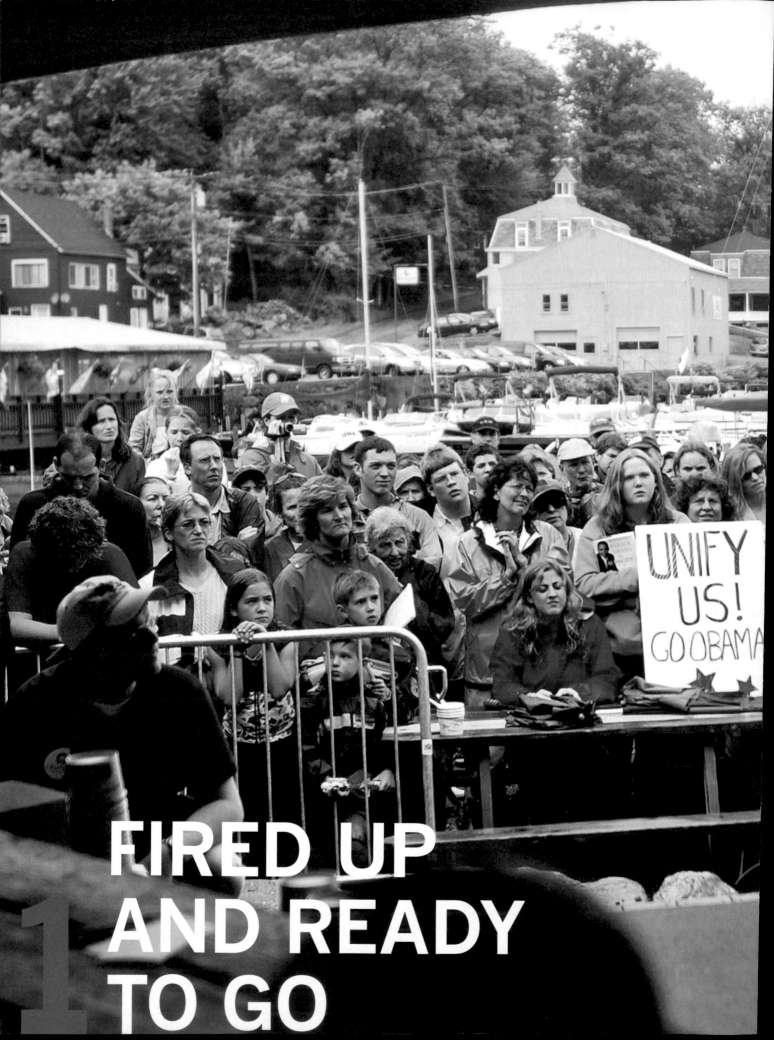

FIRED UP AND READY TO GO

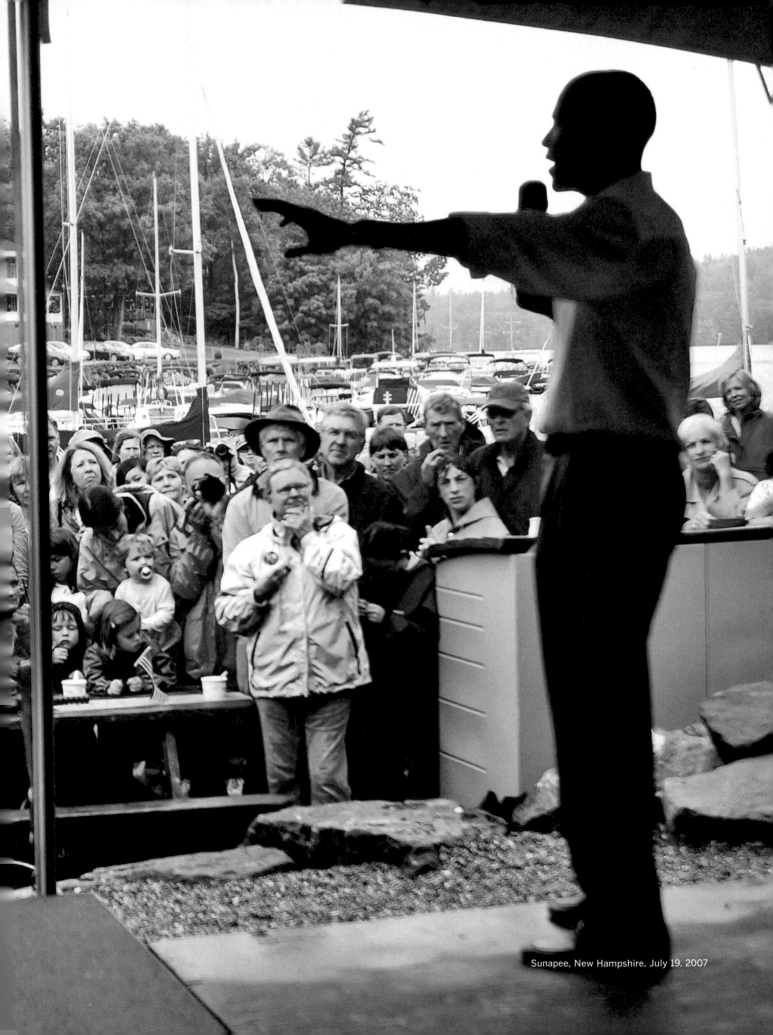

Sunapee, New Hampshire, July 19, 2007

THE EARLY DAYS

The first two weeks of the campaign were similar to what I imagine following Mick Jagger must be like—thousands of screaming fans grabbing at his clothes and holding on to his leg for dear life.

As time went on, however, the rhythm gradually slowed, until I was following Obama across the hills and plains of Iowa into show barns, **junior high school gyms, and park gazebos.** Everyone who covered him in Iowa is nostalgic for those days—the pressure was off, the stress was minimal, and it seemed as though the campaign would never end. There was no frenzy to arrive at events on time, no Secret Service equipment sweep. If I was hungry, I would stop and grab a sandwich and casually roll into the event ten minutes late.

There were, of course, big days—**the Harkin Steak Fry,** when Obama marched in at the head of a huge parade with his own marching band, and the Jefferson-Jackson Dinner, when his rousing speech may have been what put him over the top in the Iowa Caucus. But mostly there were smaller days, like **the cold, rainy morning** the Senator spent knocking on doors in Des Moines that were answered either by toddlers or no one at all, before the neighborhood finally woke up and realized who their guest was.

EADY TO GO

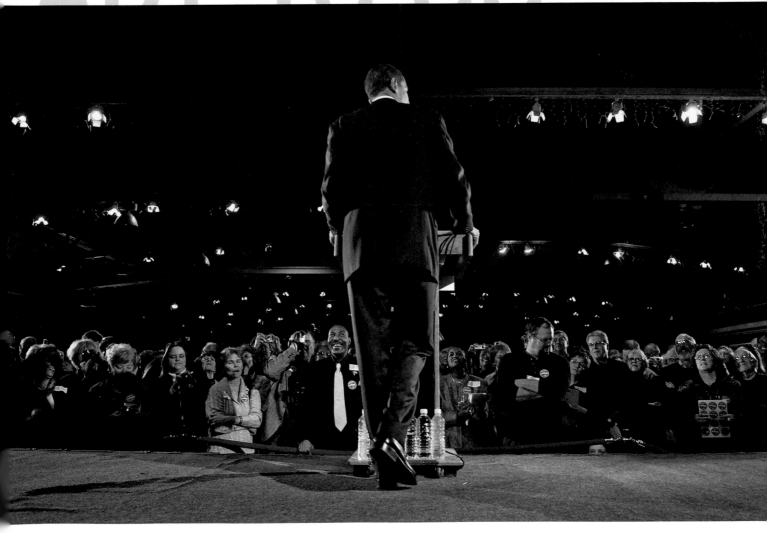

Manchester, New Hampshire
December 10, 2006

This campaign can't only be about me. It must be about us—it must be about what we can do together. . . . This campaign has to be about reclaiming the meaning of citizenship, restoring our sense of common purpose, and realizing that few obstacles can withstand the power of millions of voices calling for change.

Springfield, Illinois, February 10, 2007

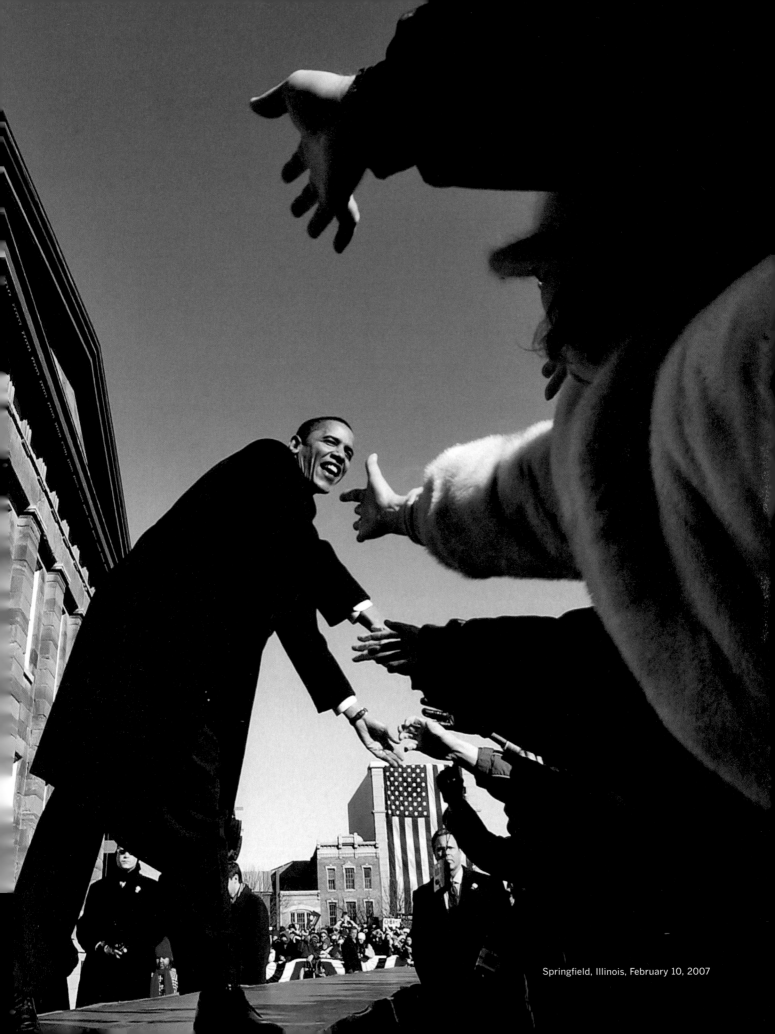

Springfield, Illinois, February 10, 2007

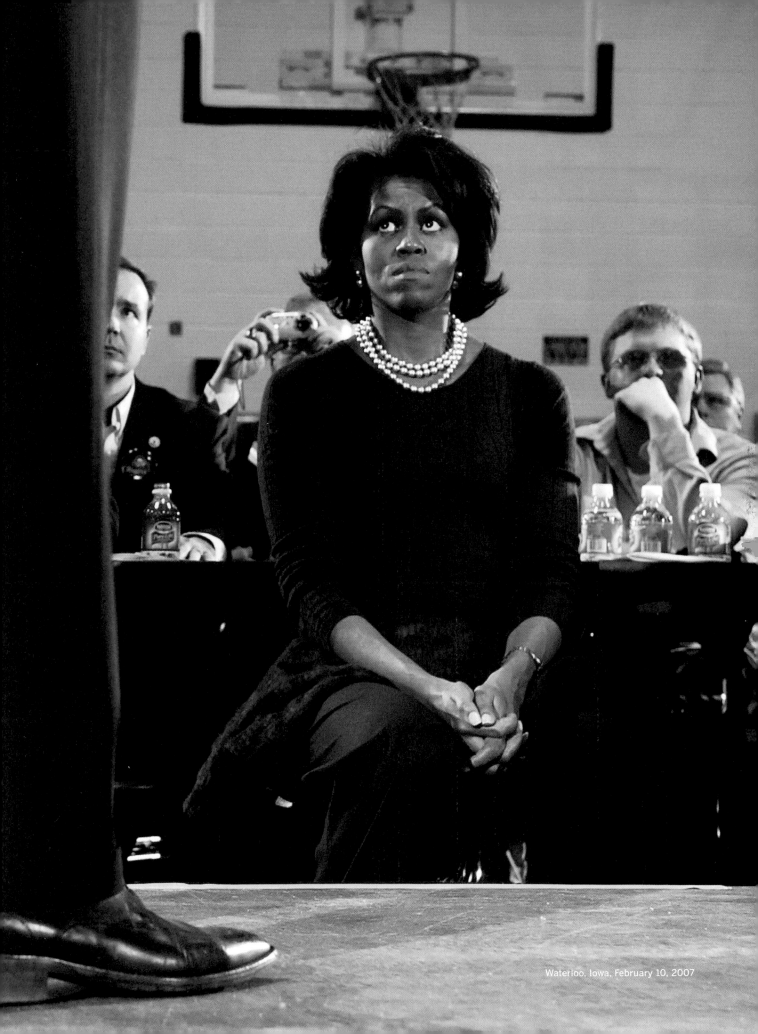

Waterloo, Iowa, February 10, 2007

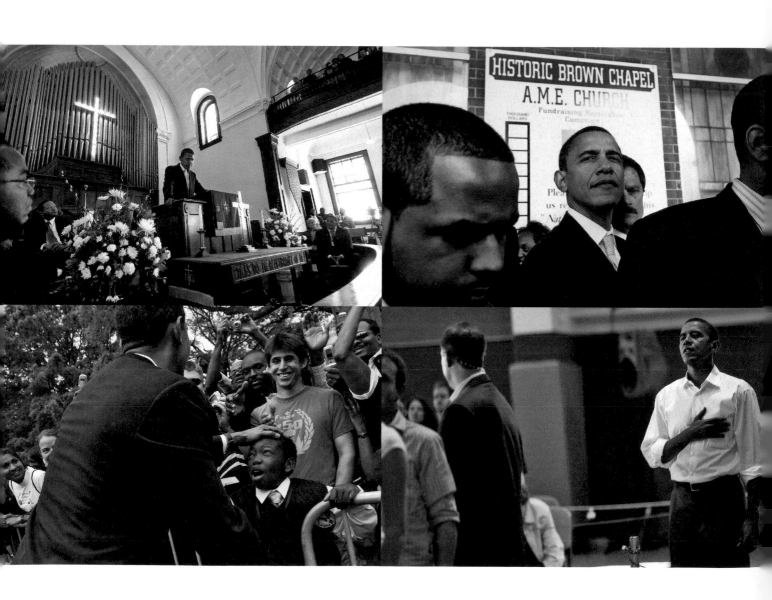

Each and every time, a new generation has risen up and done what's needed to be done. Today we are called once more—and it is time for our generation to answer that call. For that is our unyielding faith—that in the face of impossible odds, people who love their country can change it.

Springfield, Illinois, February 10, 2007

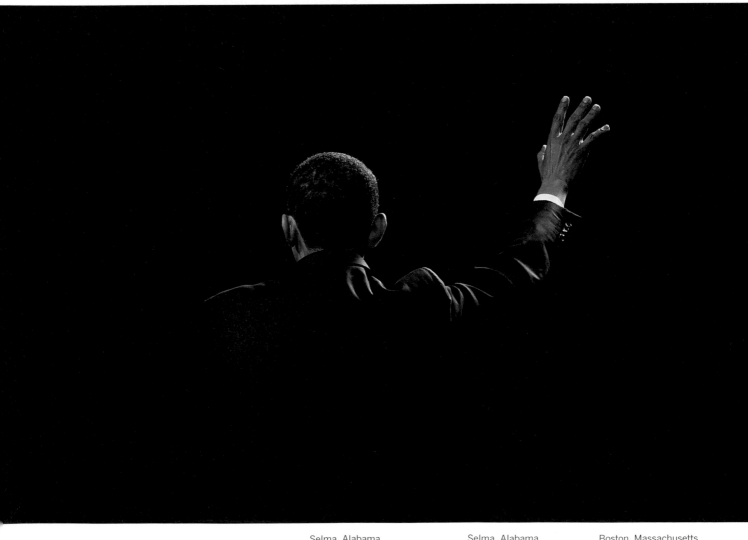

Selma, Alabama
March 4, 2007

Atlanta, Georgia
April 14, 2007

Selma, Alabama
March 4, 2007

Anamosa, Iowa
September 13, 2007

Boston, Massachusetts
April 20, 2007

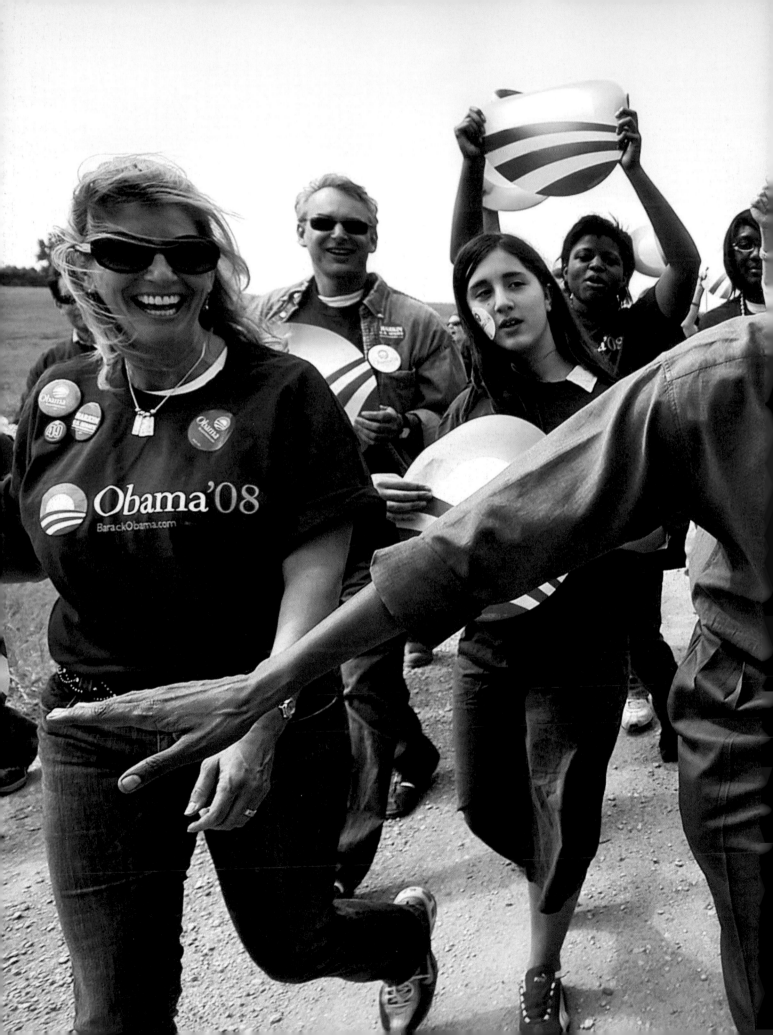

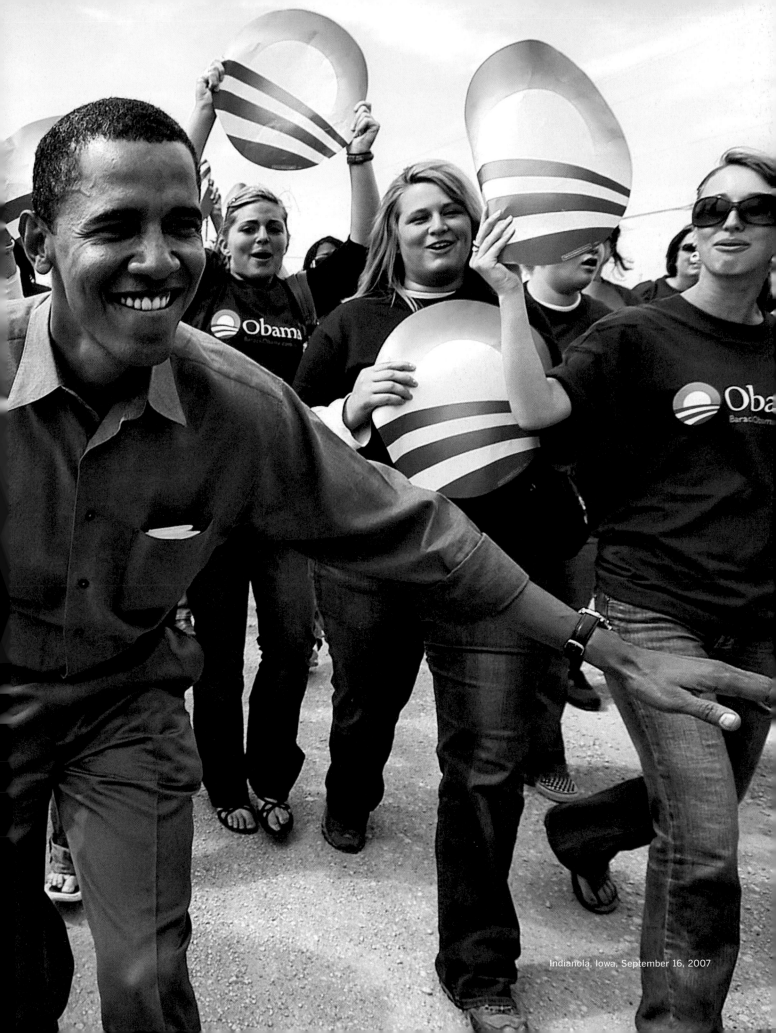

Indianola, Iowa, September 16, 2007

There's not a liberal America and a conservative America—there's the United States of America. There's not a black America and white America and Latino America and Asian America—there's the United States of America.

Boston, Massachusetts, Democratic National Convention, July 27, 2004

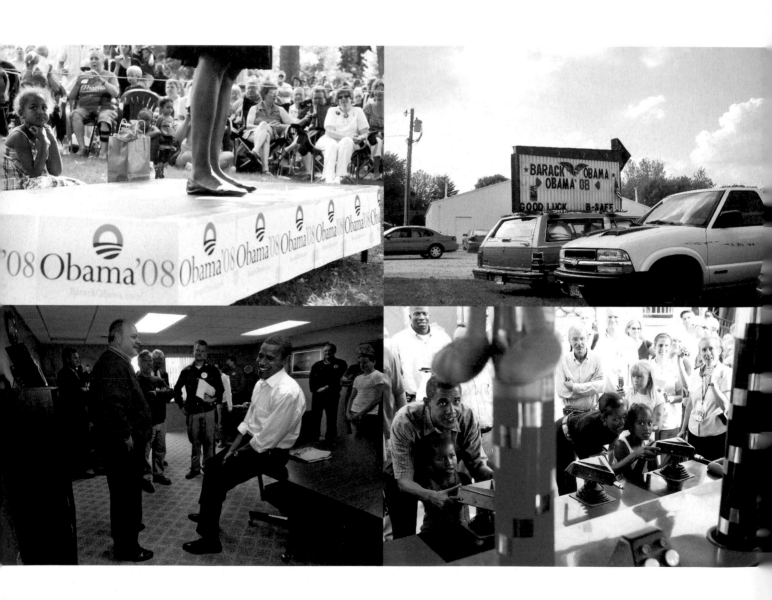

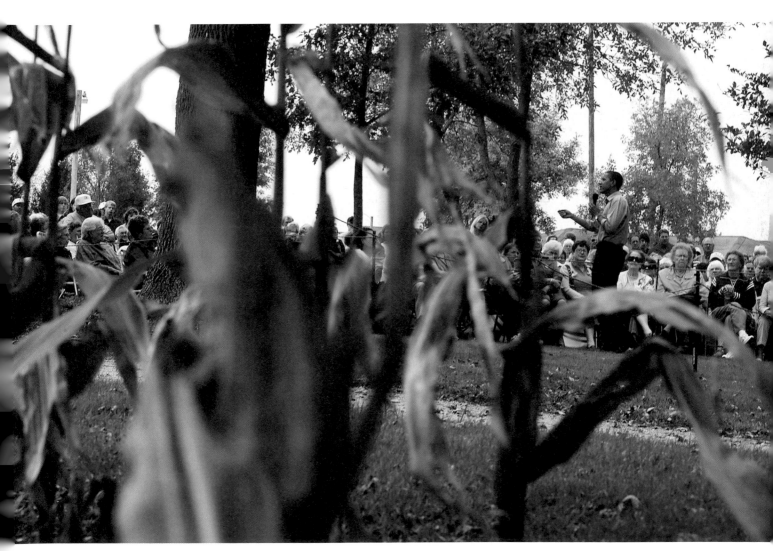

Des Moines, Iowa
July 4, 2007

Independence, Iowa
October 4, 2007

New Hampton, Iowa
October 5, 2007

Marshalltown, Iowa
October 12, 2007

Des Moines, Iowa
August 16, 2007

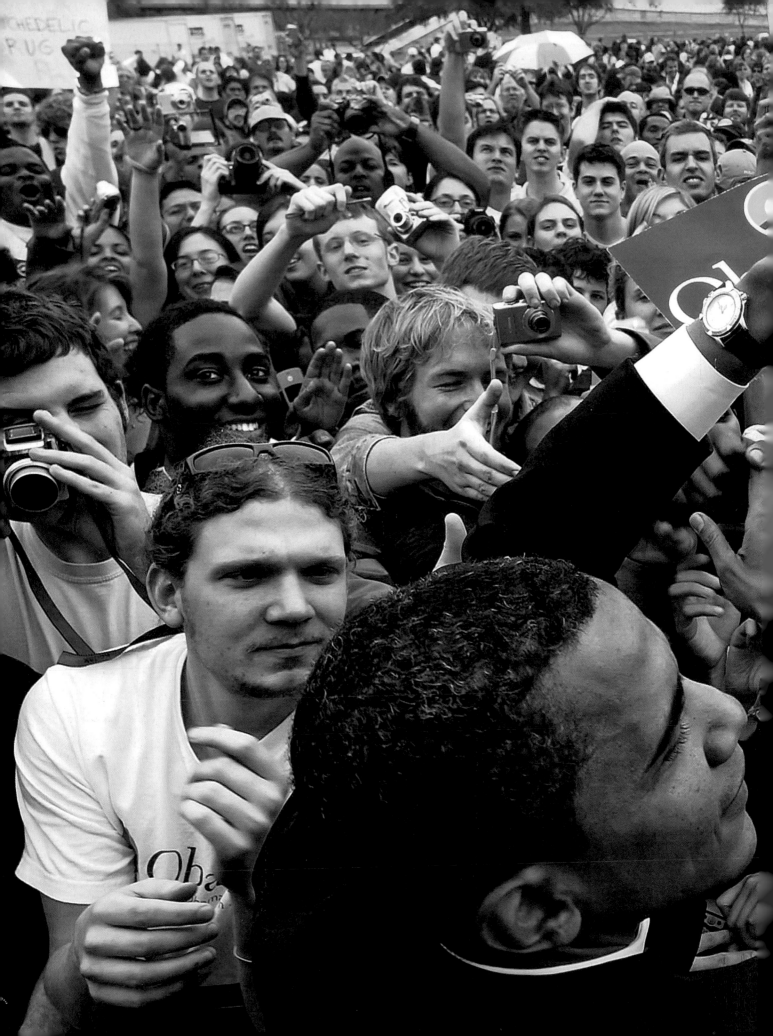

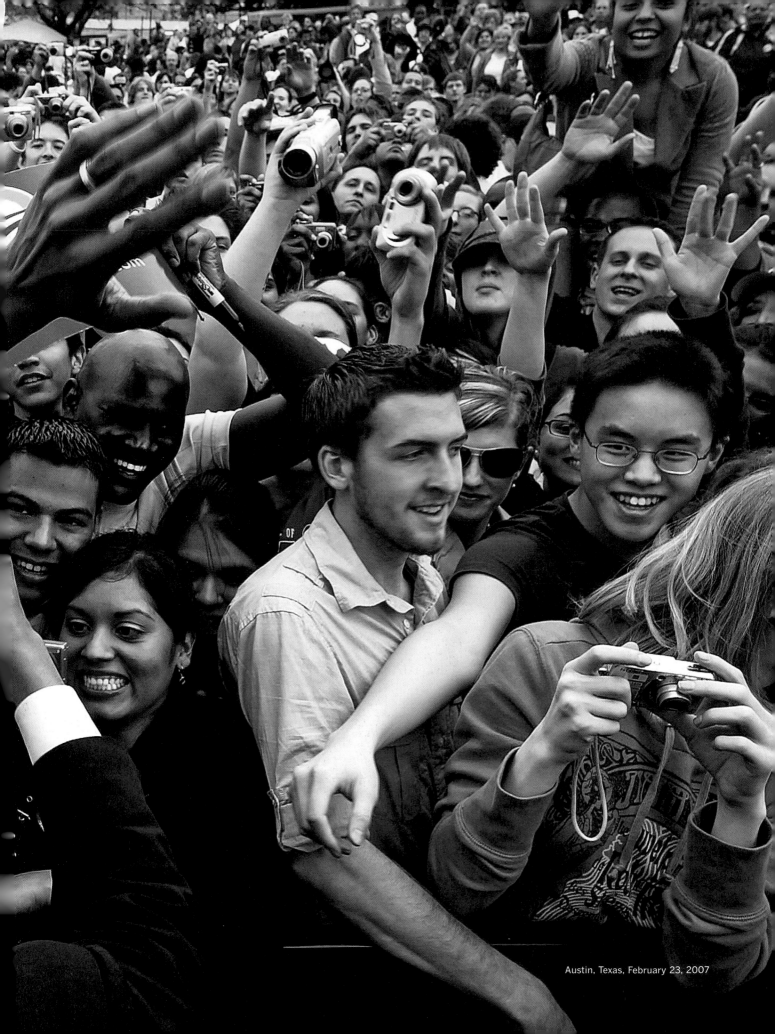

Austin, Texas, February 23, 2007

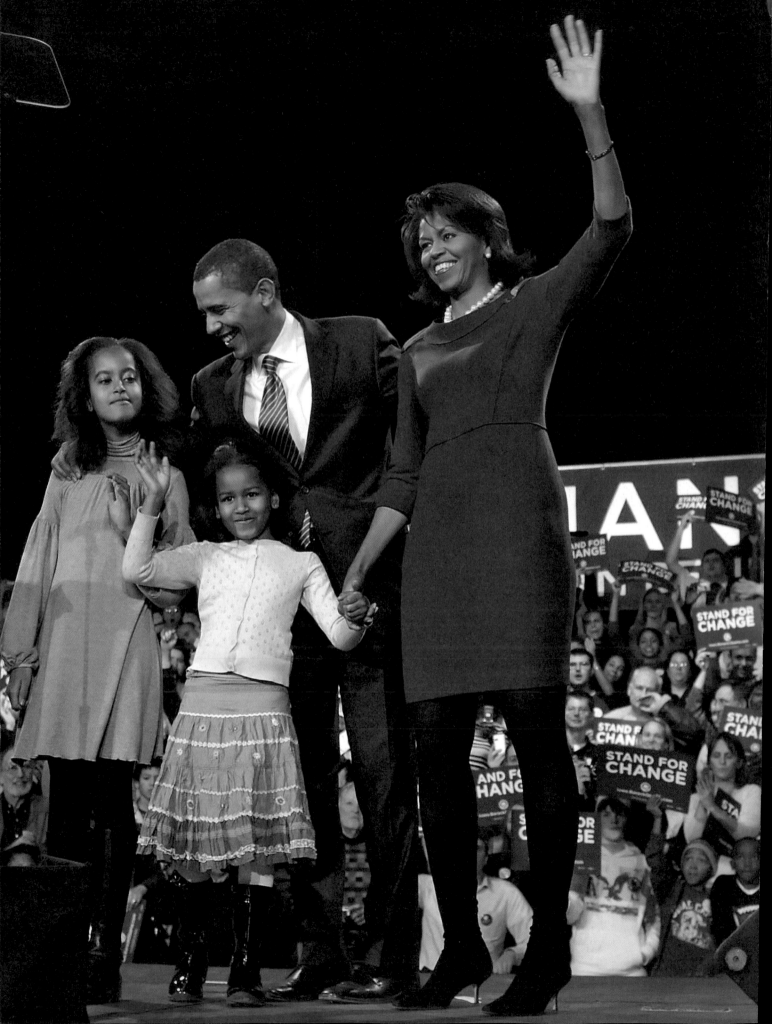

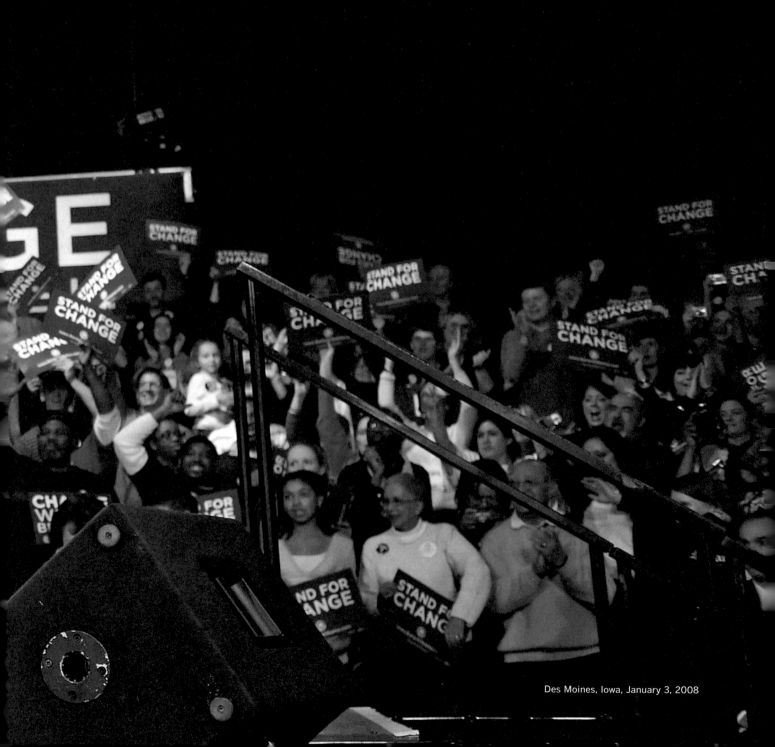

2 THEY SAID THIS DAY WOULD NEVER COME

Des Moines, Iowa, January 3, 2008

THE LEAD-UP TO IOWA

When the morning of the Iowa Caucus dawned, none of us in the traveling press knew what lay ahead. We had spent the past month on a dizzyingly nonstop tour of Iowa: five events a day, **early mornings, late nights, and long afternoons**. The relaxed early days of the campaign were long over, and it had become difficult to keep track of where we were or where we were going.

All we knew was that for Senator Obama, **everything came down to this day**. Tonight he would know if the long months spent in Iowa, talking to seemingly every citizen in the state, would pay off. He would know if his message had really reached them, if they were ready to vote for a man named Barack Obama, or if they would choose a more familiar name or a more familiar face.

Driving to the Election Night rally from a small-town caucus, I feared that it was all over, that the year I had spent covering this campaign would end quietly, on a cold, early-morning flight back to New York.

I was right about one thing. When I got to the rally, it was already over. But not in the way I had expected. Supporters were filling the stands, chanting **"USA! USA!"** and **"Obama '08!"** in triumph. The people of Iowa had spoken.

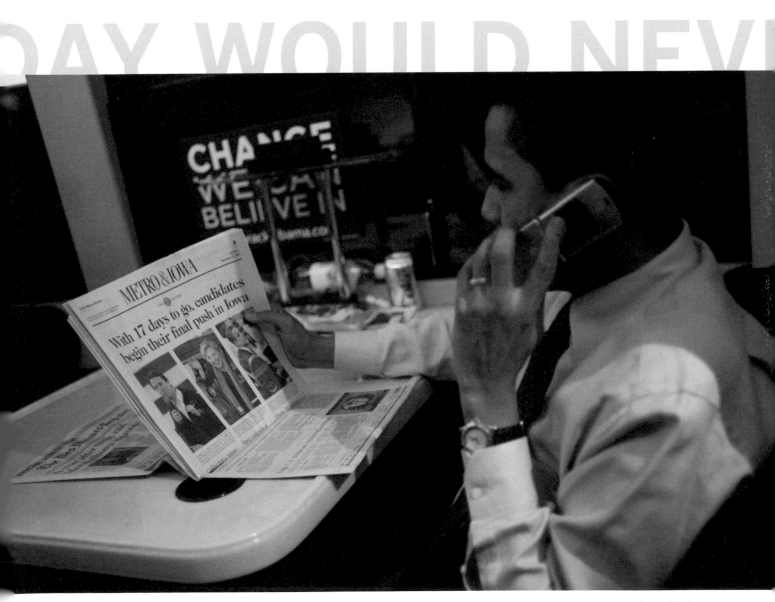

METRO & IOWA

With 17 days to go, candidates
begin their final push in Iowa

Sioux City, Iowa
December 17, 2007

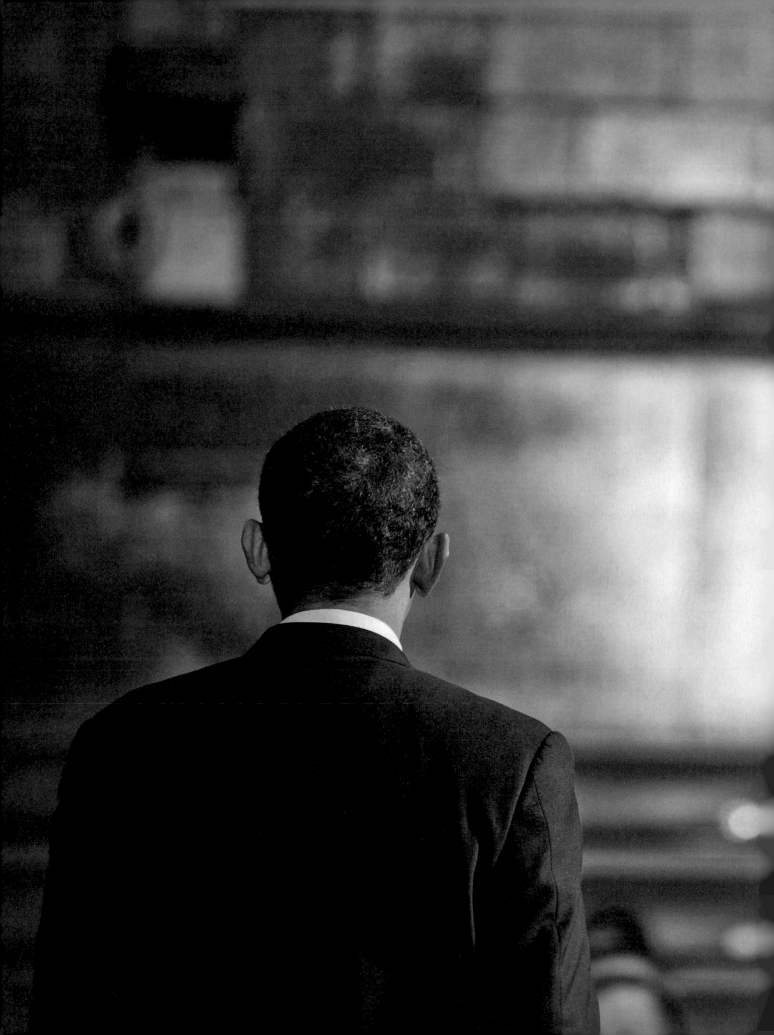

New Hampton, Iowa, December 15, 2007

You know, they said this day would never come.

They said our sights were set too high.

They said this country was too divided; too disillusioned to ever come together around a common purpose.

But on this January night—at this defining moment in history— you have done what the cynics said we couldn't do.

Des Moines, Iowa, January 3, 2008

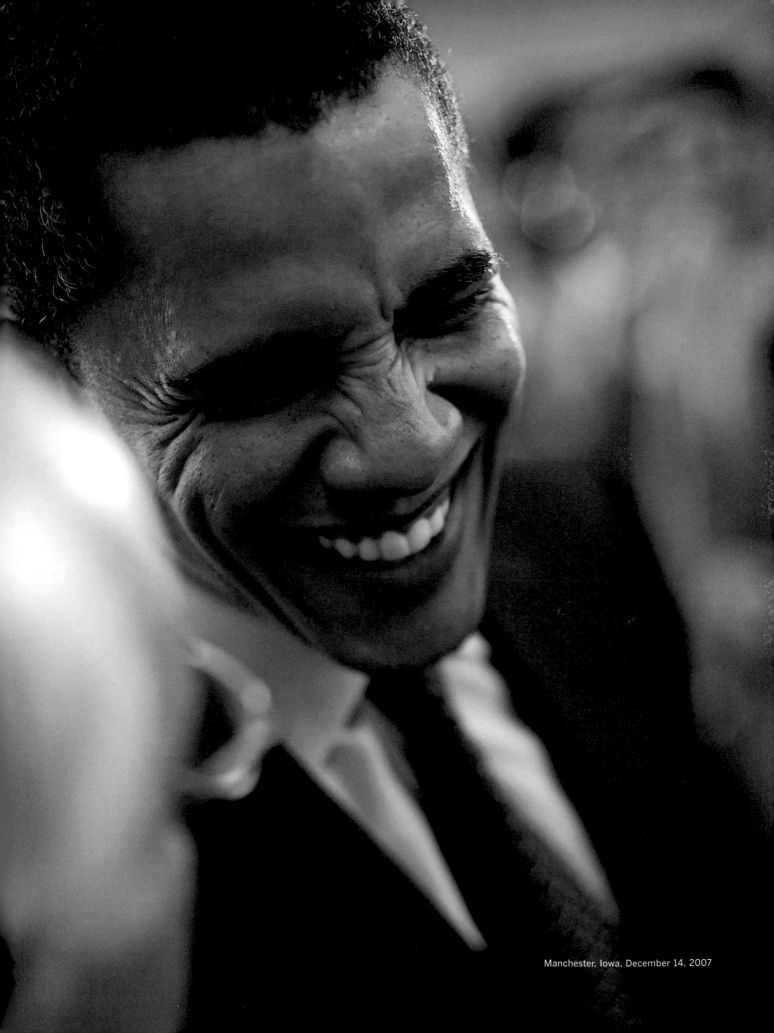

Manchester, Iowa, December 14, 2007

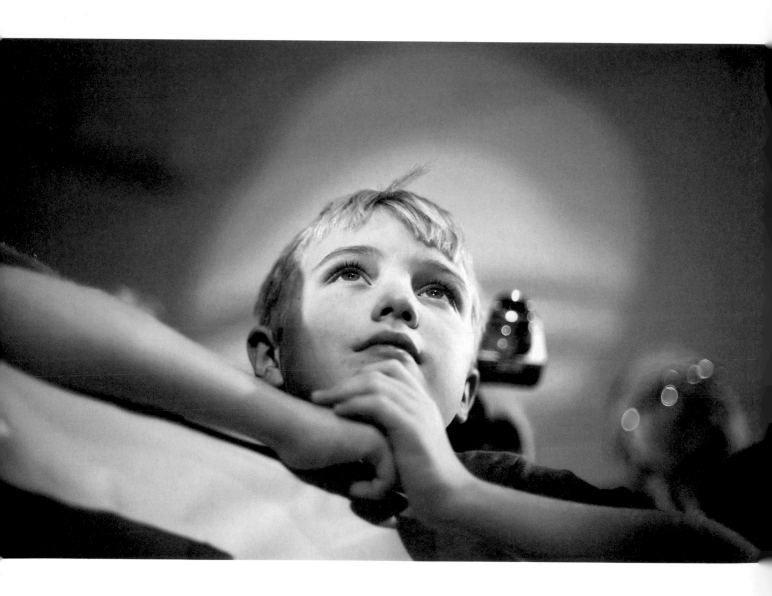

I run to give my children and their children the same chances that someone, somewhere gave me. . . . And I run to keep the promise of the United States of America alive for all those who still hunger for opportunity and thirst for equality and long to believe again.

Spartanburg, South Carolina, November 3, 2007

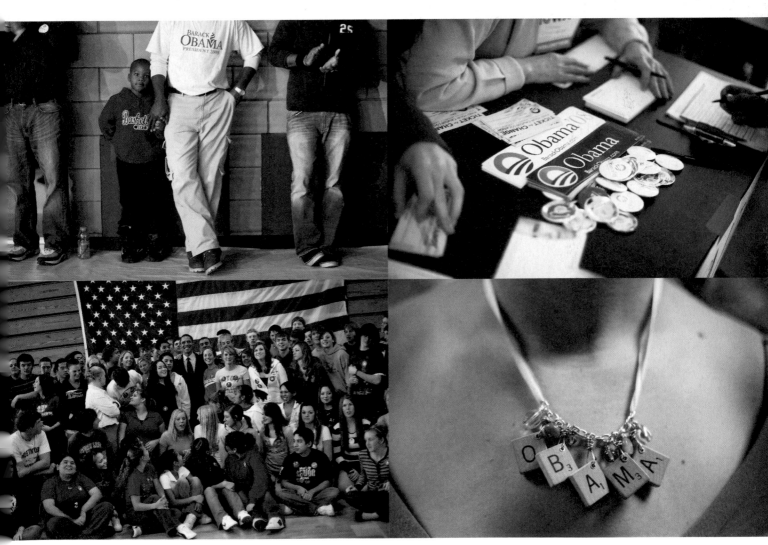

Dubuque, Iowa
January 1, 2008

Muscatine, Iowa
December 28, 2007

Knoxville, Iowa
December 30, 2008

Storm Lake, Iowa
December 17, 2007

Waterloo, Iowa
December 15, 2007

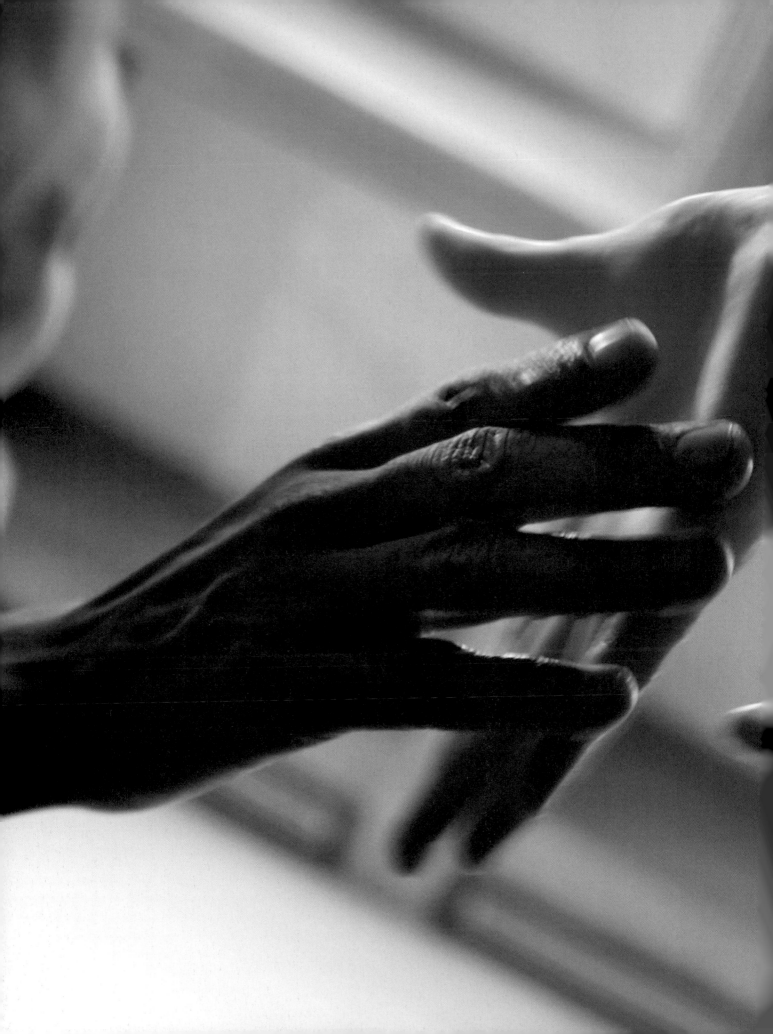

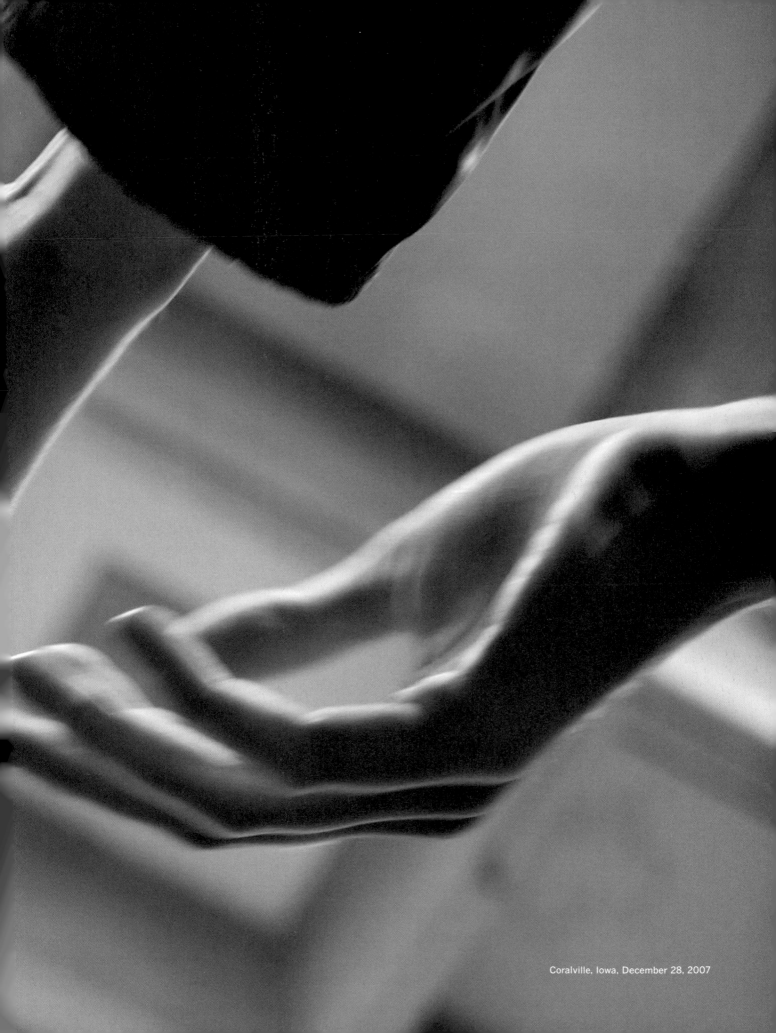

Coralville, Iowa, December 28, 2007

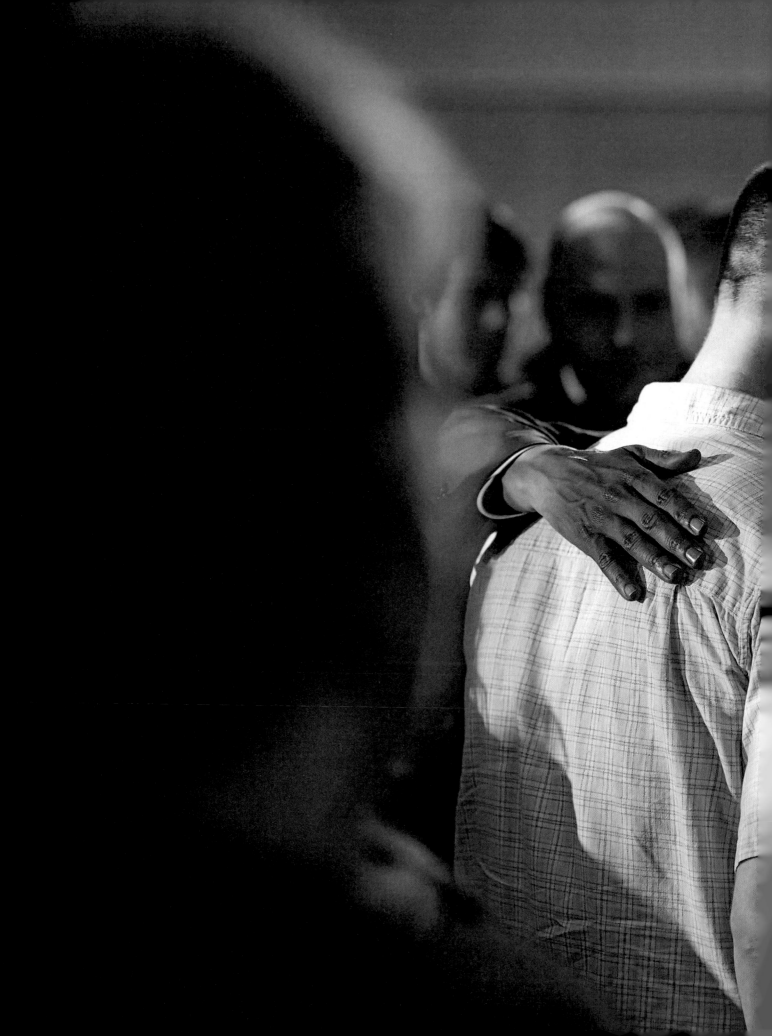

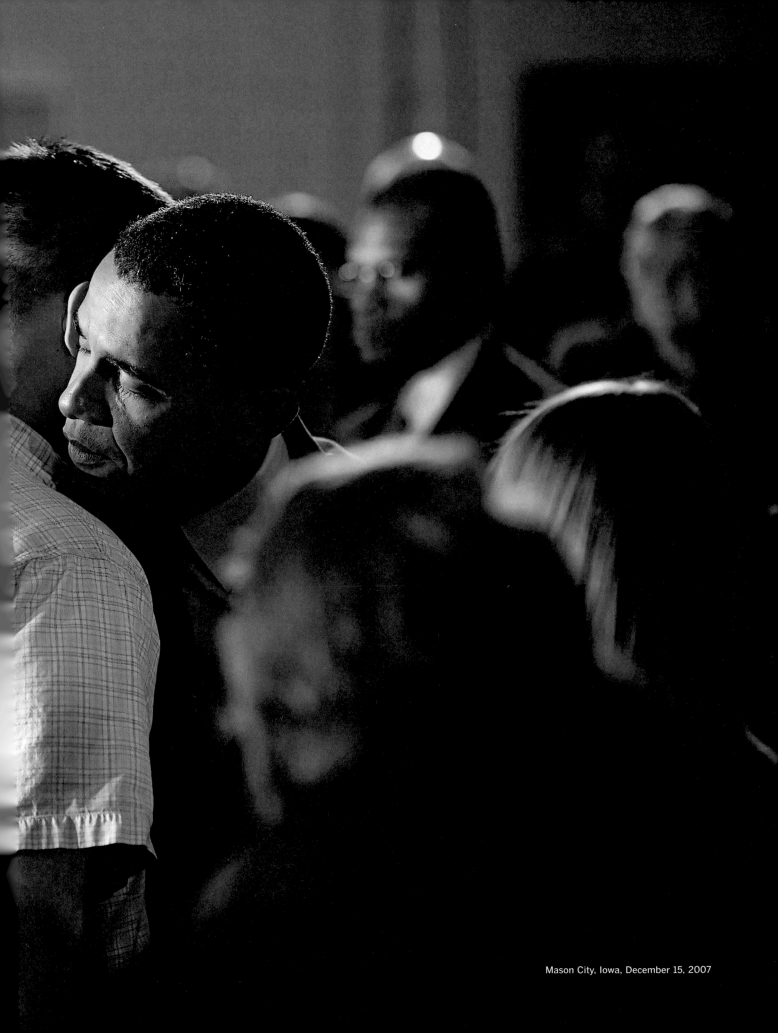

Mason City, Iowa, December 15, 2007

There has been a lot of talk in this campaign about the politics of hope. But the politics of hope doesn't mean hoping that things come easy. It's a politics of believing in things unseen; of believing in what this country might be; and of standing up for that belief and fighting for it when it's hard.

Bettendorf, Iowa, November 7, 2007

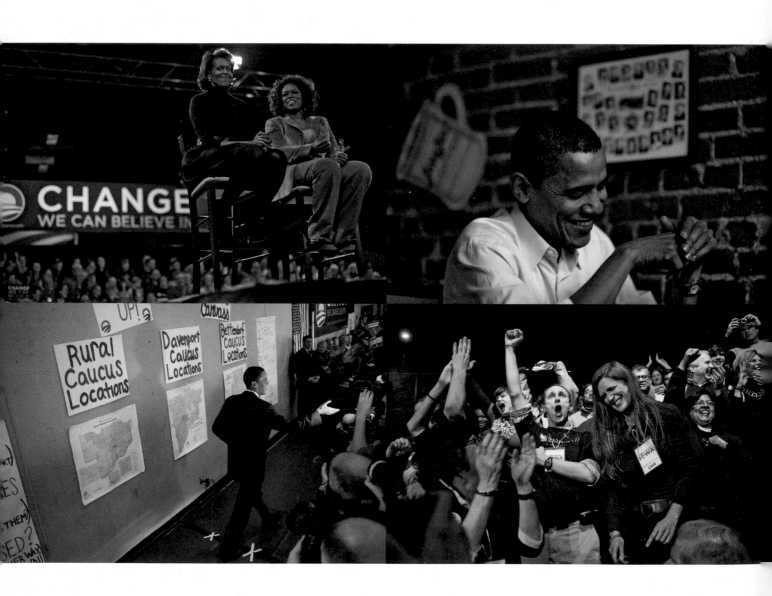

Des Moines, Iowa
December 8, 2007

Pleasantville, Iowa
December 22, 2007

Manchester, Iowa
December 14, 2007

Davenport, Iowa
January 2, 2008

Des Moines, Iowa
January 3, 2008

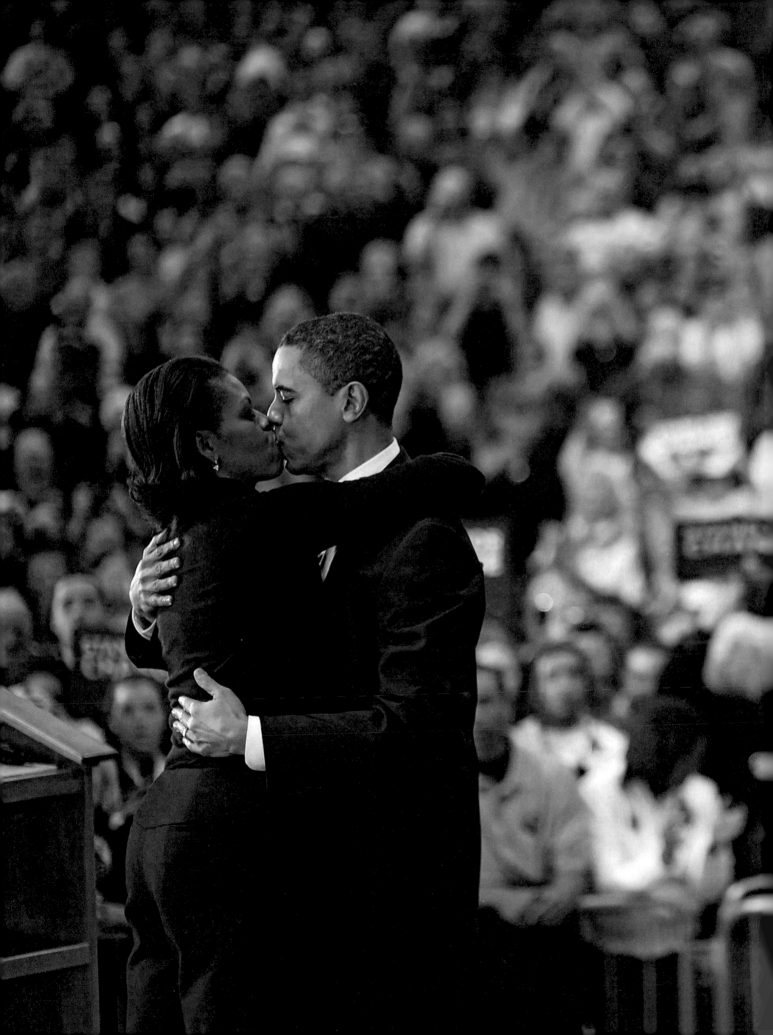

Des Moines, Iowa, January 2, 2008

WHY OBAMA?

When Senator Obama first started to run for President, much of the media was consumed with the question: who will vote for him and why? So I decided to find out.

I gave people at rallies in Austin and Los Angeles chalk and a chalkboard and asked them to write a few words about why they supported Obama's candidacy. Their answers, like his supporters themselves, varied wildly.

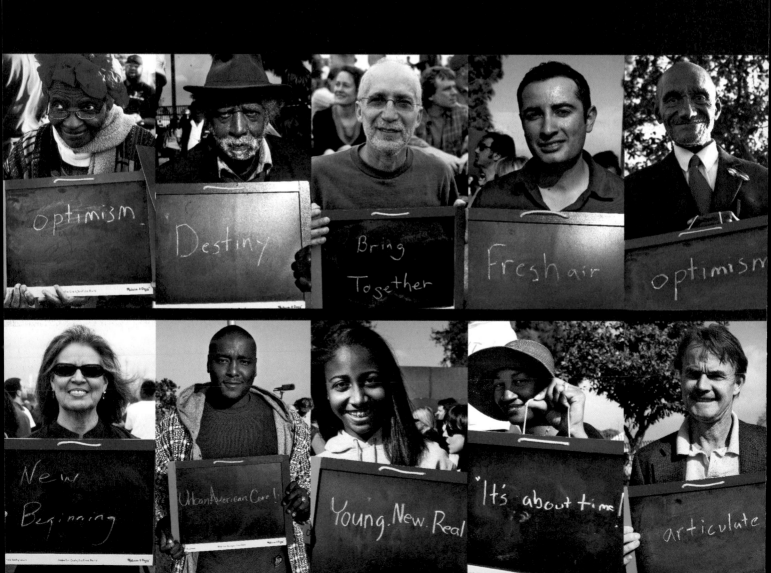

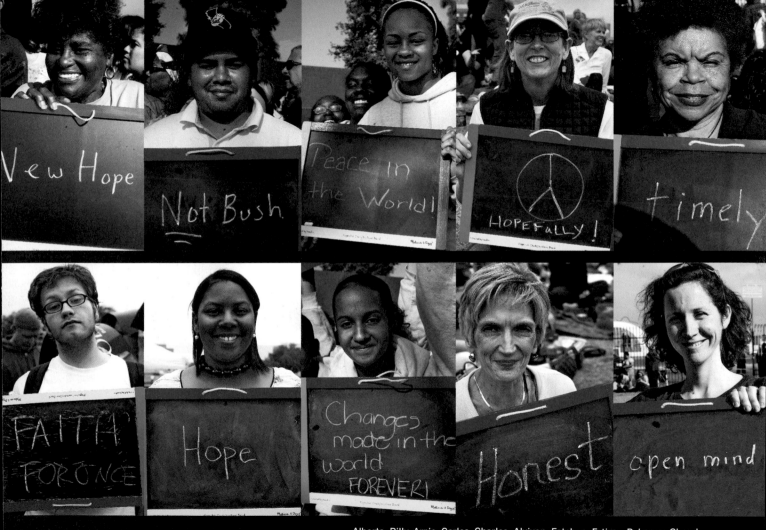

Alberta, Billy, Arnie, Carlos, Charles, Alvivon, Esteban, Fatima, Rebecca, Cheryl
Irma, Josiah, Lacie, Lilly, Noel, Colin, Adrienne, Brooke, Cindy, Christa

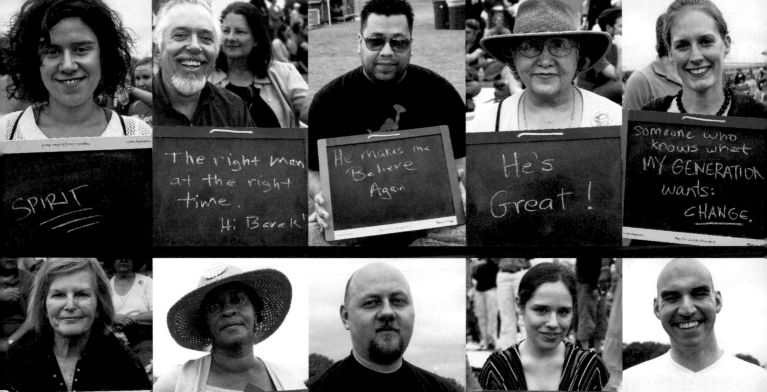

SPIRIT

The right man at the right time. Hi Barak!

He makes me Believe Again

He's Great!

Someone who knows what MY GENERATION wants: CHANGE.

He brings HOPE for the FUTURE

TRUTH Righteousness

FRESH IDEAS THAT WE NEED

A New Direction!

Knows the inner-city problems will be willing to deal with them

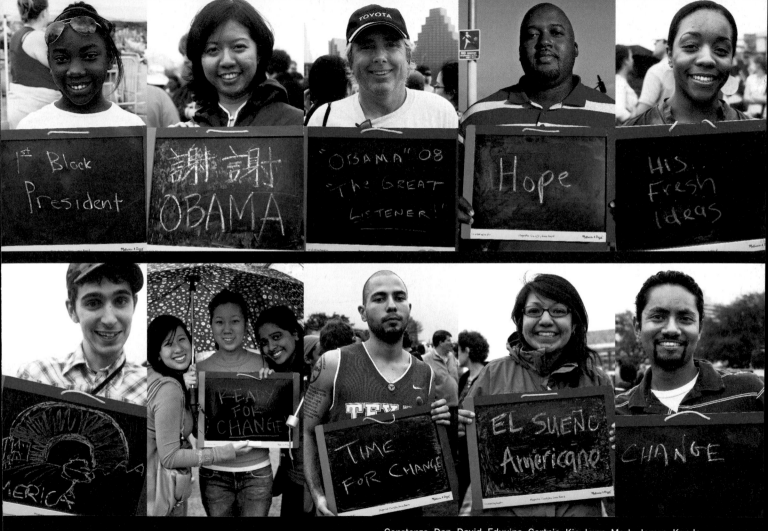

Constanza, Dan, David, Eduvina, Cortnie, Kia, Lynn, Mark, James, Kenda
Sue, Mary Elizabeth, Matt, Rachel, Ricardo, Bear, Mita, Oliva and Michelle, Rod, Ruby, Shahriyar

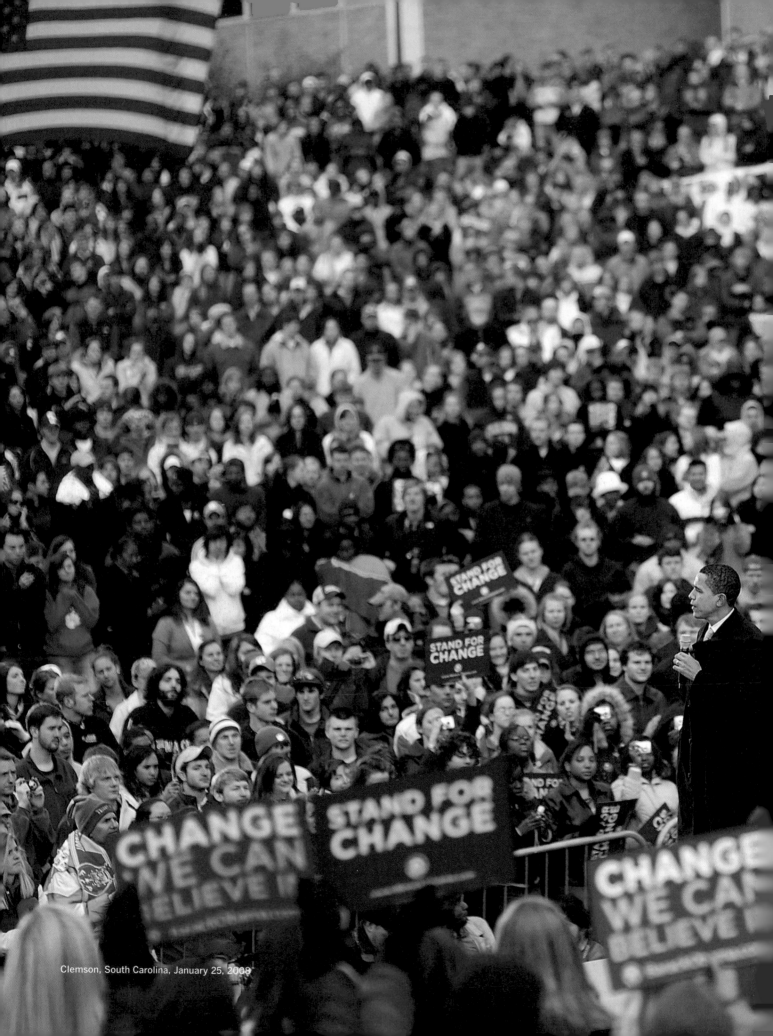

Clemson, South Carolina, January 25, 2008

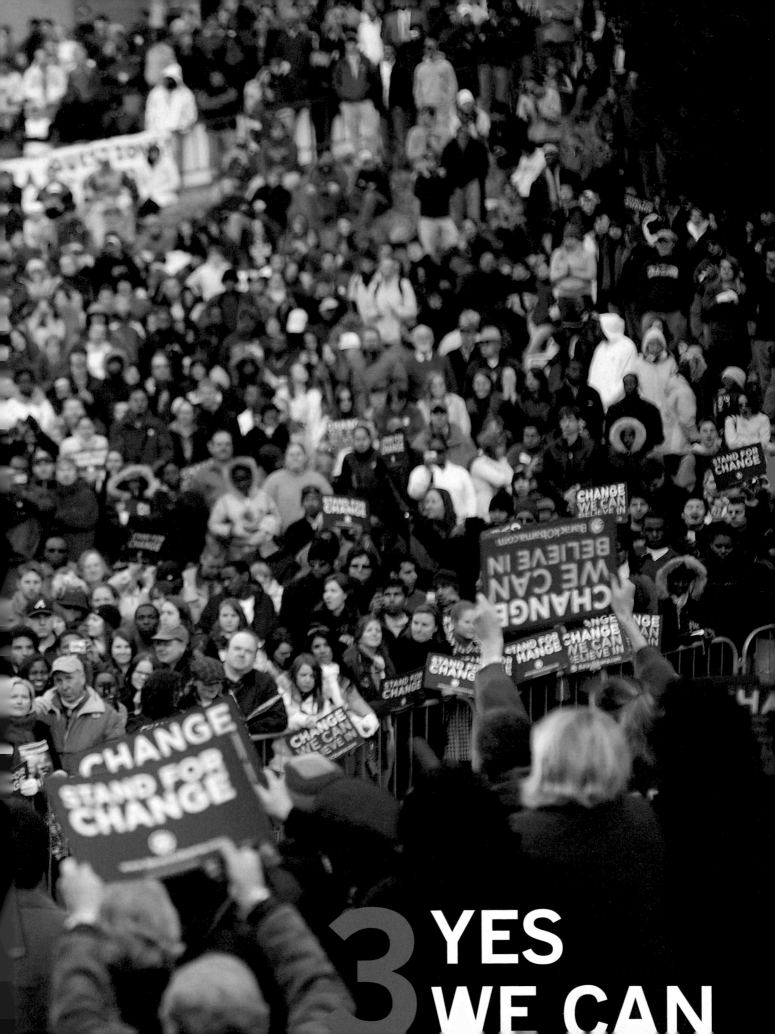

3 YES WE CAN

YES WE CAN

NEW HAMPSHIRE TO SOUTH CAROLINA

The New Hampshire primary was a blur of cold and sleep deprivation. Every single event was wildly overcrowded, and on one occasion the fire marshal wouldn't even let the traveling press in. People lined up in the cold for hours just to get a glimpse of Senator Obama as he walked into a building. Two nights before the primary, I sat in the buffer area between the stage and the floor and **felt the ground shake** with the stomps and cheers of his supporters. It seemed like there was no way that he could lose. Until he did.

South Carolina was my favorite part of the campaign. While the ground-breaking nature of his candidacy was always obvious, it was not until we were in South Carolina that I really started to understand how he had expanded people's sense of possibility. The older people in South Carolina have lived through times that I can't even imagine, and many of them told me they couldn't believe they had lived long enough to see this moment. And the young people there spoke of goals shifted, soaring aspirations, and a new role model. **They pressed their faces against windows**, waited along the side of the road for a glimpse of the motorcade, and watched him speak with silent tears streaming from their eyes.

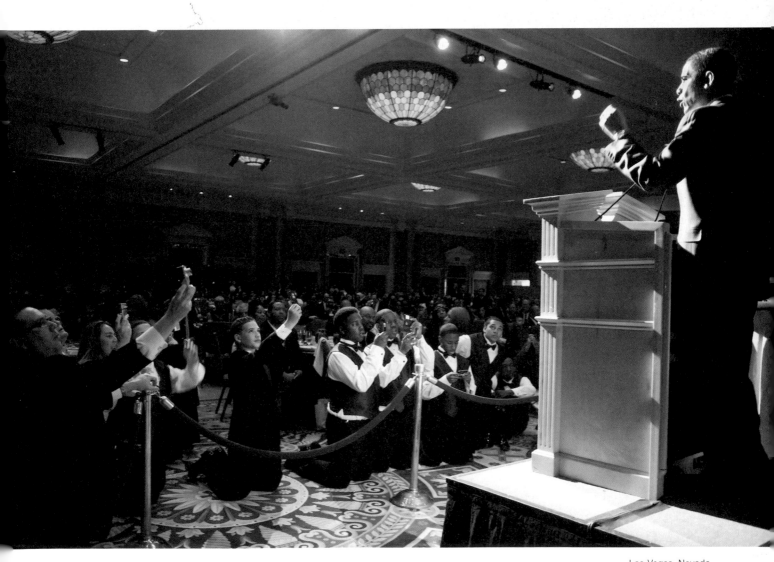

Las Vegas, Nevada
January 18, 2008

Salem, New Hampshire, January 6, 2008

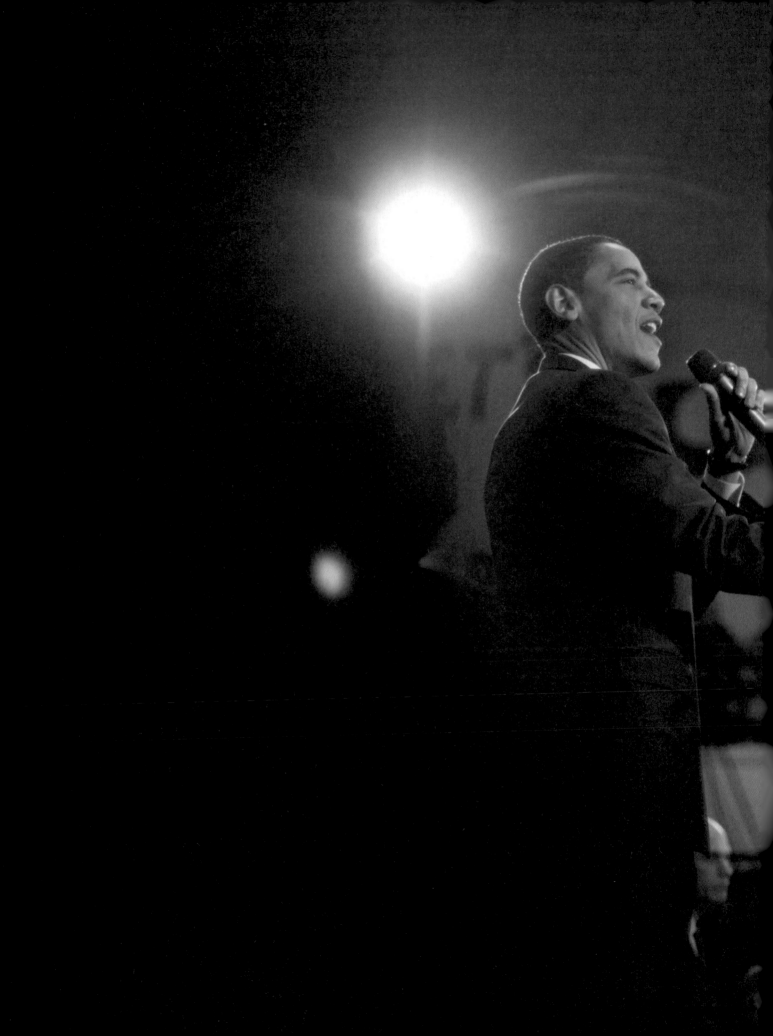

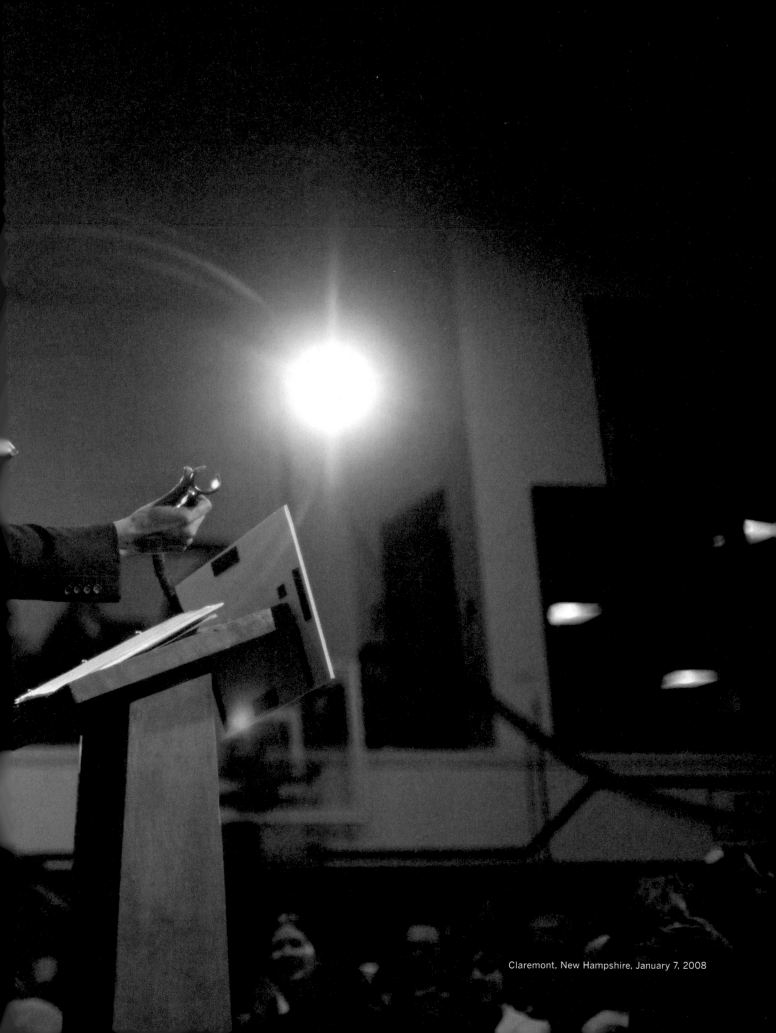

Claremont, New Hampshire, January 7, 2008

Yes we can. It was the call of workers who organized; women who reached for the ballot; a President who chose the moon as our new frontier; and a King who took us to the mountaintop and pointed the way to the Promised Land.

Yes we can to justice and equality. Yes we can to opportunity and prosperity. Yes we can heal this nation. Yes we can repair this world. Yes we can.

Nashua, New Hampshire, January 8, 2008

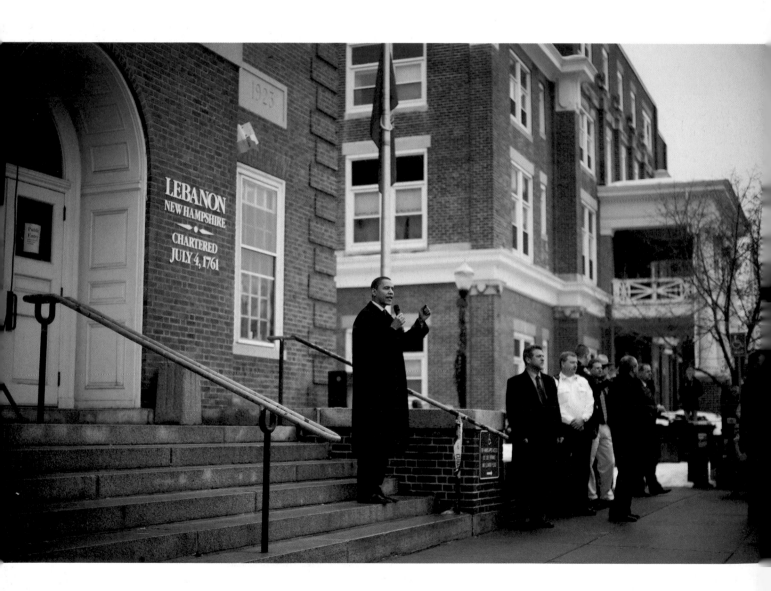

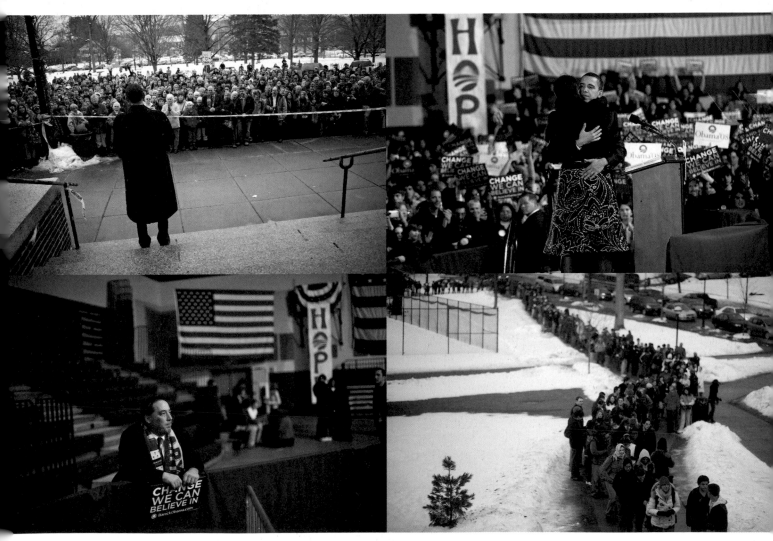

Lebanon, New Hampshire
January 7, 2008

Nashua, New Hampshire
January 8, 2008

Lebanon, New Hampshire
January 7, 2008

Nashua, New Hampshire
January 8, 2008

Hanover, New Hampshire
January 8, 2008

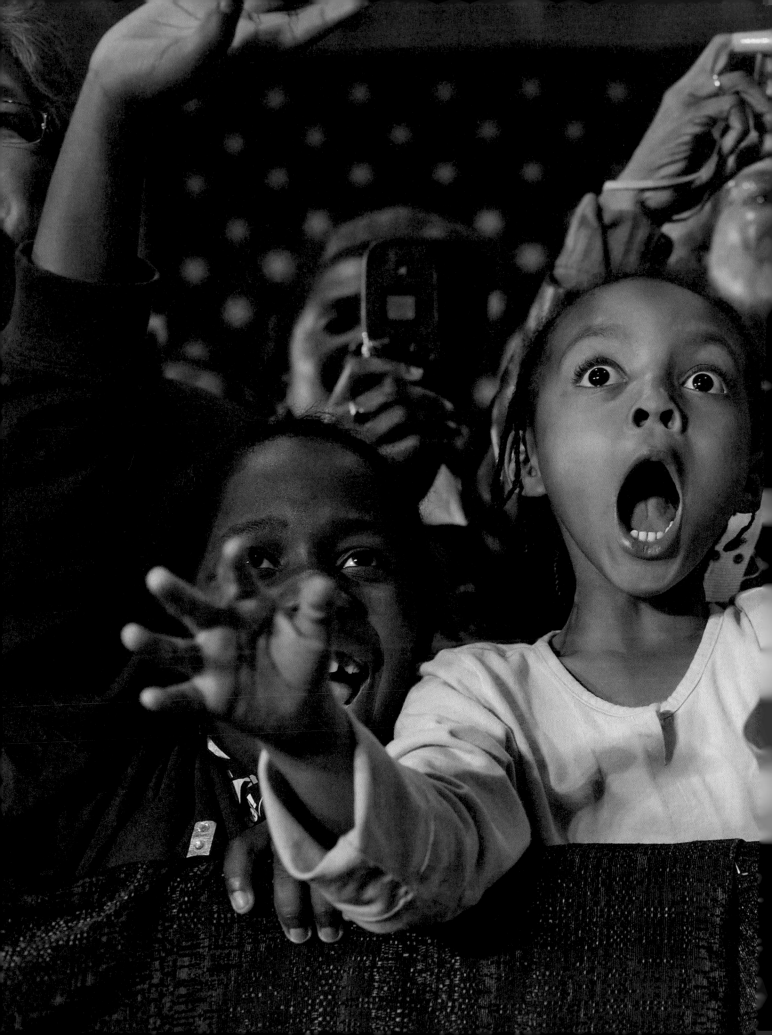

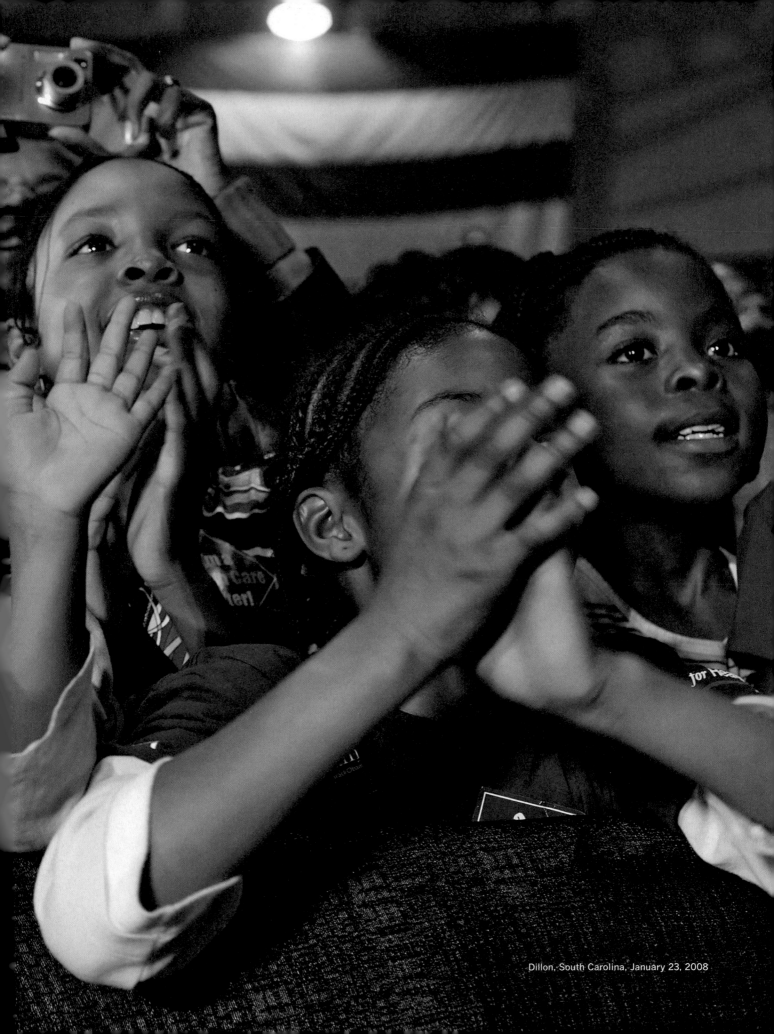

Dillon, South Carolina, January 23, 2008

Change will not be easy. . . . There will be setbacks and false starts, and sometimes we will make mistakes. But as hard as it may seem, we cannot lose hope. Because there are people all across this country who are counting on us; who can't afford another four years without health care or good schools or decent wages because our leaders couldn't come together and get it done.

Columbia, South Carolina, January 26, 2008

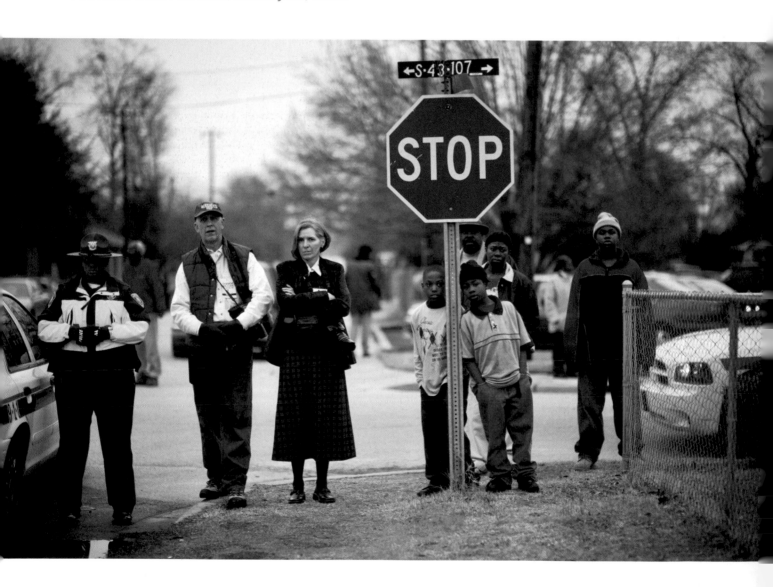

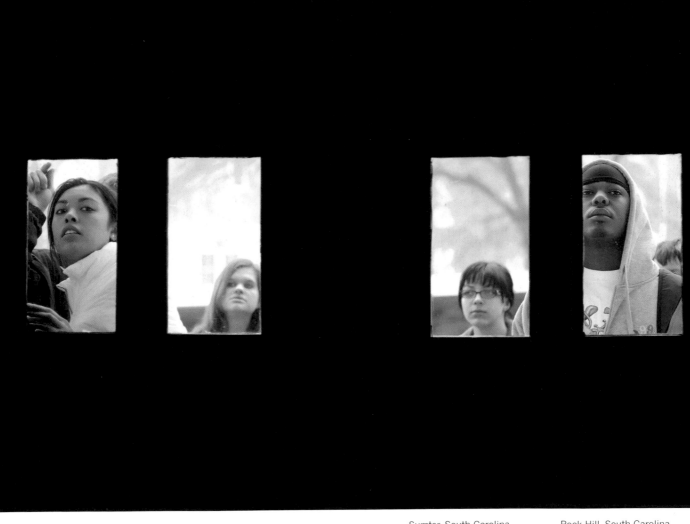

Sumter, South Carolina
January 23, 2008

Rock Hill, South Carolina
January 23, 2008

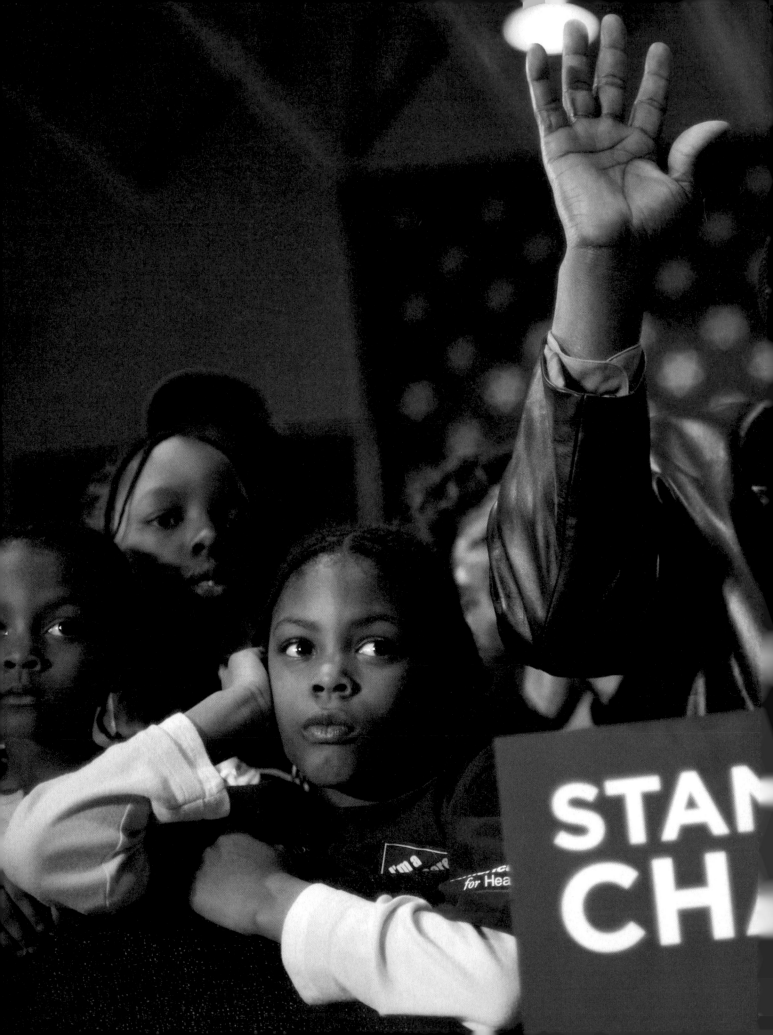

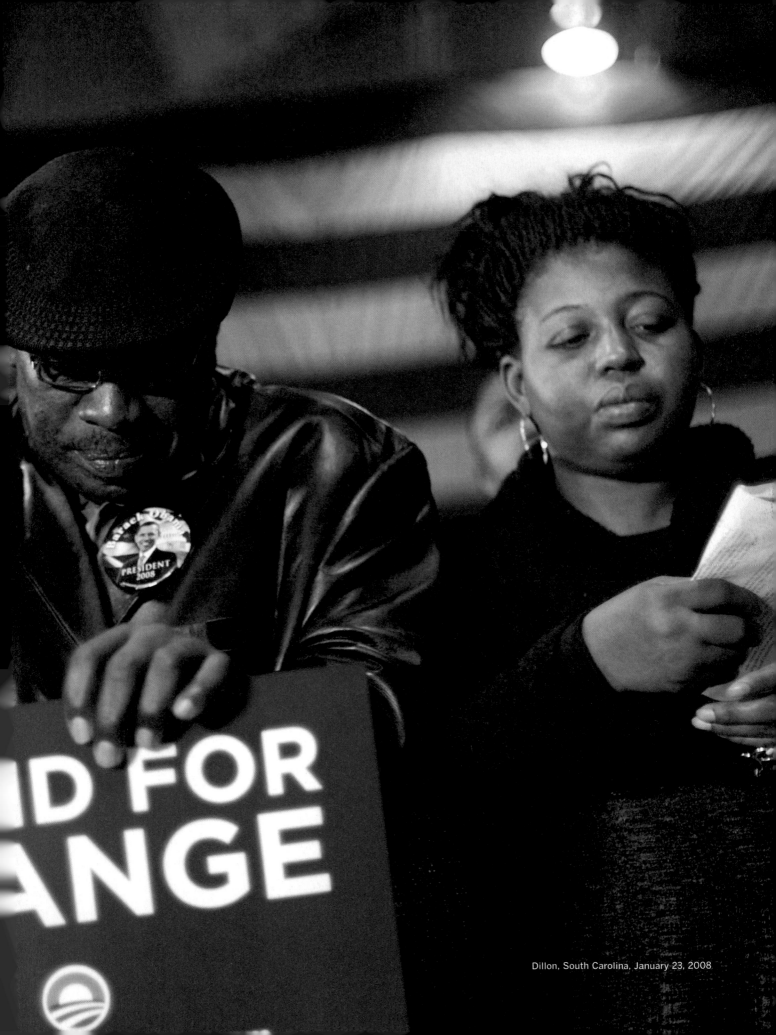

Dillon, South Carolina, January 23, 2008

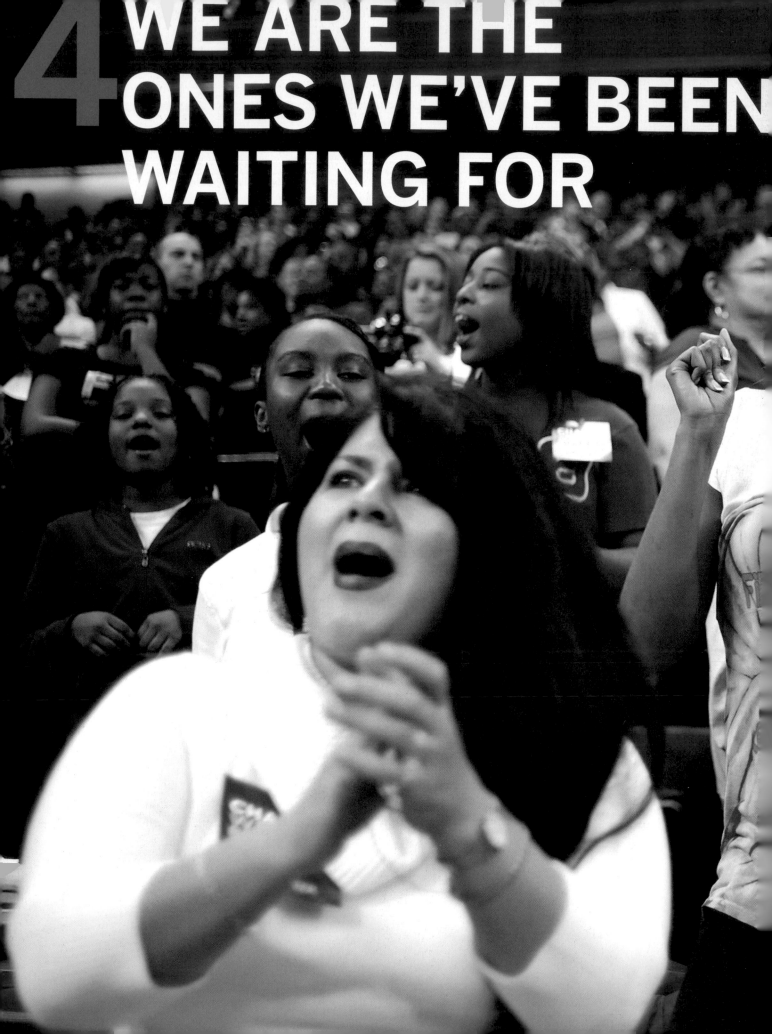

4 WE ARE THE ONES WE'VE BEEN WAITING FOR

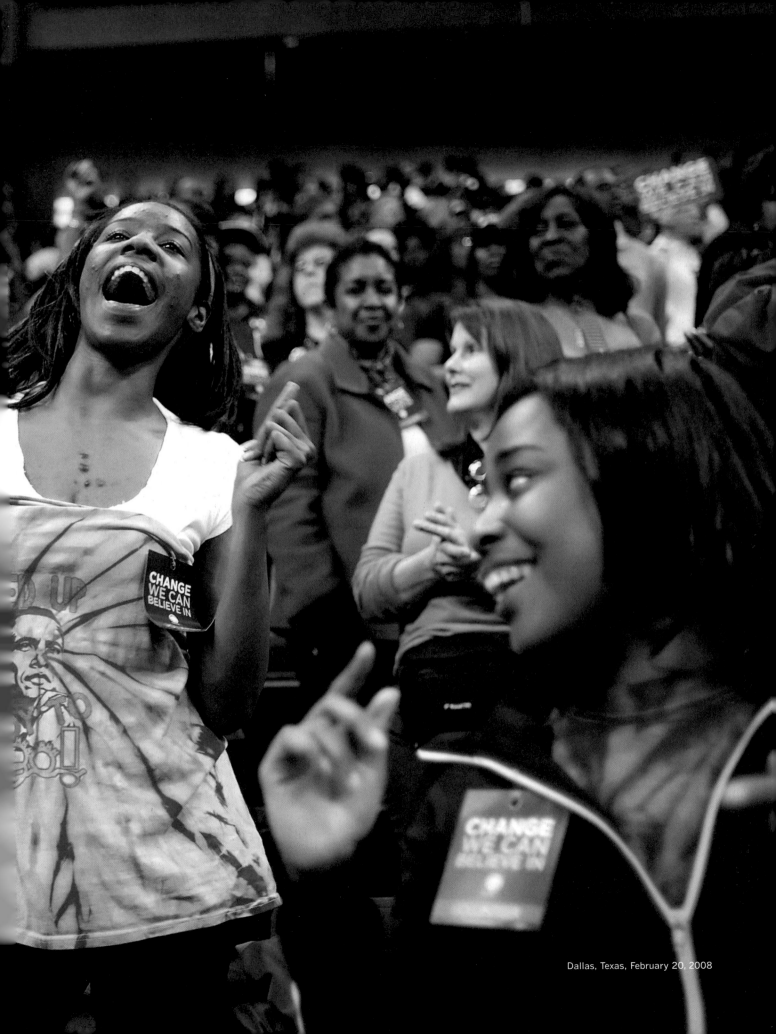

Dallas, Texas, February 20, 2008

WE ARE THE ONE

SUPER TUESDAY TO TEXAS

As the Senator began campaigning in Super Tuesday states, we got off the bus and onto the plane. Gone were the days of small town-hall meetings. Now we jetted from huge rally to huge rally.

For a photographer, it was great. **The energy was high and the pictures reflected that.** As we entered each new city, we could see people lined up trying to get into the rallies. The crowds were dancing, singing, and shouting with glee as we rolled in. We had warm weather for the first time in ages and we generally had early nights, so we could pretend we had lives outside of work. As in New Hampshire, however, the massive turnout often did not translate into the votes Obama needed to win.

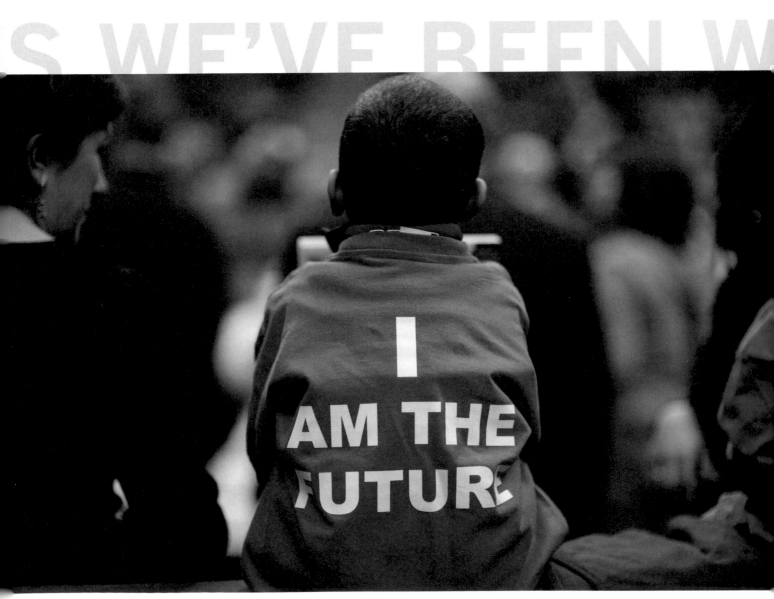

Hartford, Connecticut
February 4, 2008

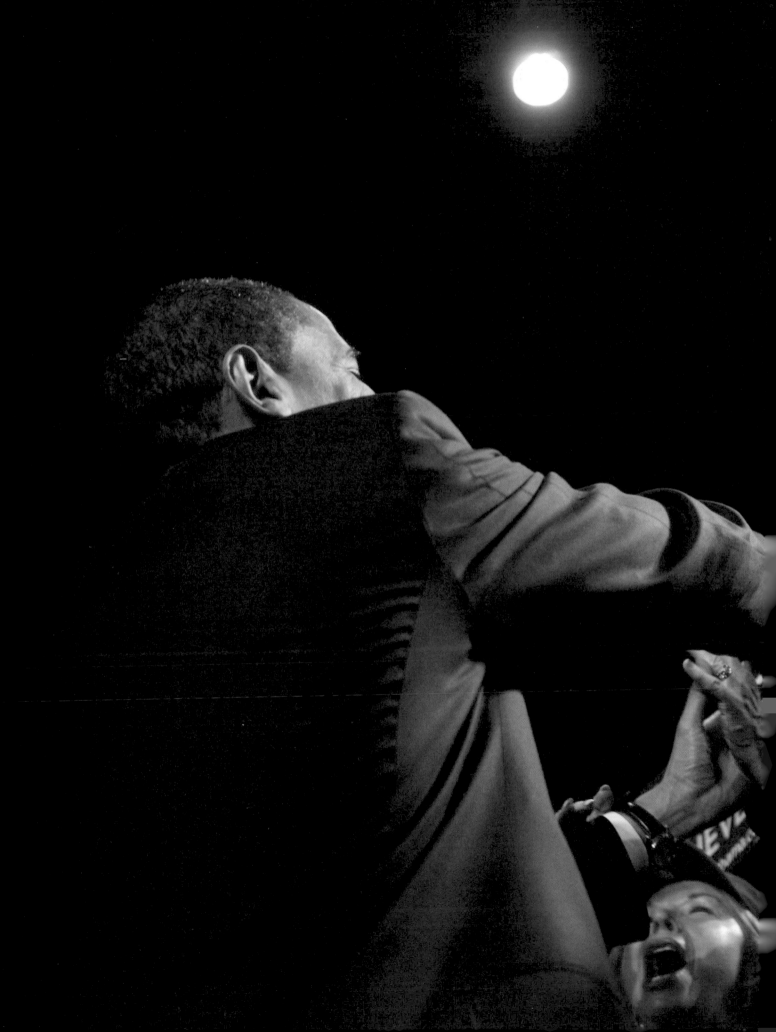

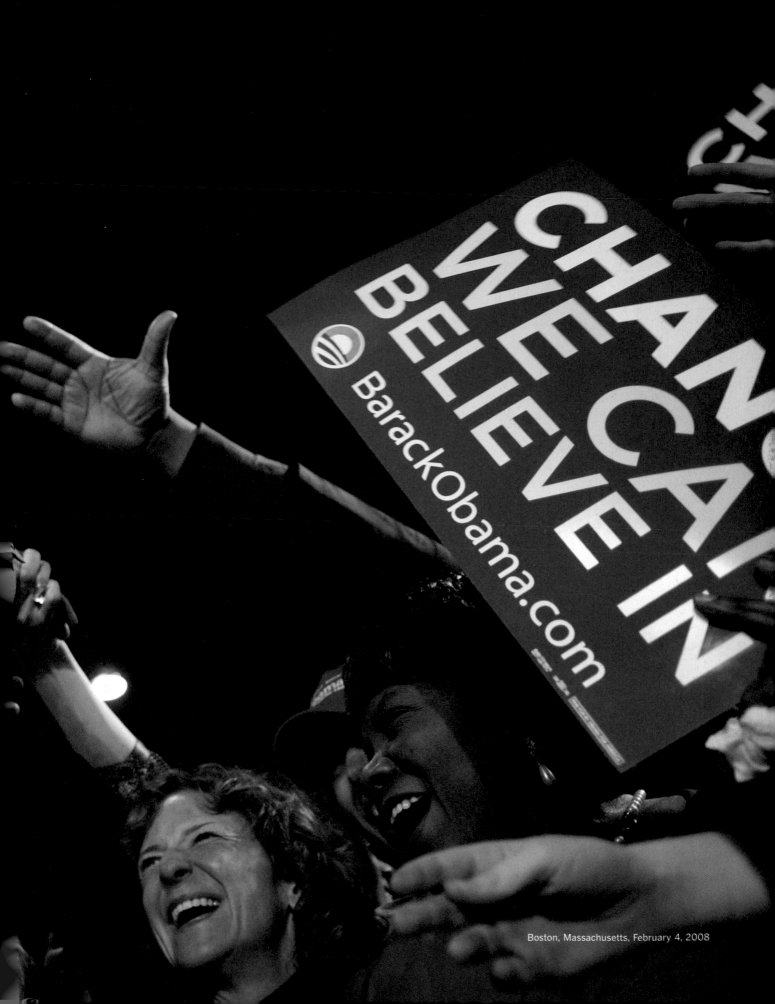

Boston, Massachusetts, February 4, 2008

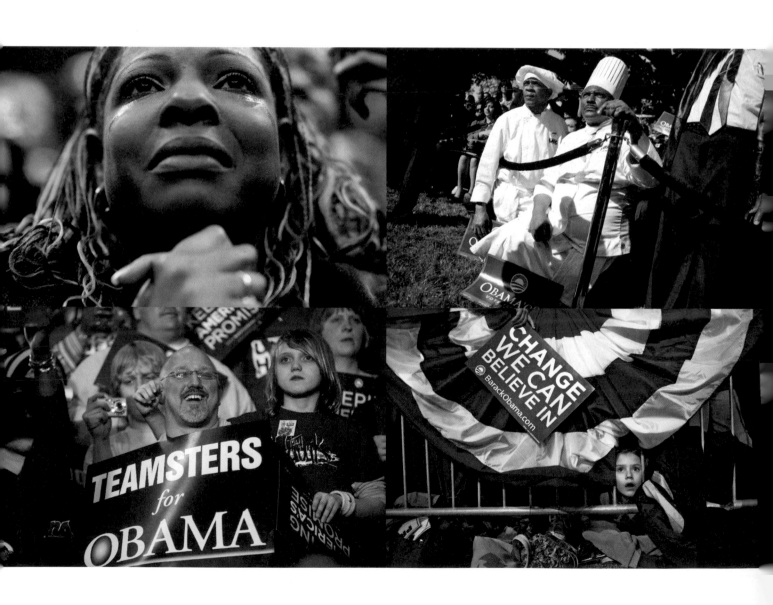

We are the party of Jefferson, who wrote
the words that we are still trying to heed—that
all of us are created equal—that all of us deserve
the chance to pursue our happiness.

Richmond, Virginia, February 9, 2008

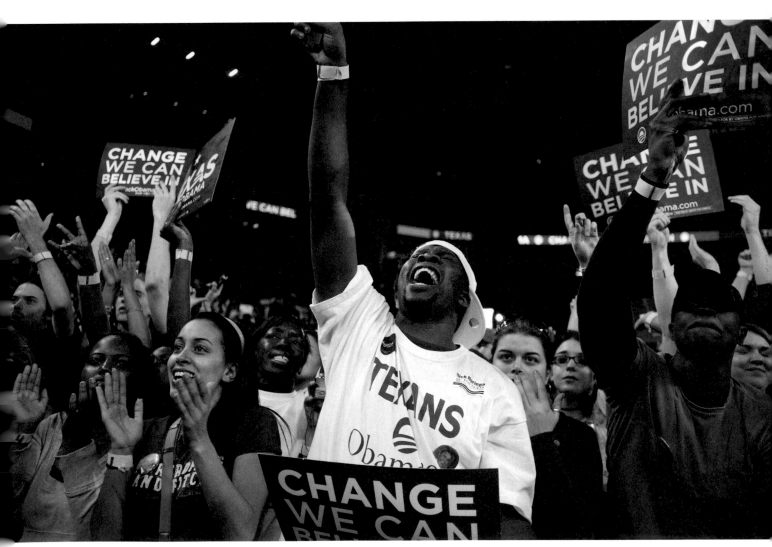

Dallas, Texas
February 20, 2008

Los Angeles, California
January 31, 2008

Houston, Texas
February 19, 2008

Toledo, Ohio
February 24, 2008

Boston, Massachusetts
February 4, 2008

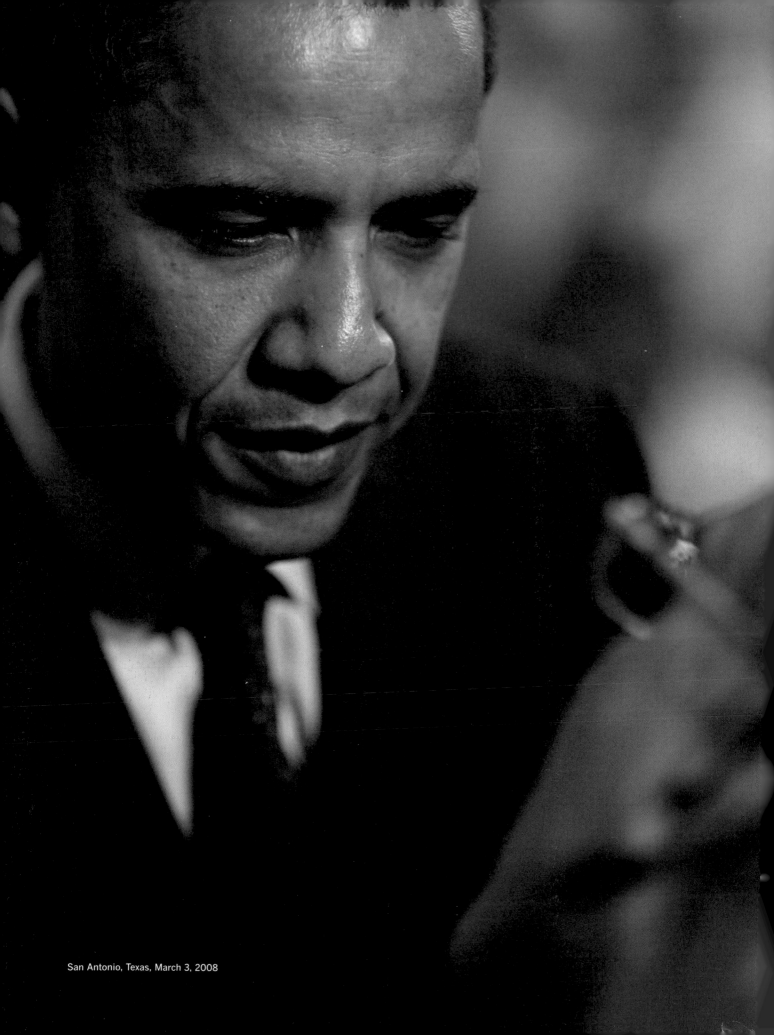

San Antonio, Texas, March 3, 2008

I should not be here today. I was not born into money or status. I was born to a teenage mom in Hawaii, and my dad left us when I was two. But my family gave me love, they gave me education, and most of all they gave me hope—hope that in America, no dream is beyond our grasp if we reach for it, and fight for it, and work for it.

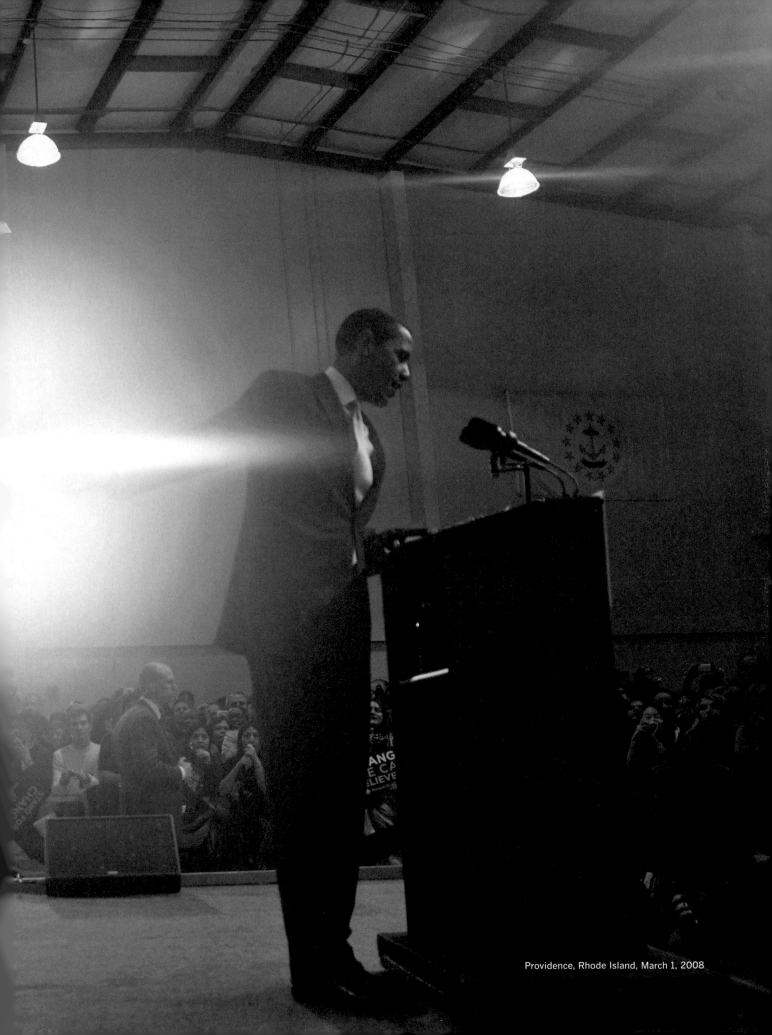

Providence, Rhode Island, March 1, 2008

What began as a whisper in Springfield soon carried across the cornfields of Iowa, where farmers and factory workers, students and seniors stood up in numbers we've never seen. They stood up to say that maybe this year we don't have to settle for a politics where scoring points is more important than solving problems. . . . This time can be different.

Chicago, Illinois, February 5, 2008

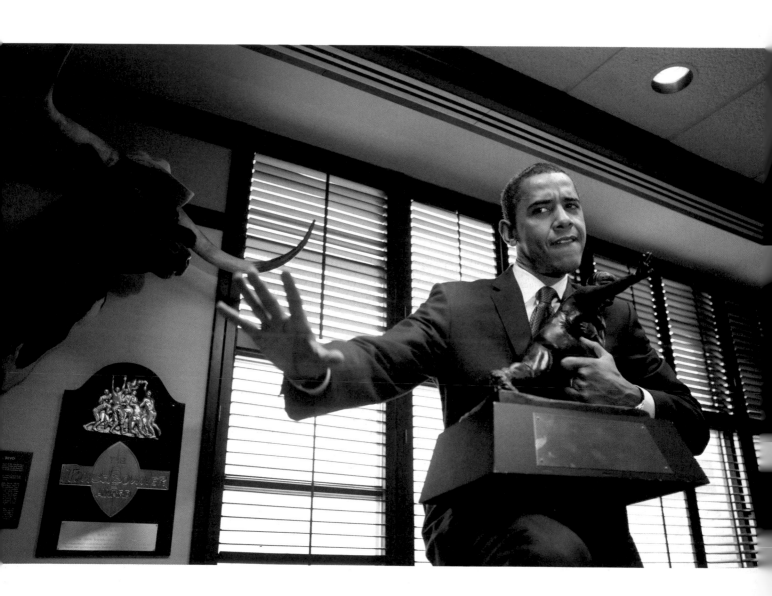

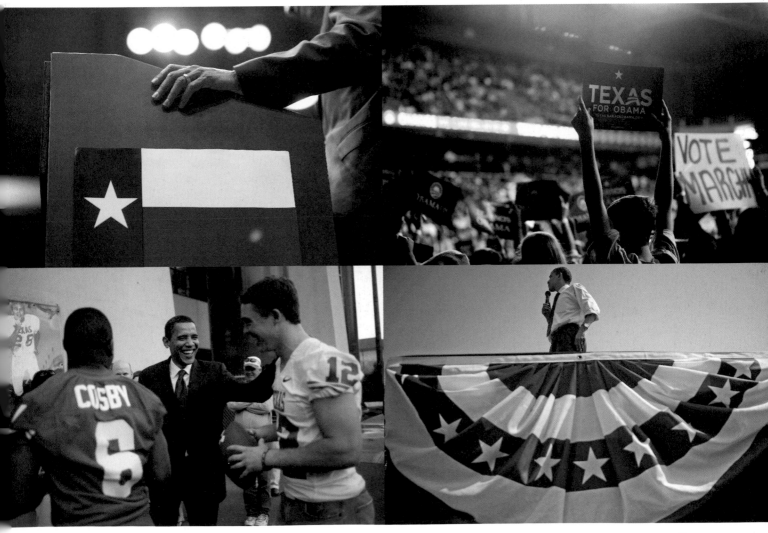

Austin, Texas
February 21, 2008

Austin, Texas
February 28, 2008

Corpus Christi, Texas
February 22, 2008

Austin, Texas
February 21, 2008

Edinburg, Texas
February 22, 2008

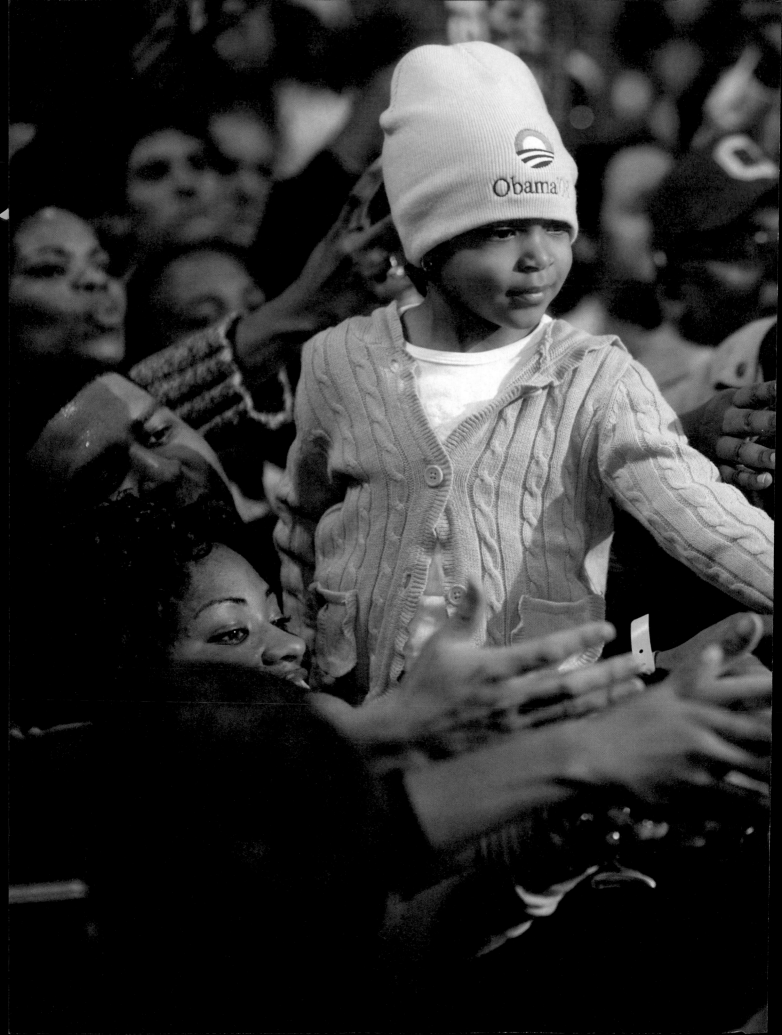

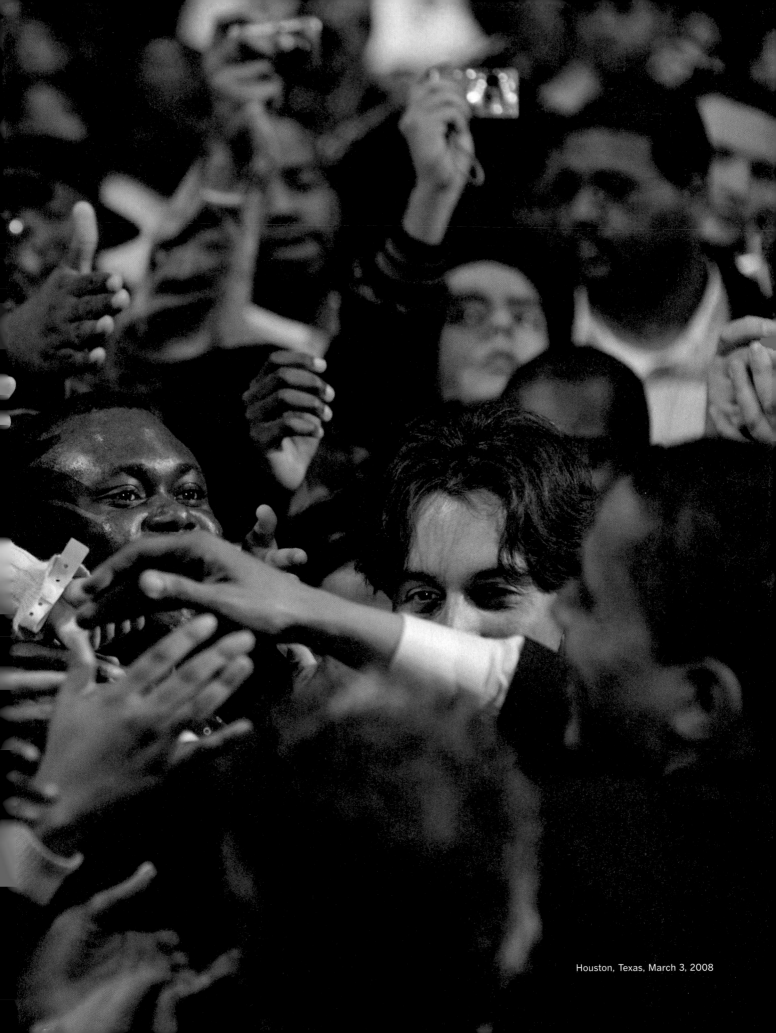

Houston, Texas, March 3, 2008

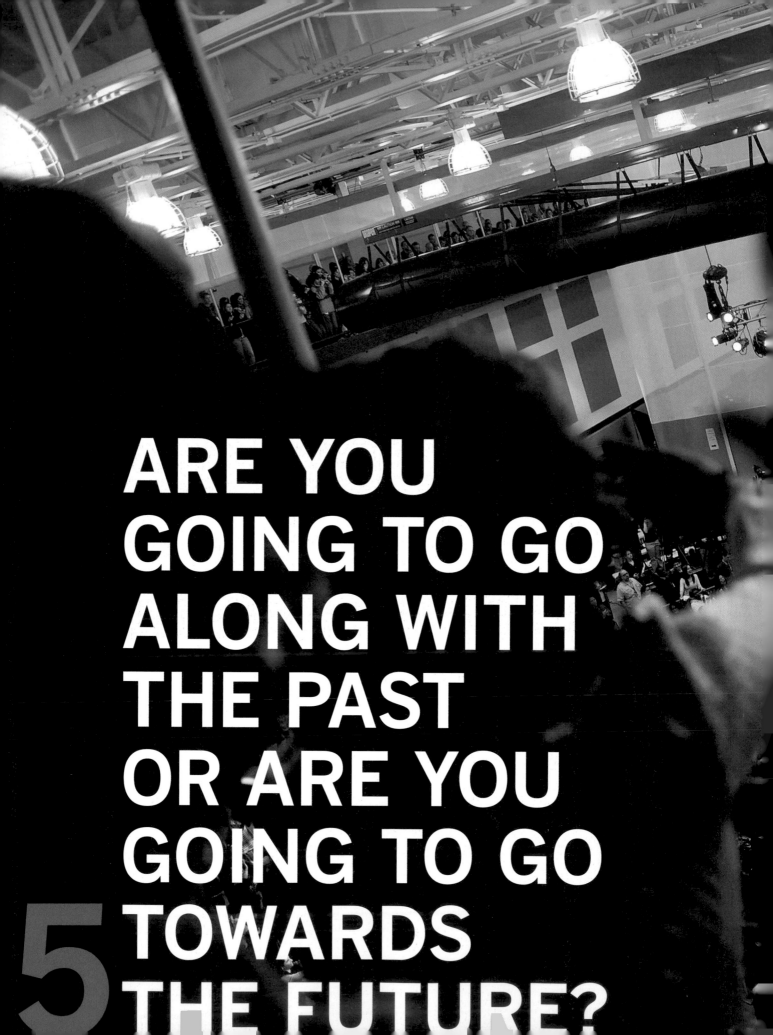

ARE YOU
GOING TO GO
ALONG WITH
THE PAST
OR ARE YOU
GOING TO GO
TOWARDS
THE FUTURE?

5

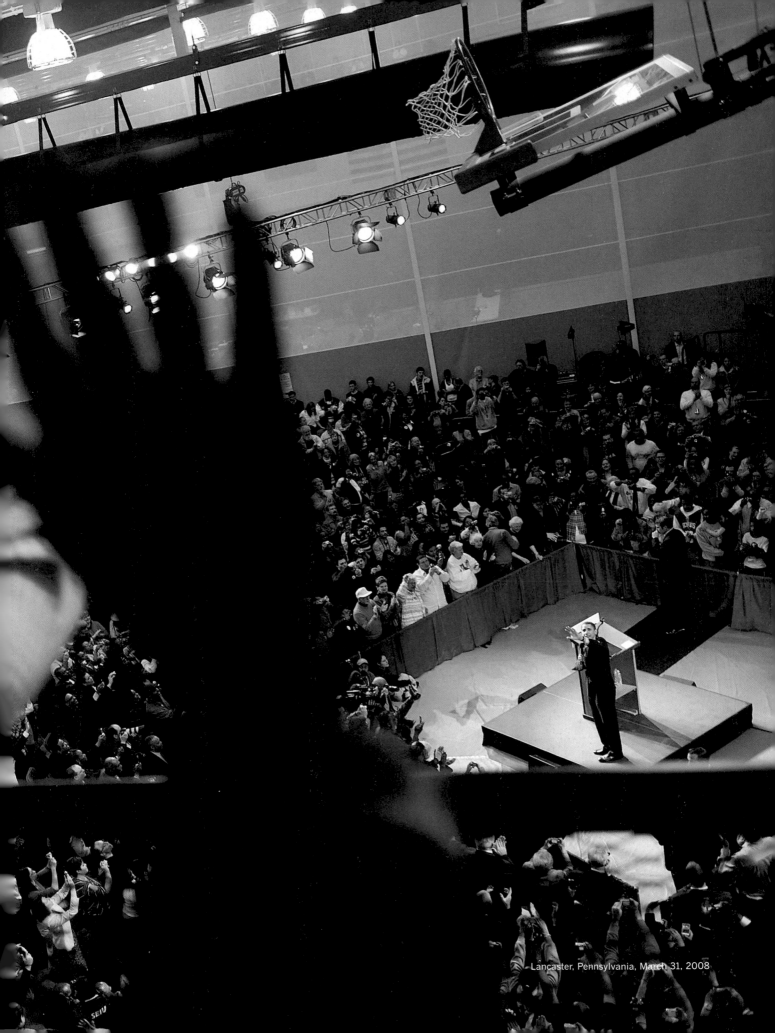

Lancaster, Pennsylvania, March 31, 2008

MISSISSIPPI TO PENNSYLVANIA

Photographers don't always pay attention to what speakers are saying. Shooting requires concentration, and words often wash by us. I caught a section of Obama's speeches here and there, and I noticed when his tone changed, but I was more **attuned to the rhythms of his voice** than his actual words.

His speech on March 18, 2008, began like many others. But that day, the Reverend Wright tapes had forced him to confront head-on the issue of race in America. At Constitution Center in Philadelphia, he delivered his **"A More Perfect Union"** speech. It was not until a few minutes into the speech, when I noticed tears rolling freely down the face of the Senator's best friend, Marty Nesbitt, that I realized I needed to pay closer attention. His words that day will be studied for generations.

As we traversed the state on buses and trains, going from bowling alleys and bovine research facilities to bars and factories, we were largely insulated from the greater issues being discussed. But it seemed like **no coincidence** that he gave that speech in Pennsylvania. Sure, it was the obvious choice because of the upcoming primary, but it was also the first place where citizens openly talked to reporters about their unwillingness to vote for a black man.

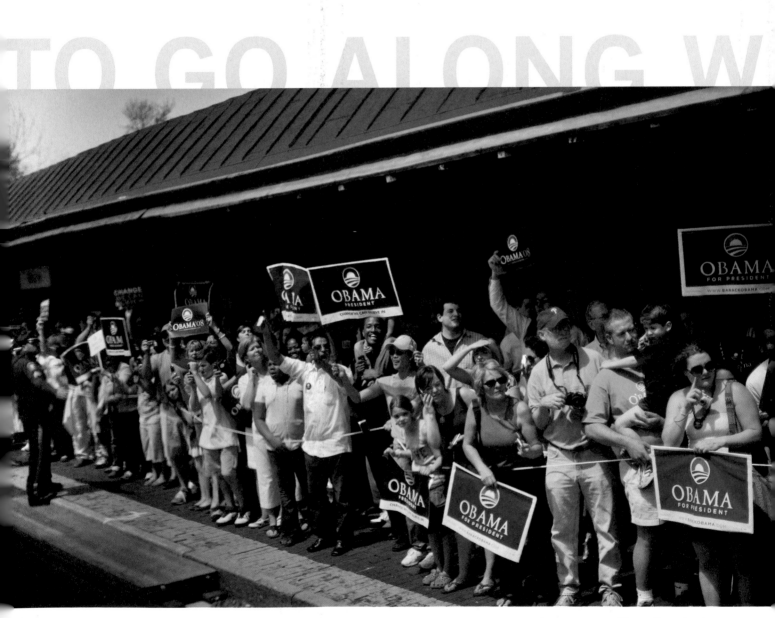

Wayne, Pennsylvania
April 19, 2008

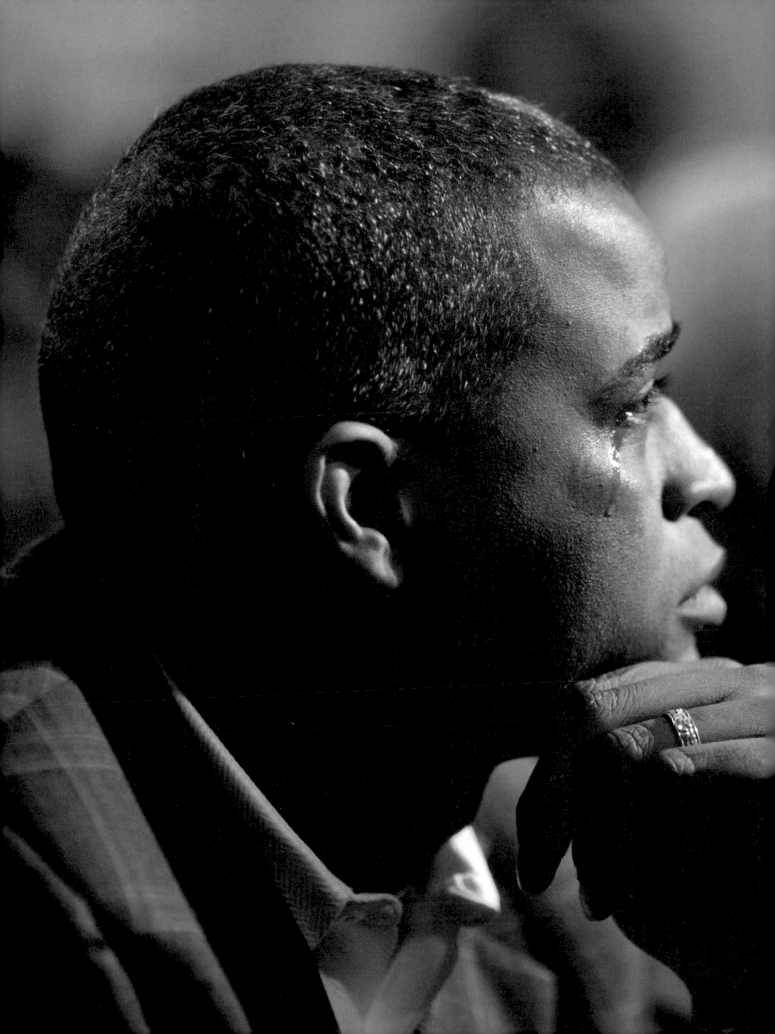

Philadelphia, Pennsylvania, March 18, 2008

This union may never be perfect, but generation after generation has shown that it can always be perfected.

Philadelphia, Pennsylvania, March 18, 2008

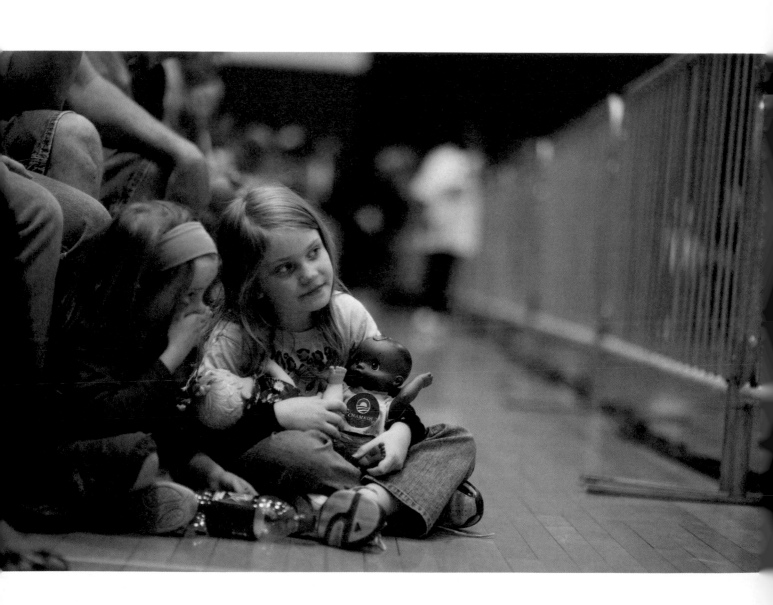

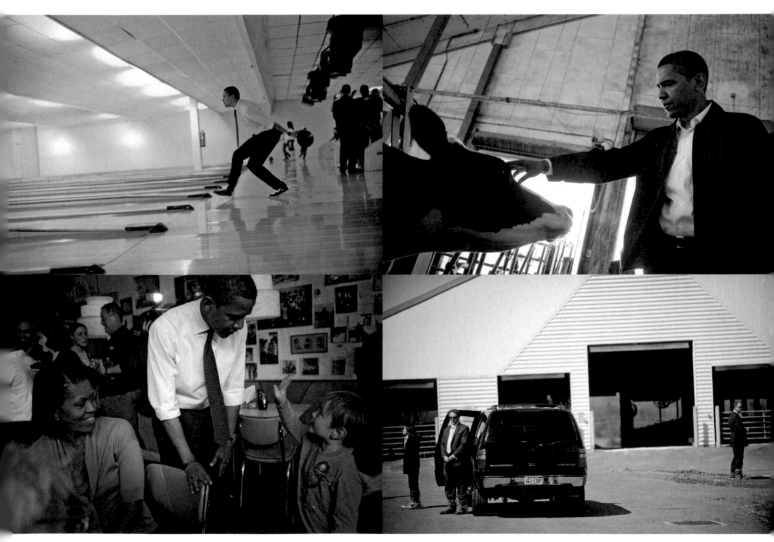

McKeesport, Pennsylvania
April 21, 2008

Altoona, Pennsylvania
March 29, 2008

State College, Pennsylvania
March 30, 2008

Pittsburgh, Pennsylvania
April 22, 2008

State College, Pennsylvania
March 30, 2008

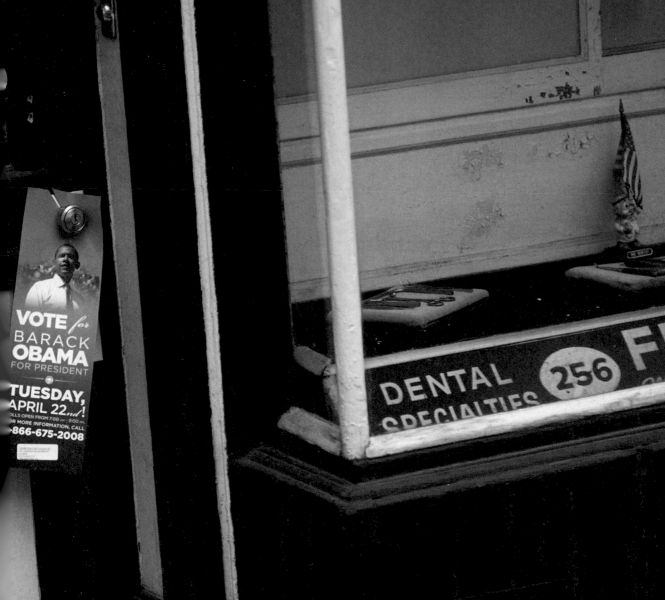

VOTE *for*
BARACK
OBAMA
FOR PRESIDENT

TUESDAY,
APRIL 22*nd*!
POLLS OPEN FROM 7:00 AM - 8:00 PM

FOR MORE INFORMATION, CALL
866-675-2008

DENTAL
SPECIALTIES 256 FRAN

Philadelphia, Pennsylvania, April 22, 2008

In the end, then, what is called for is nothing more, and nothing less, than what all the world's great religions demand—that we do unto others as we would have them do unto us. Let us be our brother's keeper, Scripture tells us. Let us be our sister's keeper. Let us find that common stake we all have in one another, and let our politics reflect that spirit as well.

Philadelphia, Pennsylvania, March 18, 2008

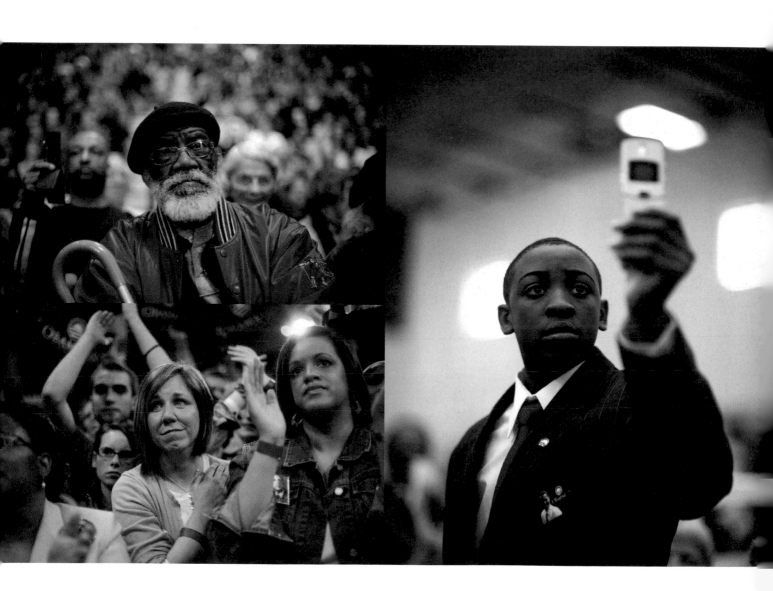

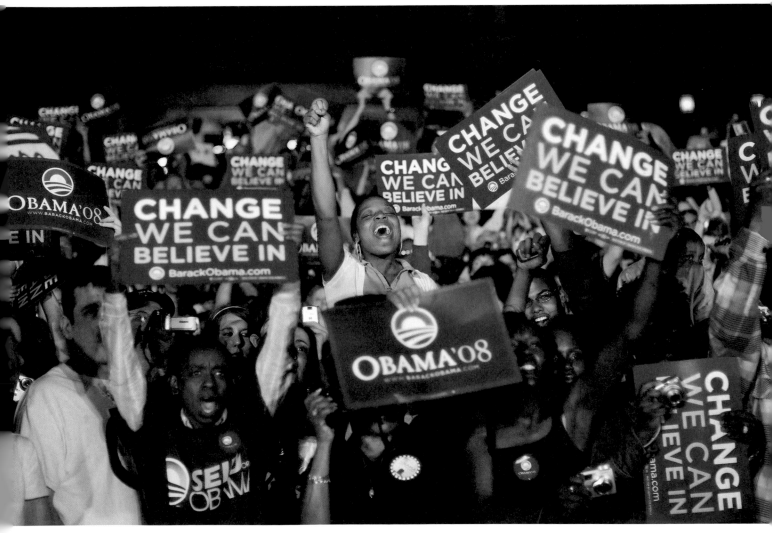

Wallingford, Pennsylvania
April 2, 2008

Erie, Pennsylvania
April 18, 2008

Harrisburg, Pennsylvania
April 19, 2008

Pittsburgh, Pennsylvania
April 21, 2008

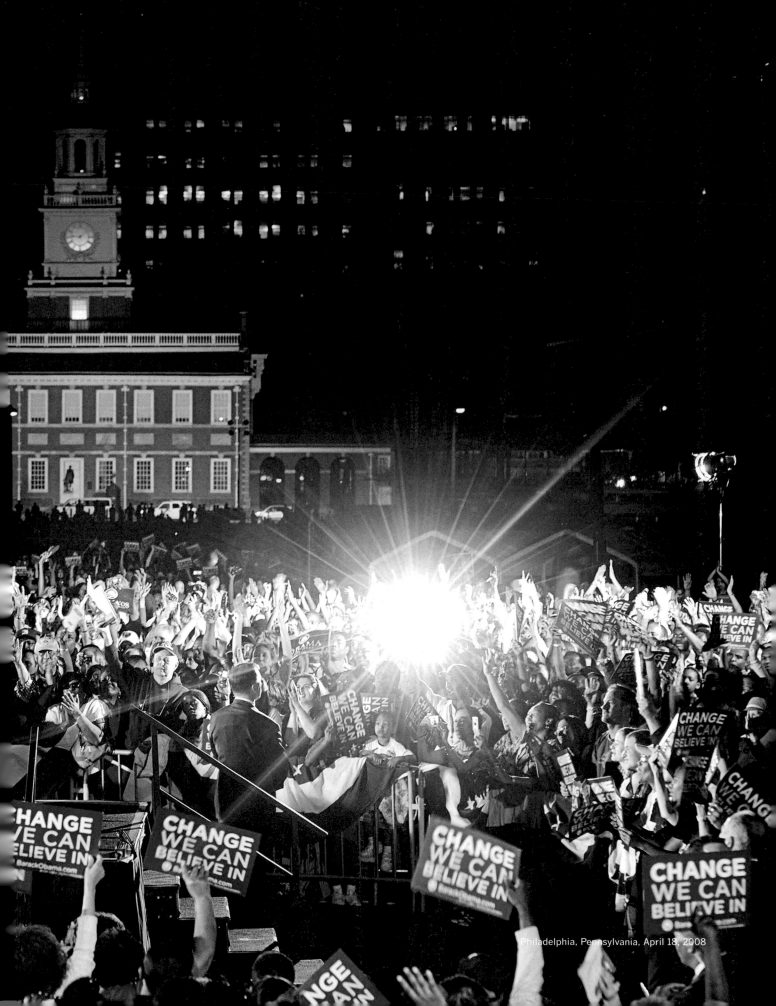

Philadelphia, Pennsylvania, April 18, 2008

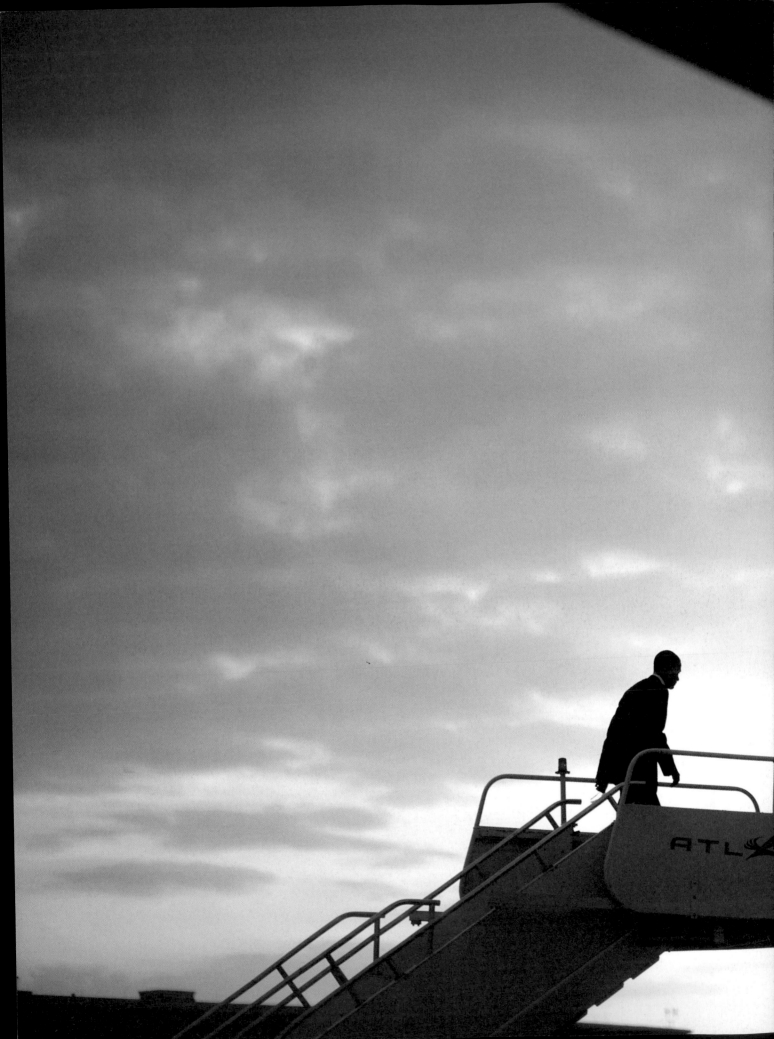

Philadelphia, Pennsylvania, April 22, 2008

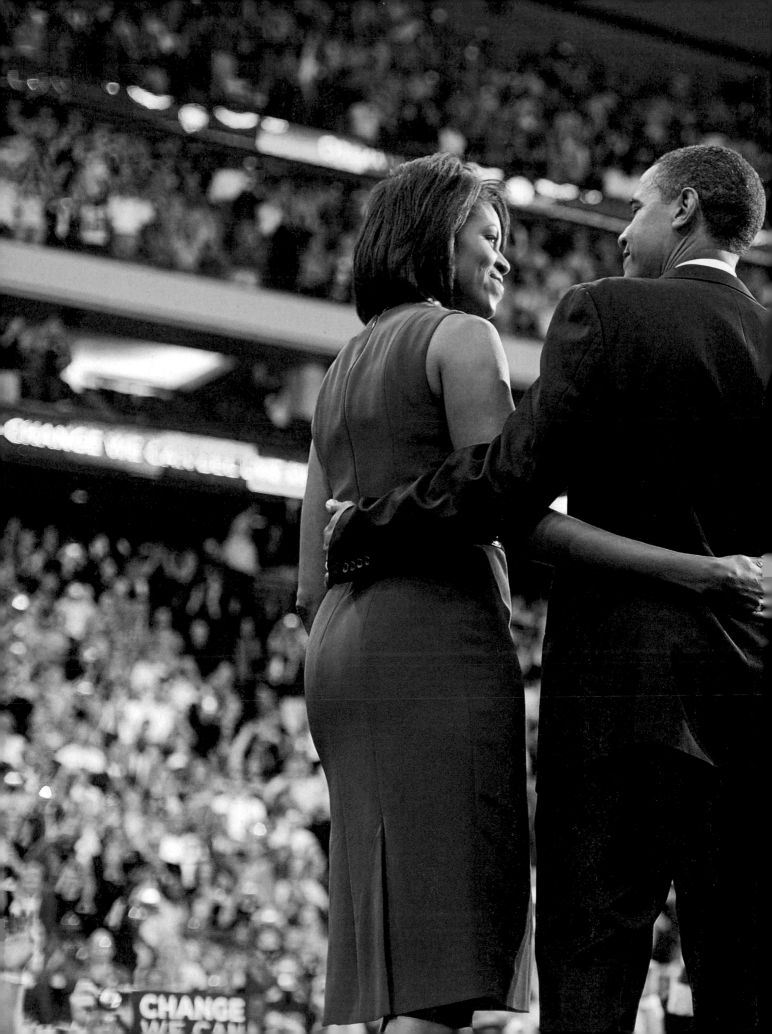

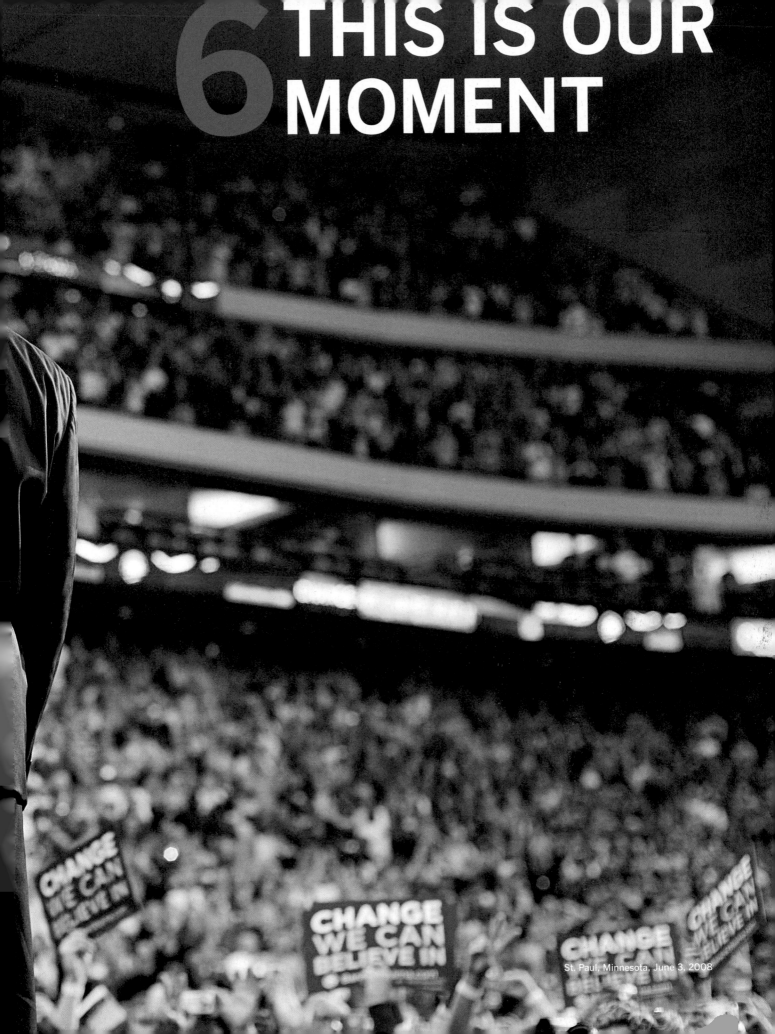

6 THIS IS OUR MOMENT

St. Paul, Minnesota, June 3, 2008

THIS IS OUR MOM

NORTH CAROLINA TO THE NOMINATION

Indiana and North Carolina felt like Iowa Version 2.0. The events grew **smaller and more intimate**. Obama played basketball on a farm in rural Indiana, he took his daughters to a roller-skating rink, he played pool with a veteran, and he stopped by taverns and factories, fried chicken restaurants and VFW halls.

For those of us covering him, **time seemed to stand still**. It felt as if we would always be sitting on a bus driving through rolling cornfields. Barack Obama would always be locked in political combat with Hillary Clinton. We would always be covering his race for the Democratic nomination.

Until the night in St. Paul, when it ended with his **victory**.

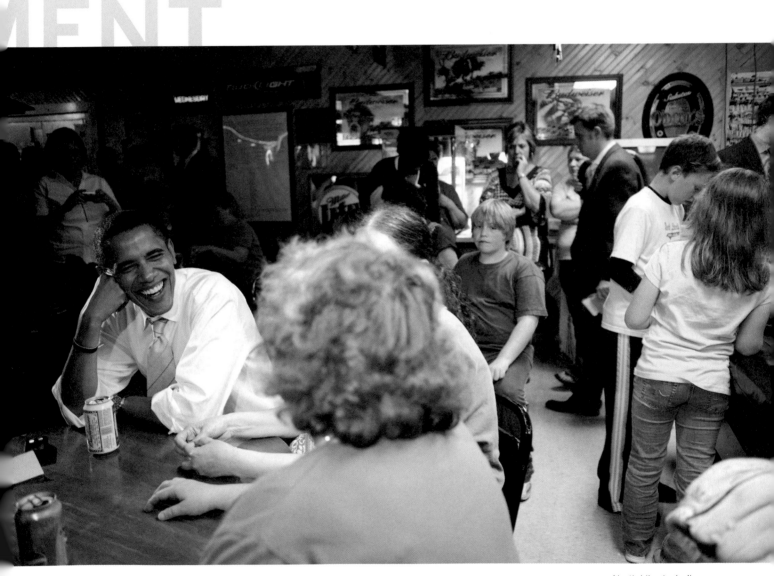

North Liberty, Indiana
May 1, 2008

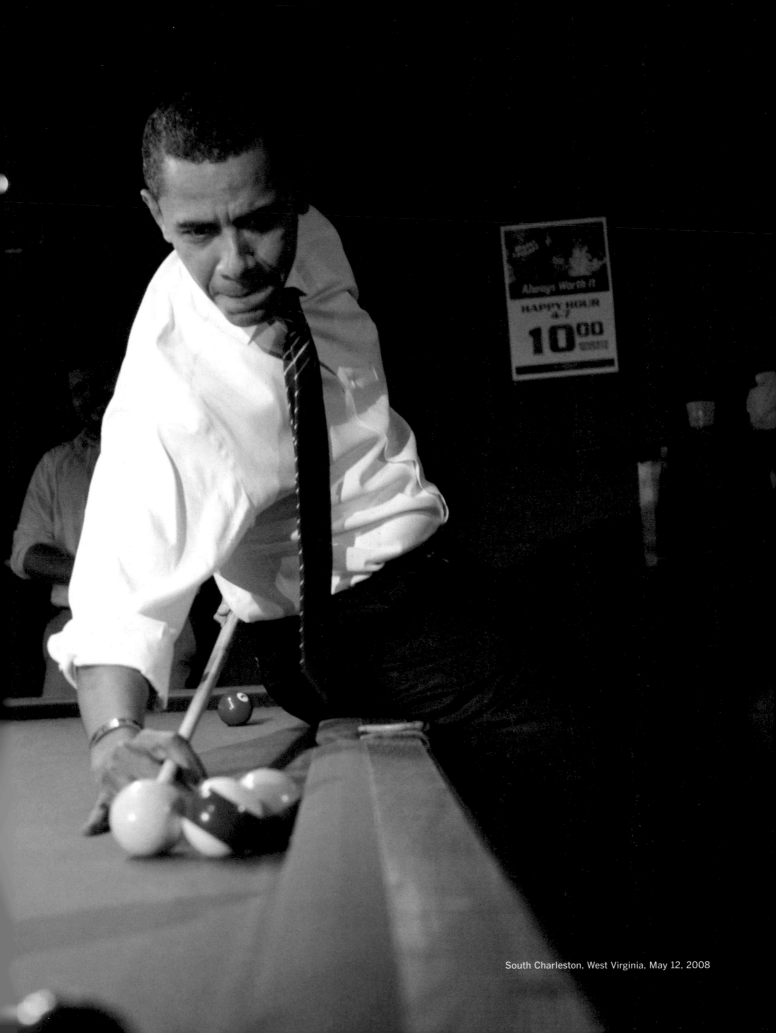

South Charleston, West Virginia, May 12, 2008

I love this country too much to see it divided
and distracted at this moment in history.
I believe in our ability to perfect this union
because it's the only reason I'm standing here
today. And I know the promise of America
because I have lived it.

Raleigh, North Carolina, May 6, 2008

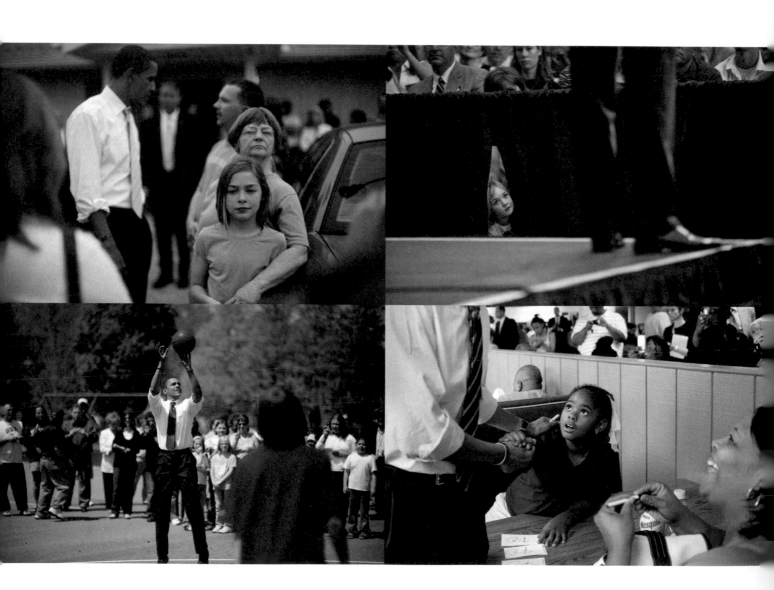

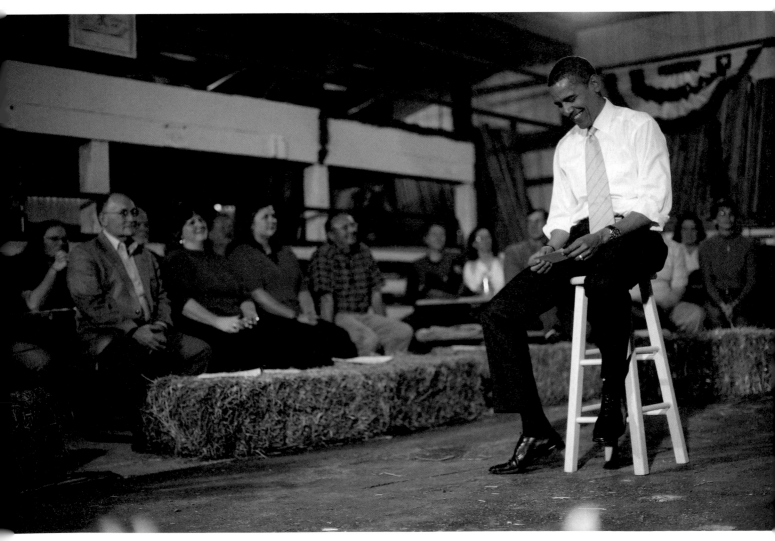

North Liberty, Indiana
May 1, 2008

Billings, Montana
May 19, 2008

South Bend, Indiana
May 1, 2008

Elkhart, Indiana
May 4, 2008

Greensboro, North Carolina
May 5, 2008

Louisville, Kentucky, May 12, 2008

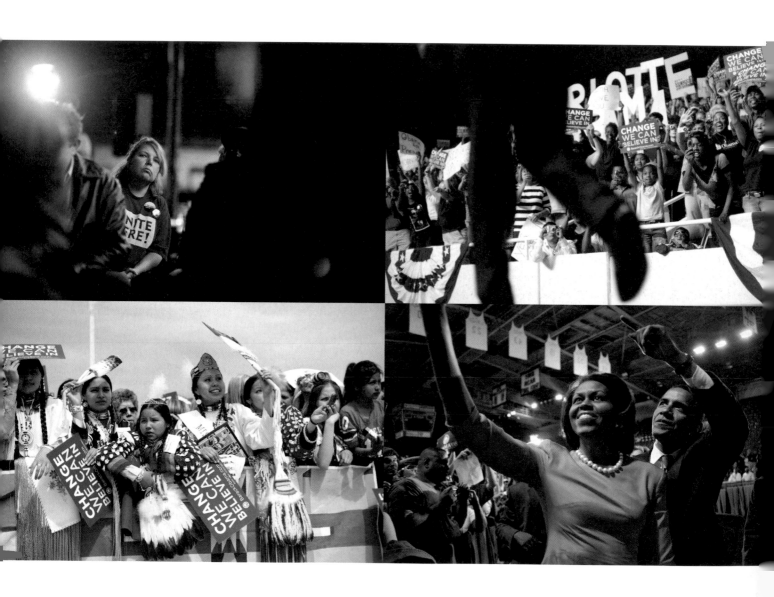

The journey will be difficult. The road will be long. I face this challenge with profound humility and knowledge of my own limitations. But I also face it with limitless faith in the capacity of the American people.

St. Paul, Minnesota, June 3, 2008

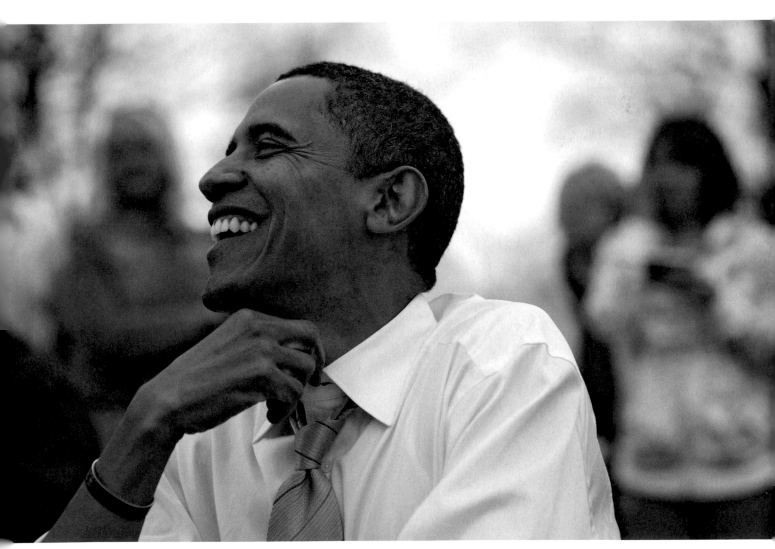

Munster, Indiana
May 2, 2008

Charlotte, North Carolina
May 2, 2008

Union Mills, Indiana
May 1, 2008

Crow Agency, Montana
May 19, 2008

Raleigh, North Carolina
May 6, 2008

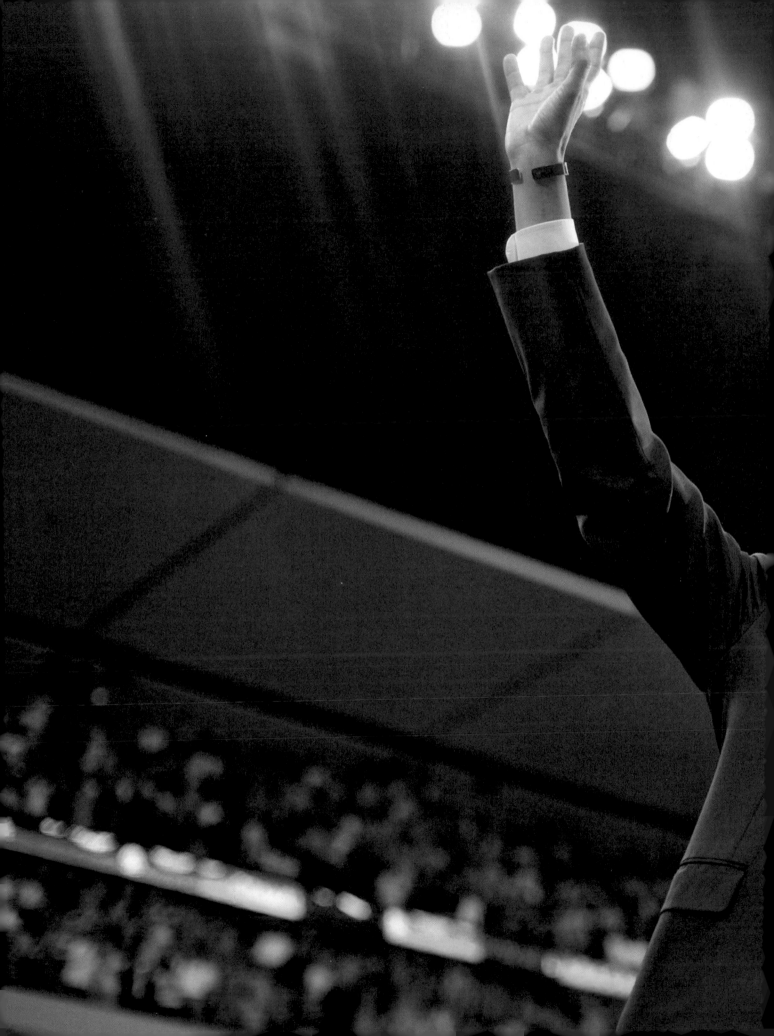

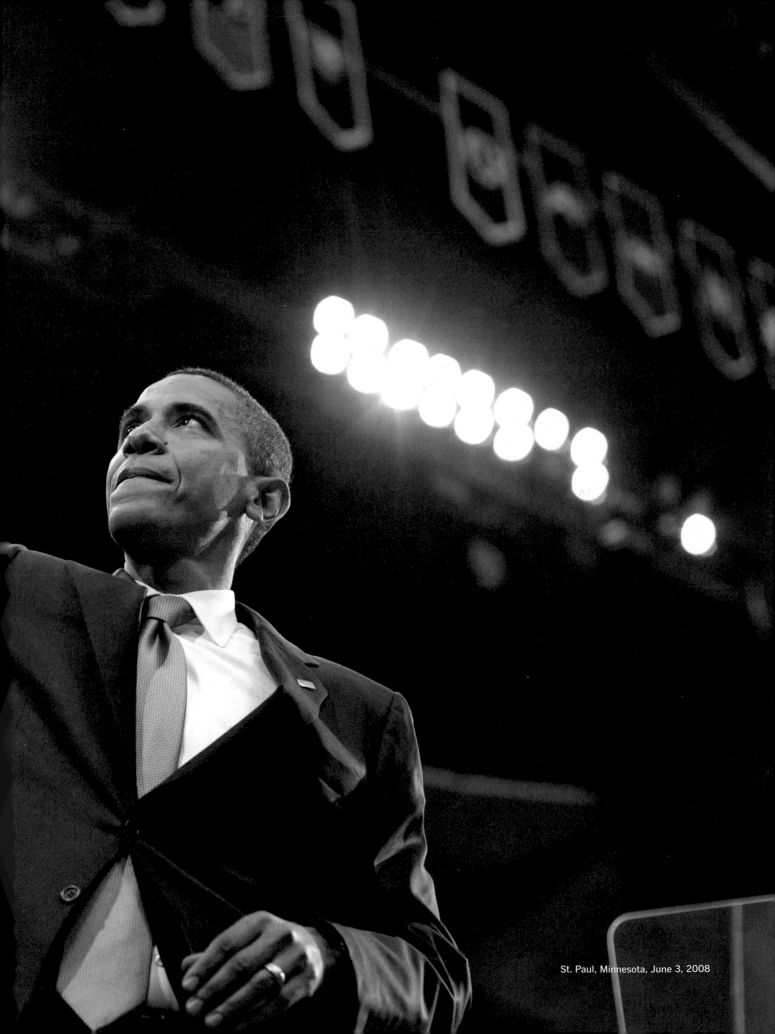

St. Paul, Minnesota, June 3, 2008

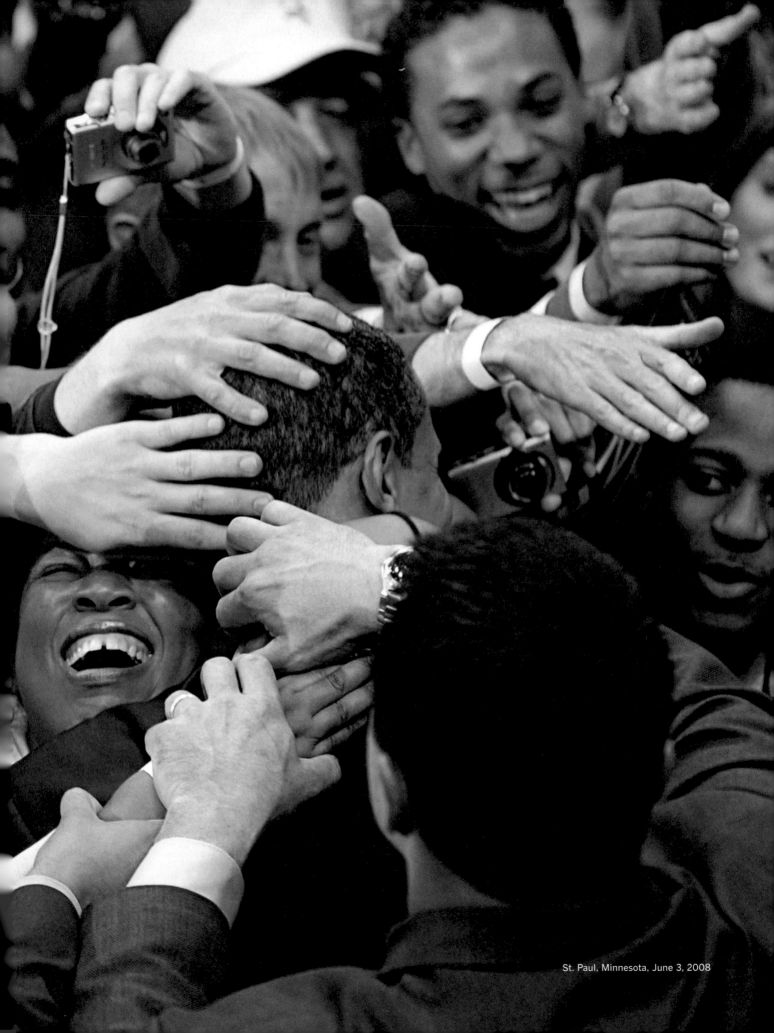

St. Paul, Minnesota, June 3, 2008

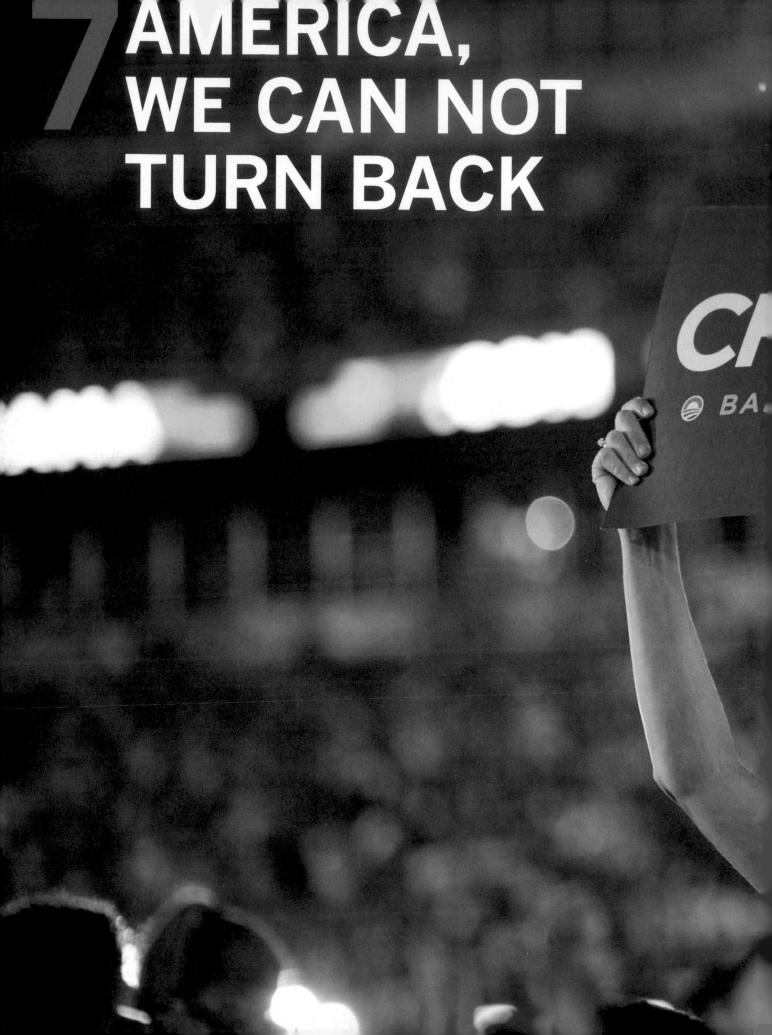

7 AMERICA,
WE CAN NOT
TURN BACK

Denver, Colorado, August 28, 2008

THE ROAD TO THE CONVENTION

The summer was slower, with fewer rallies per day. Some of the pressure was off, and the Senator started making more **unscheduled stops, at fruit stands and auto factories** and the like. Rallies tended to be outdoors and more relaxed. Picnic tables featured heavily in those months.

There were two exceptions: the rally in Berlin and the Democratic National Convention. In Berlin, more than two hundred thousand Europeans, Africans, Asians, and Americans gathered to watch this one man speak. I am young enough that it was a shock to see **Europeans waving American flags**. As Jon Stewart later joked, it seemed like they were broken: they weren't on fire.

The Convention was another story. Hugely theatrical and a strange mix of deeply organized and completely chaotic, the pressure was on for Obama. After all, he had launched his national political career with a powerful speech at the DNC four years before. How could he top his earlier performance? The campaign decided to move the Convention's final night to Denver's 72,000-seat Invesco Field. Under the stars rather than in a basketball arena, and **in front of ordinary citizens along with party delegates**, he gave a sober, serious, and yet still stirring speech.

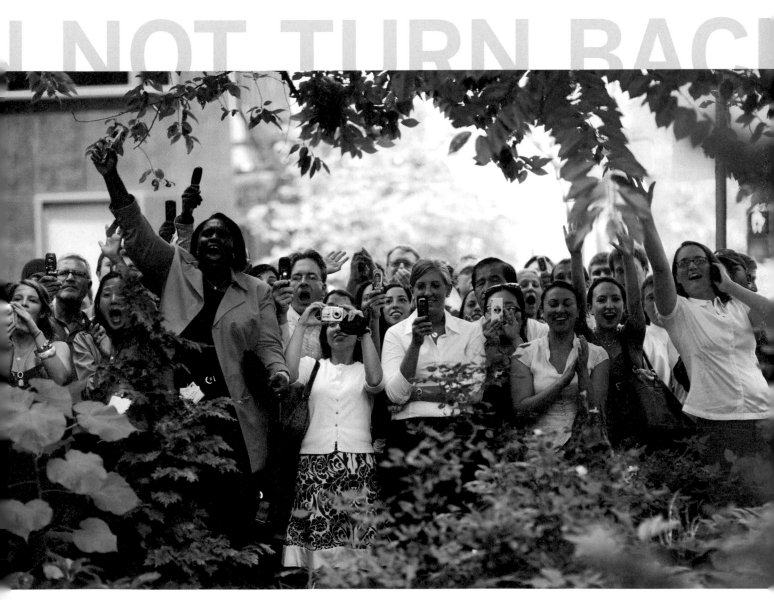

I NOT TURN BACK

Washington, D.C.
July 29, 2008

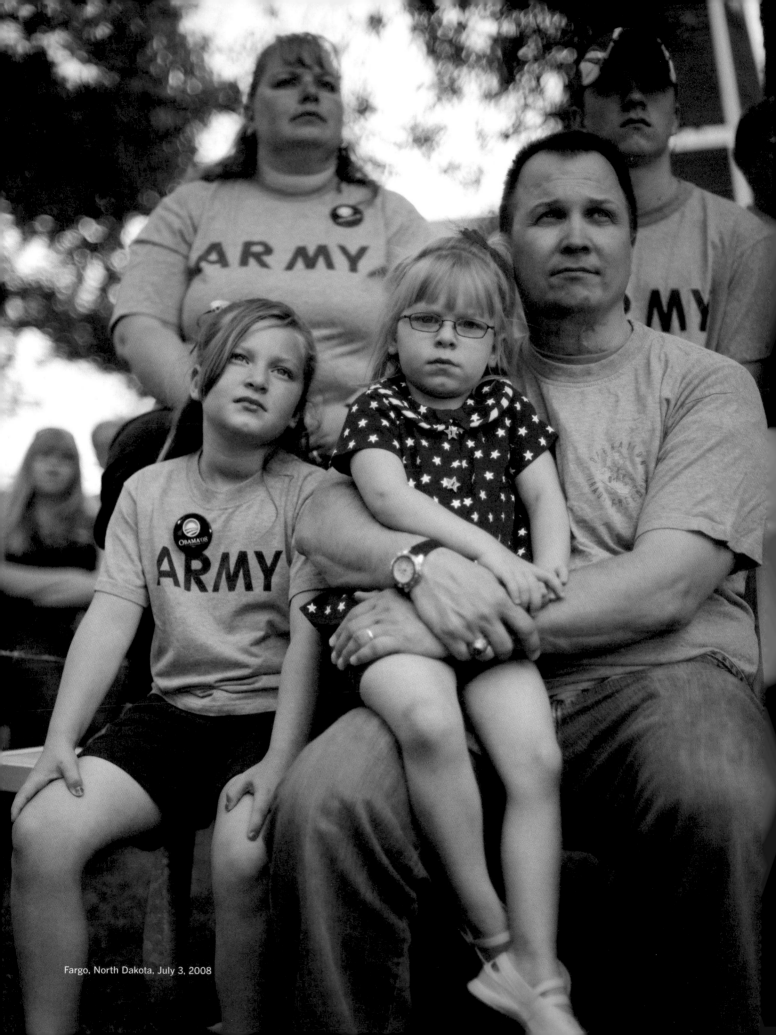

Fargo, North Dakota, July 3, 2008

The men and women who serve in our battlefields may be Democrats and Republicans and Independents, but they have fought together and bled together and some died together under the same proud flag. They have not served a Red America or a Blue America—they have served the United States of America.

What has always united us—what has always driven our people; what drew my father to America's shores—is a set of ideals that speak to aspirations shared by all people: that we can live free from fear and free from want; that we can speak our minds and assemble with whomever we choose and worship as we please.

Berlin, Germany, July 24, 2008

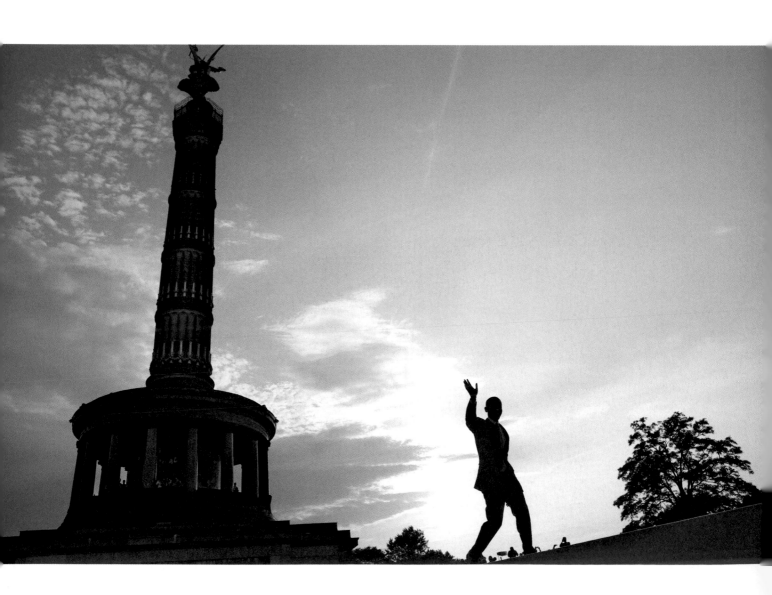

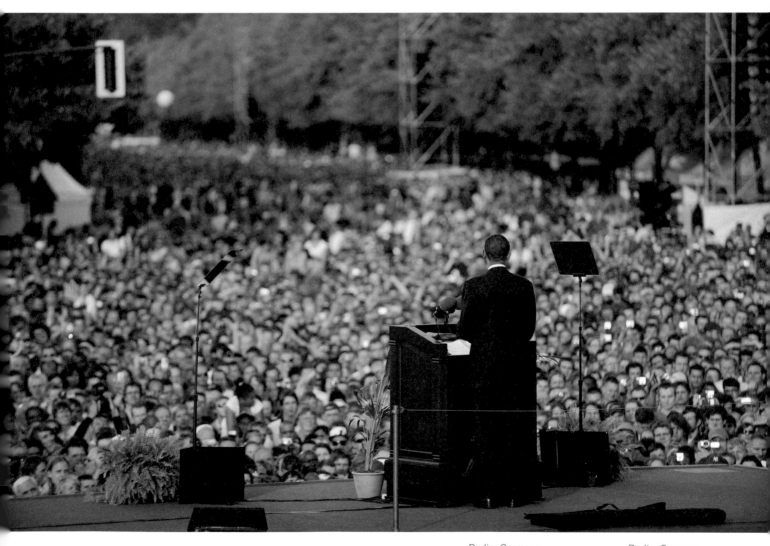

Berlin, Germany
July 24, 2008

Berlin, Germany
July 24, 2008

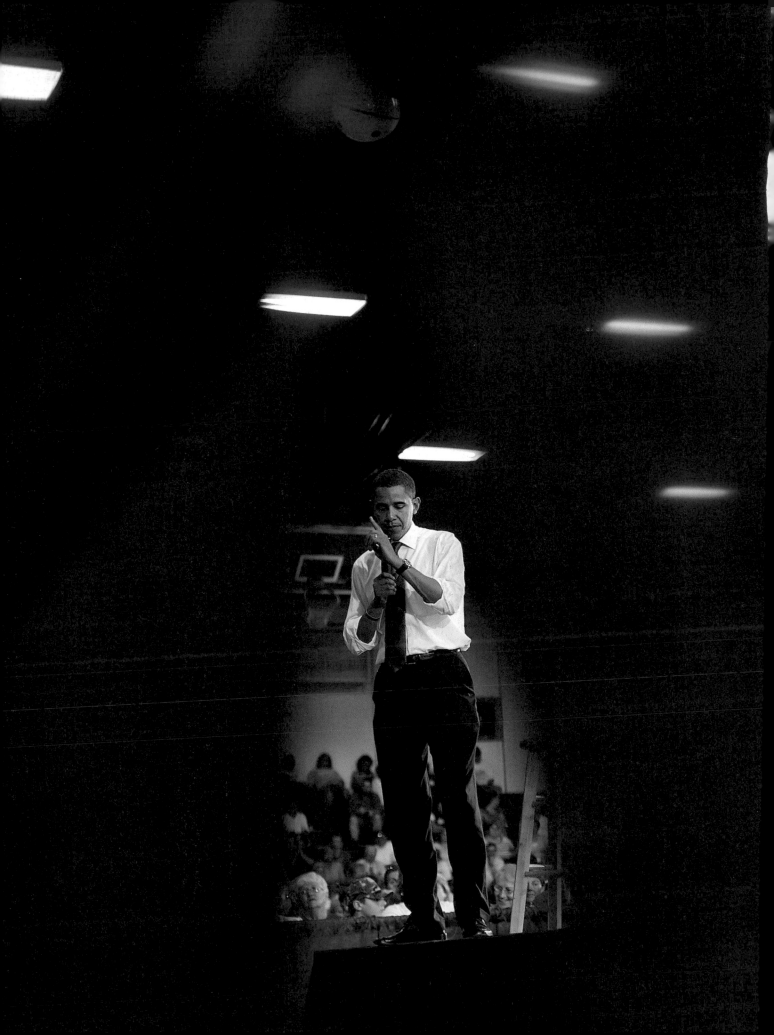

Cedar Rapids, Iowa, July 31, 2008

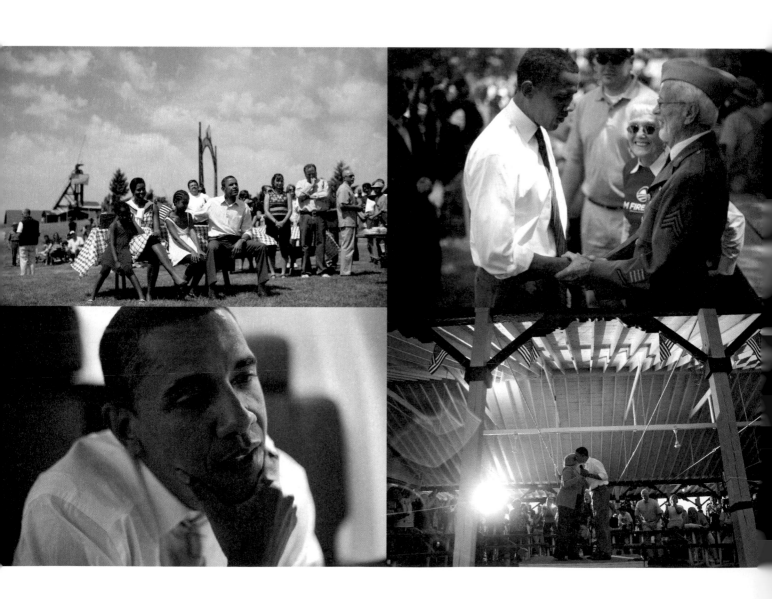

Change happens because the American people demand it—because they rise up and insist on new ideas and new leadership, a new politics for a new time. America, this is one of those moments.

Denver, Colorado, Democratic National Convention, August 28, 2008

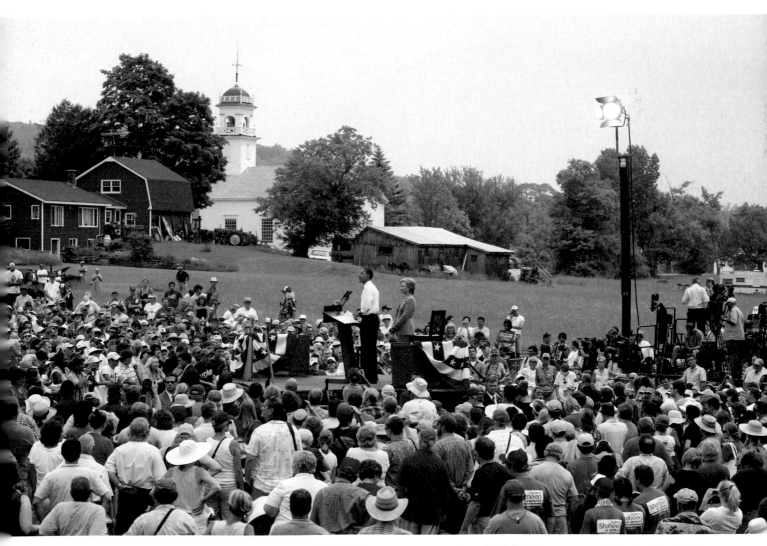

Butte, Montana
July 4, 2008

Norfolk, Virginia
August 21, 2008

Fargo, North Dakota
July 3, 2008

Union, Missouri
July 30, 2008

Unity, New Hampshire
June 27, 2008

Billings, Montana, August 27, 2008

What the naysayers don't understand is that this election has never been about me. It's been about you.

Denver, Colorado, Democratic National Convention, August 28, 2008

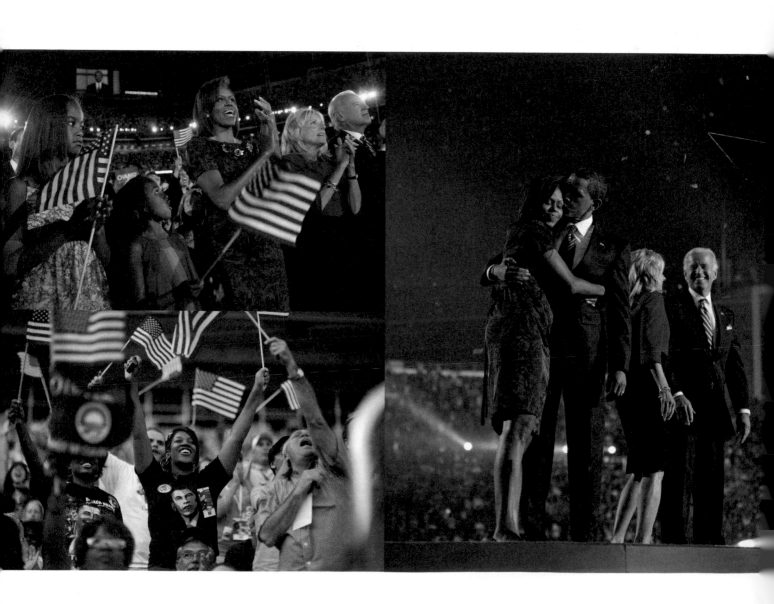

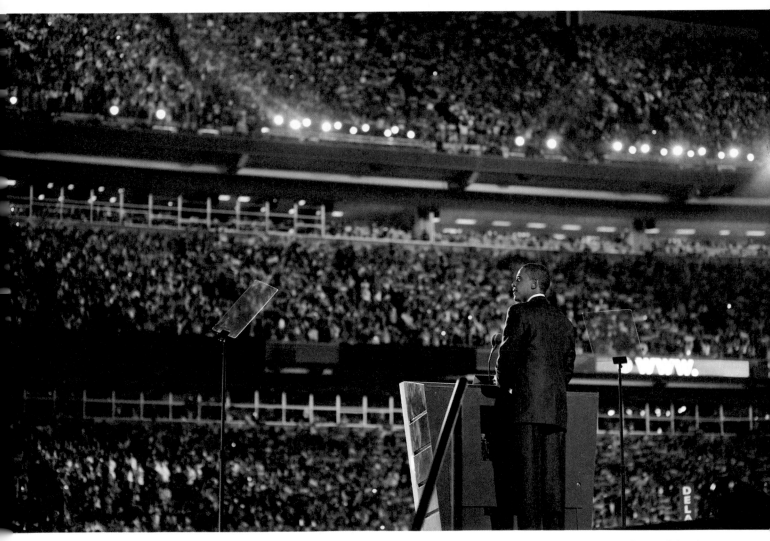

Denver, Colorado
August 28, 2008

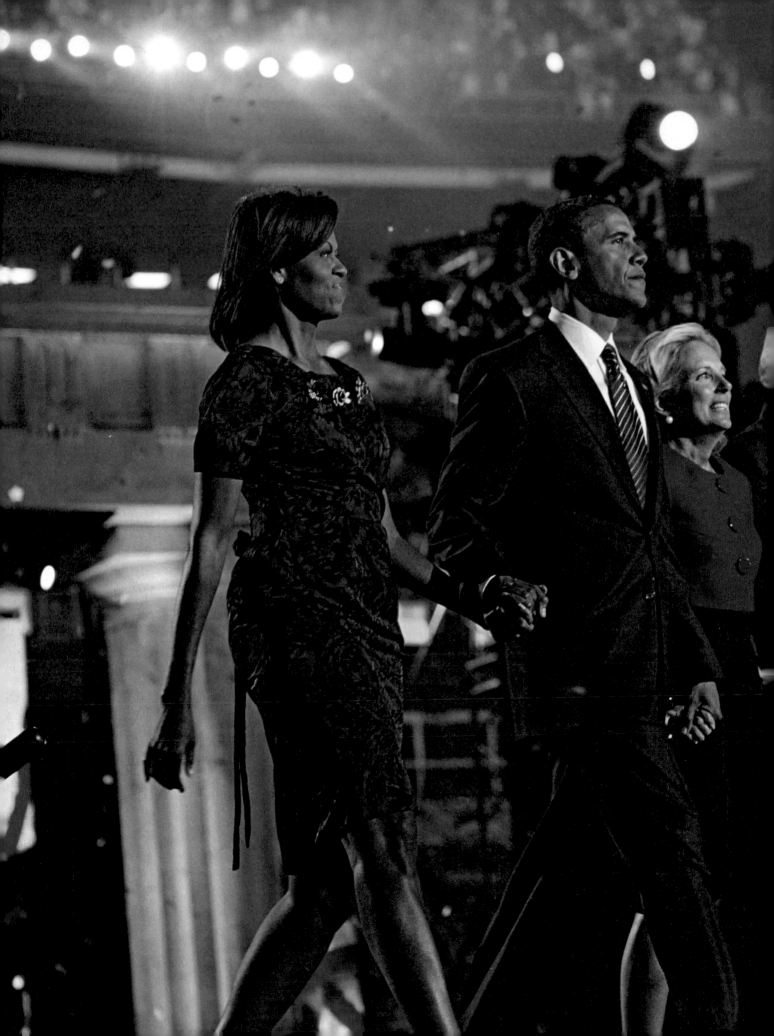

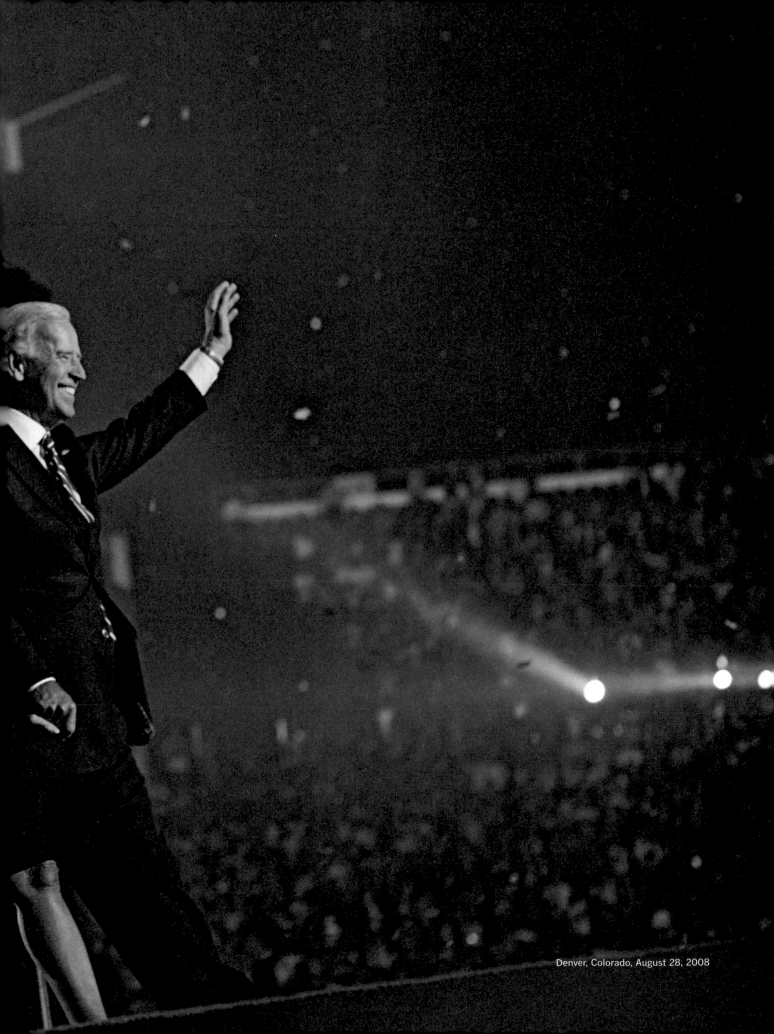

Denver, Colorado, August 28, 2008

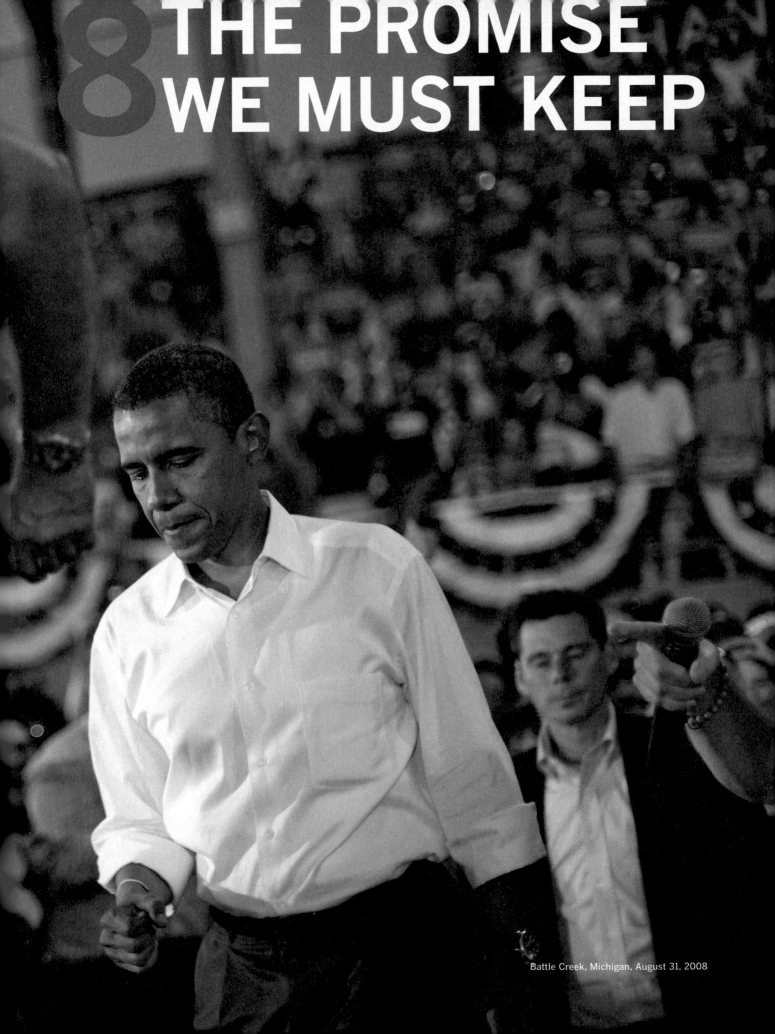

8 THE PROMISE WE MUST KEEP

Battle Creek, Michigan, August 31, 2008

TOWARD THE FINISH

After the Convention, it seemed like the only thing Obama had to do was keep cool. John McCain's campaign was imploding, his pick of Sarah Palin, which had once seemed inspired, was proving to be disastrous, and the collapse of the economy made the Republican Party look dangerous and out of touch.

Obama relaxed a bit, enjoying the few days on the trail with his running mate, Senator Joe Biden. After the cool and collected Obama, **Biden and his heartfelt unpredictability** was a breath of fresh air. In addition, our schedule grew lighter. The Senator would take three down days before each debate to prepare, so we enjoyed what we called "Debate Camp," with little to do but, in one especially good case, lie on the beach at our resort hotel. At the same time, the economic downturn made the race much more serious. Policy discussions were no longer abstract ideas. The candidates' plans were pored over as if they mattered, because they did.

MUST KEEP

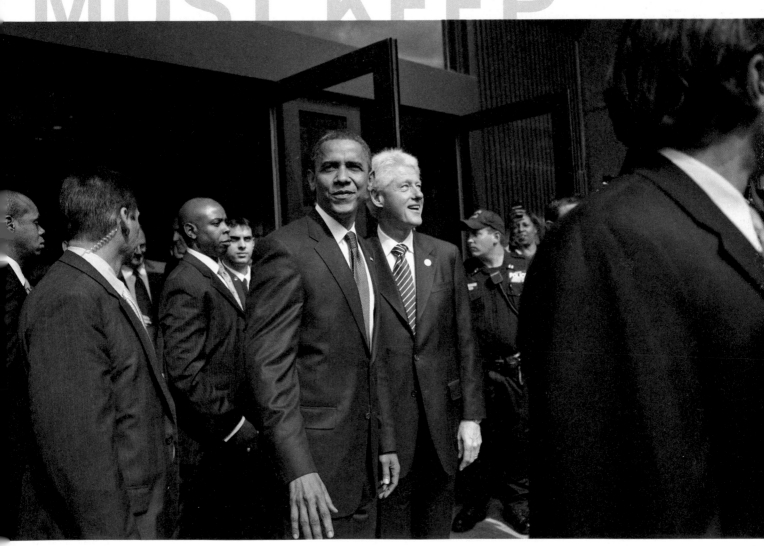

New York, New York
September 11, 2008

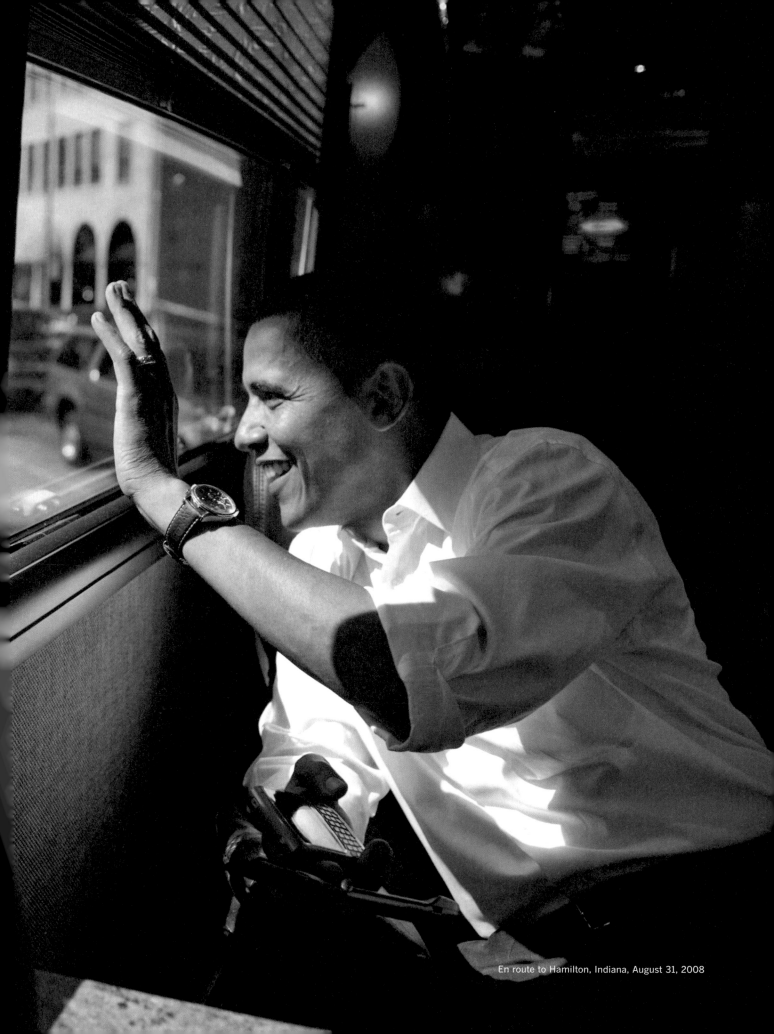

En route to Hamilton, Indiana, August 31, 2008

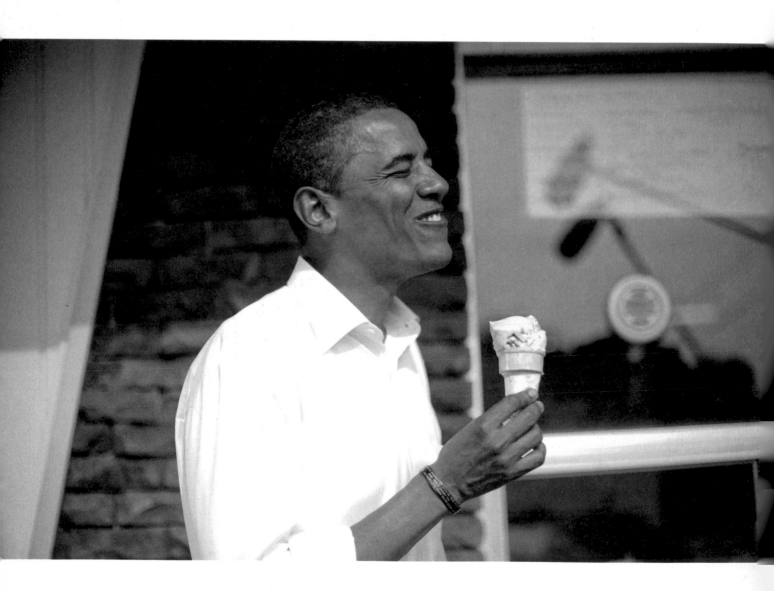

I feel good about our chances, because I've got something more powerful than they do: I've got you. In this campaign, you have already shown what history teaches us—that at defining moments like this one, the change we need doesn't come from Washington. Change comes to Washington.

Dover, New Hampshire, September 12, 2008

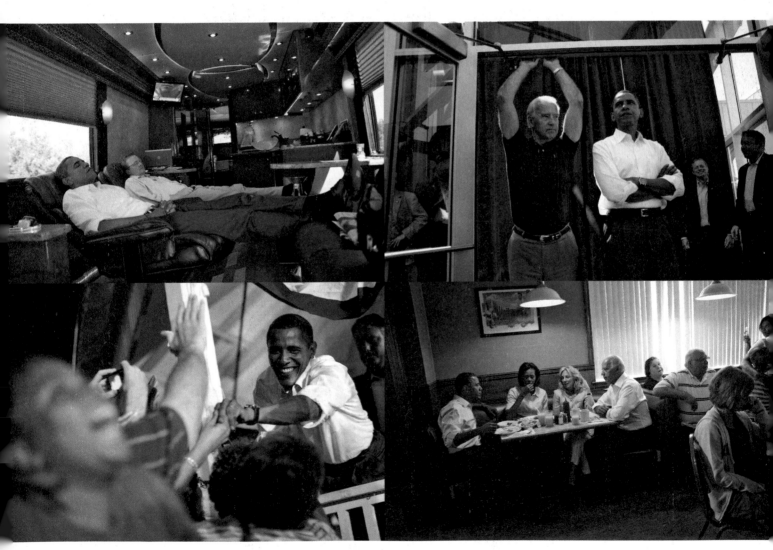

Aliquippa, Pennsylvania
August 29, 2008

En route to Hamilton, Indiana
August 31, 2008

Toledo, Ohio
August 31, 2008

Beaver, Pennsylvania
August 29, 2008

Boardman, Ohio
August 30, 2008

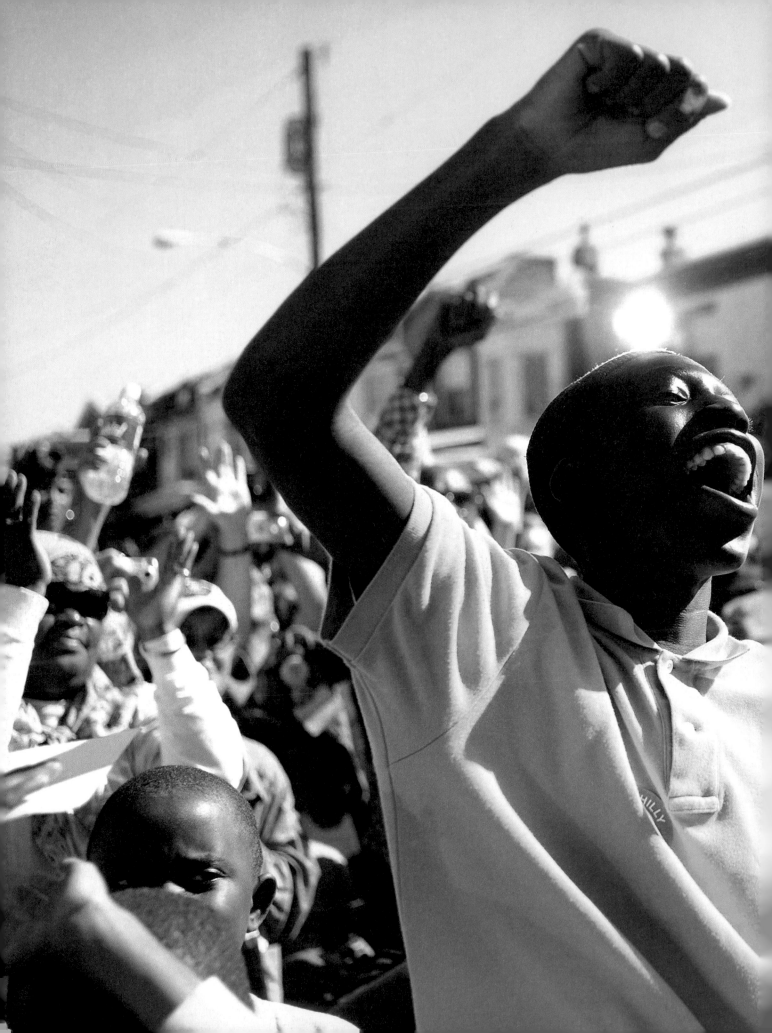

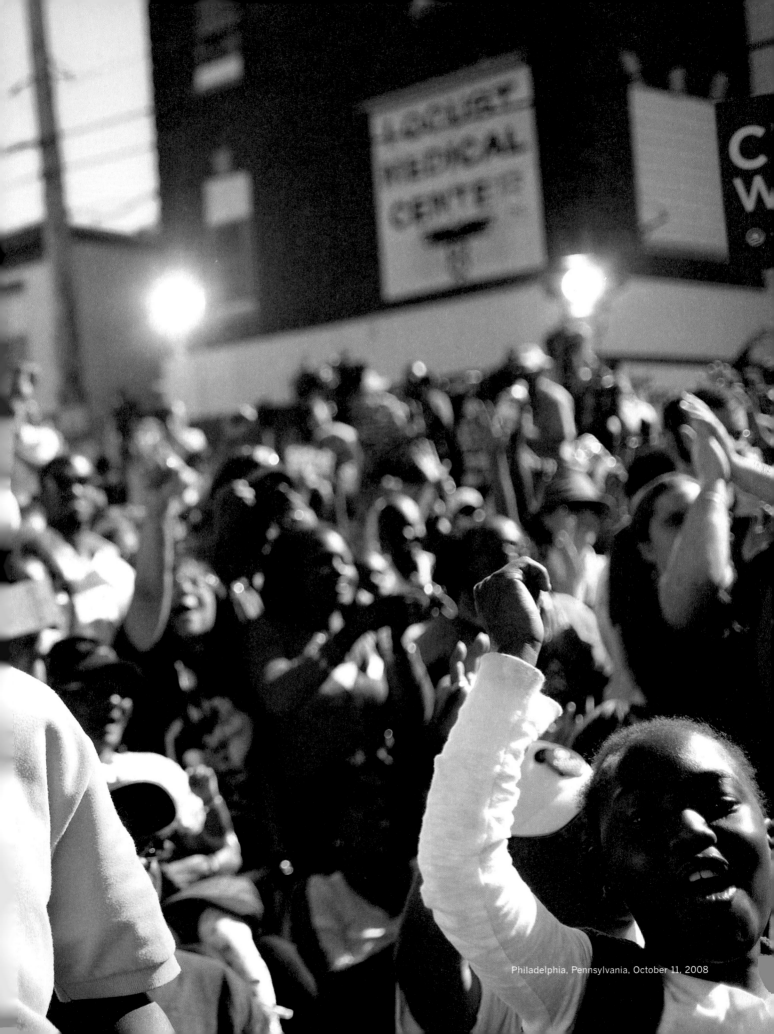

Philadelphia, Pennsylvania, October 11, 2008

I ask you to believe—not just in my ability to bring about change, but in yours.

I know this change is possible. Because I have seen it over the last twenty-one months. Because in this campaign, I have had the privilege to witness what is best in America.

Canton, Ohio, October 27, 2008

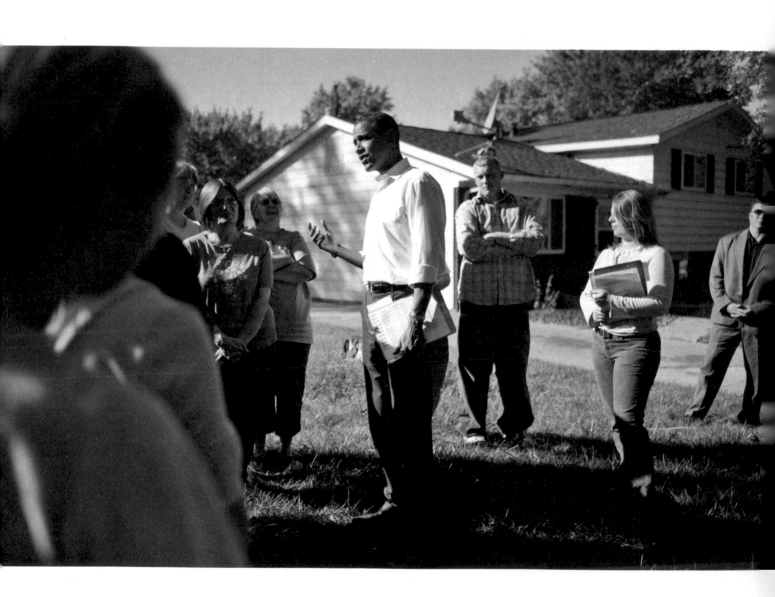

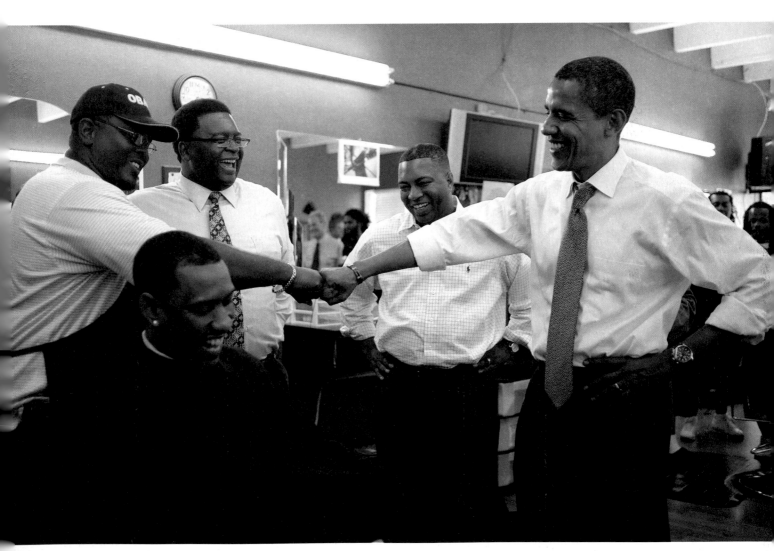

Holland, Ohio
October 12, 2008

Fort Lauderdale, Florida
October 21, 2008

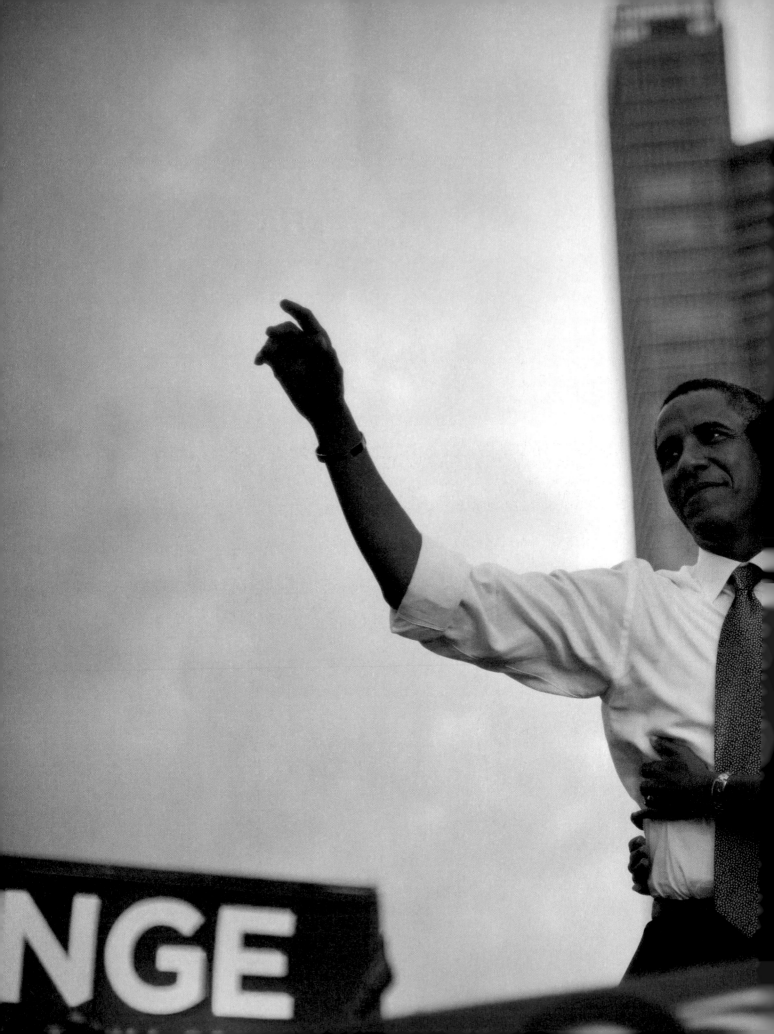

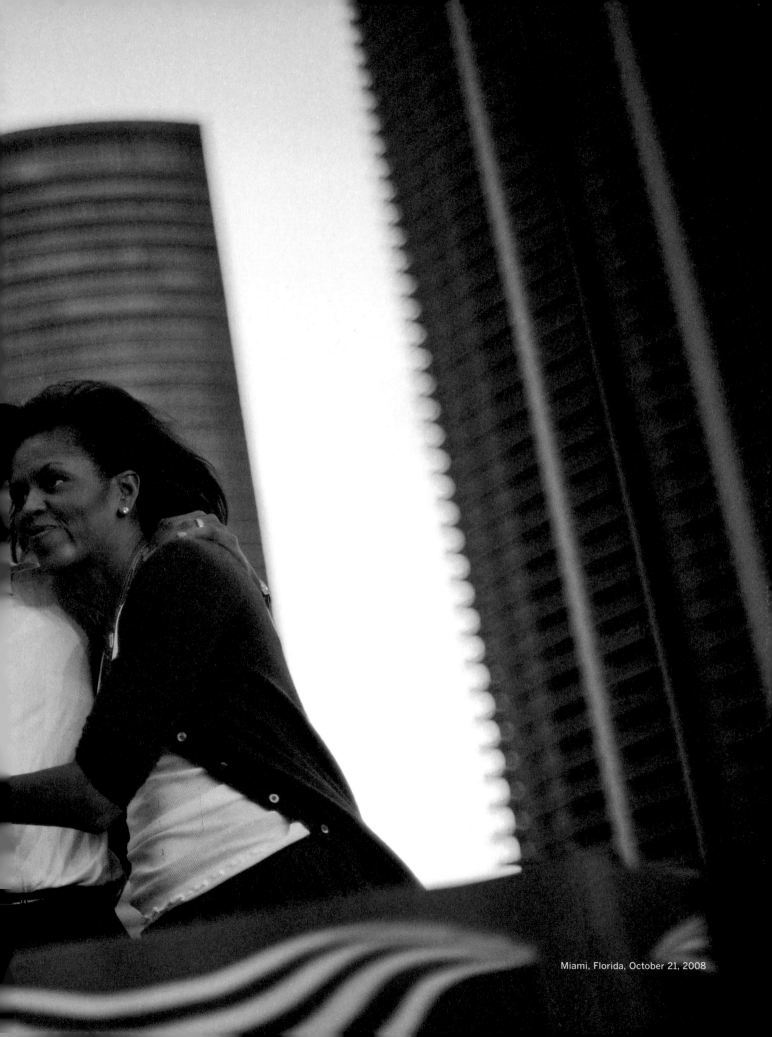

Miami, Florida, October 21, 2008

Miami, Florida, October 21, 2008

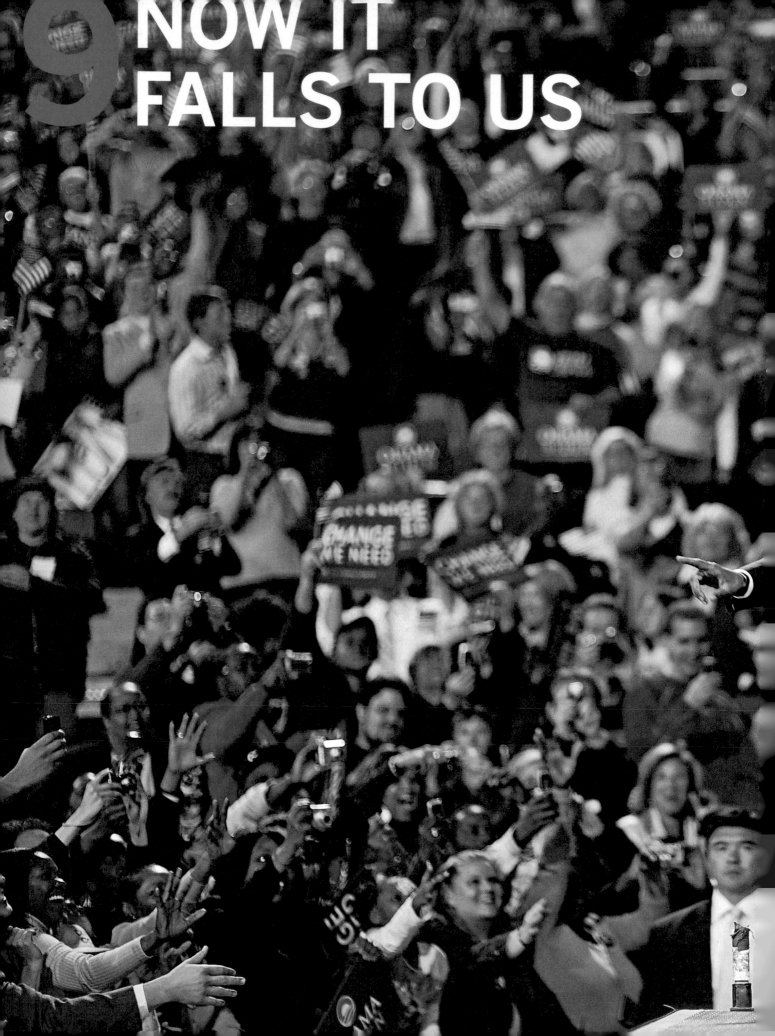

NOW IT FALLS TO US

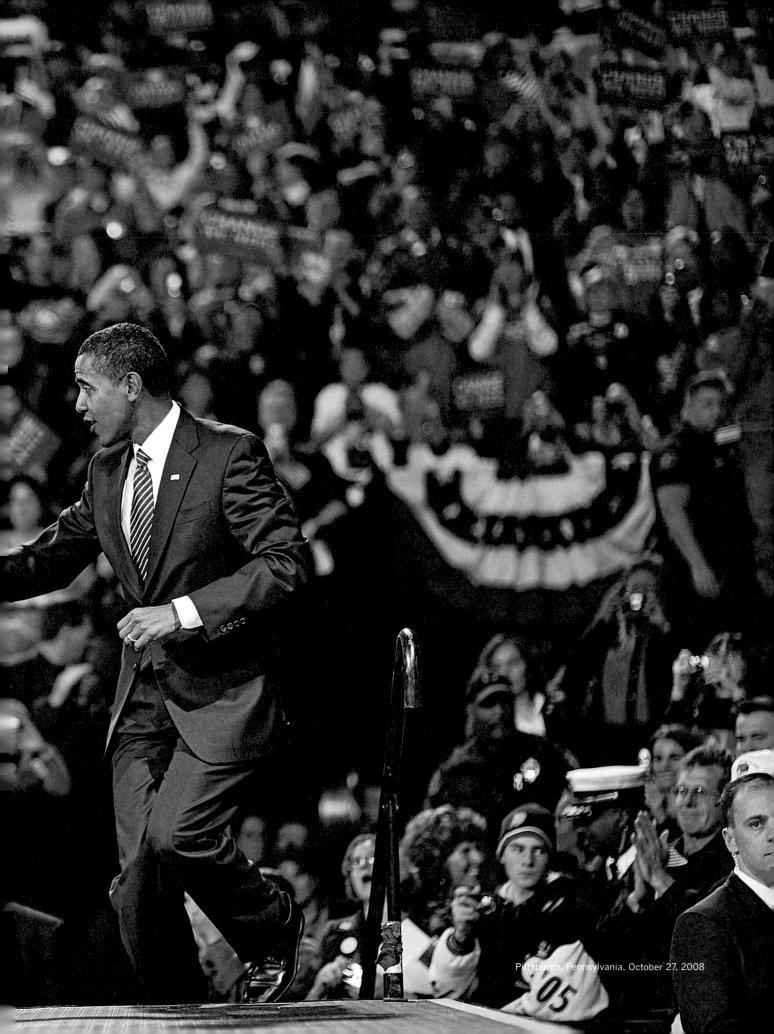

Pittsburgh, Pennsylvania, October 27, 2008

THE LAST DAYS OF THE GENERAL ELECTION

The last days of the general election were bittersweet. The days were getting shorter and colder and we all started to say our goodbyes, realizing that one way or another, it was all coming to an end. The death of Madelyn Dunham, Obama's grandmother, was **a heartbreaking coda to a very long road**. It was inconceivably sad that no one from his childhood would be there for him at the end.

It was hard not to look back at the ways that the campaign had changed and how it had changed Obama. I have always thought that Obama was the rare politician who ran for office because he wanted the job, rather than the title. As the country sank deeper into economic despair and **as his supporters' faith in him grew**, I saw him grow graver and more solemn.

156

US

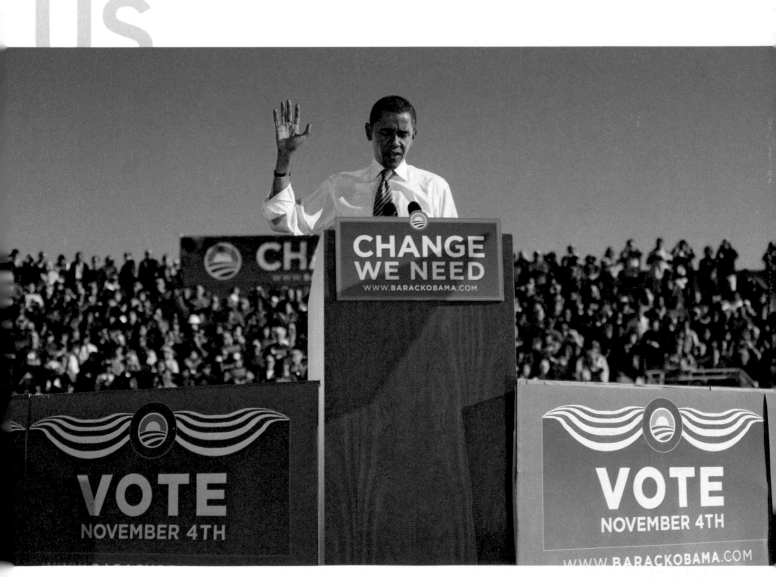

Reno, Nevada
October 25, 2008

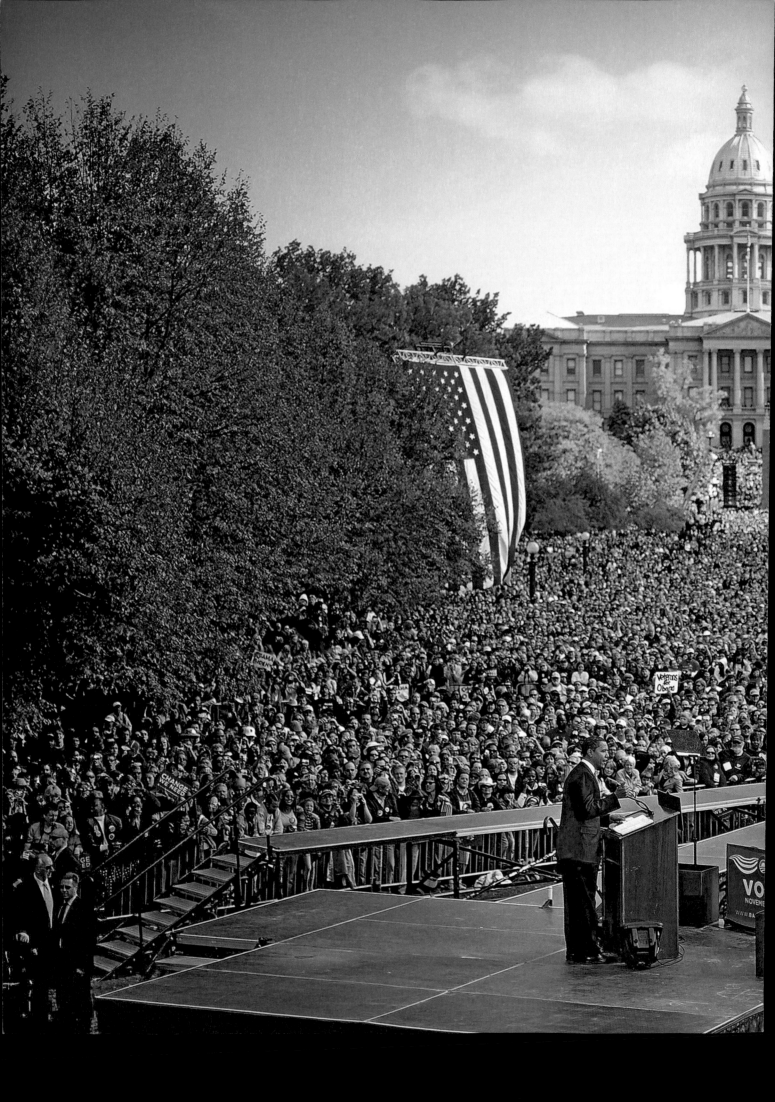

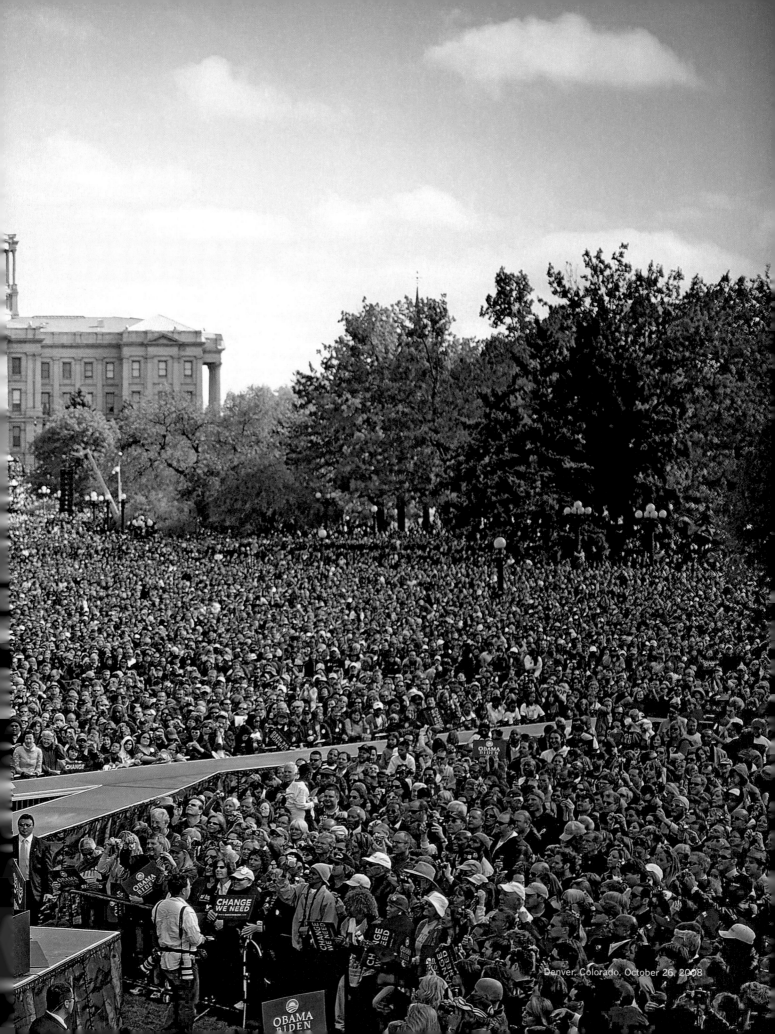

Denver, Colorado, October 26, 2008

That's what hope is—
that thing inside us that insists,
despite all evidence to the
contrary, that something better
is waiting around the bend; that
insists there are better days
ahead. If we're willing to work
for it. If we're willing to shed our
fears and our doubts. If we're
willing to reach deep down inside
ourselves when we're tired
and come back fighting harder.

Raleigh, North Carolina, October 29, 2008

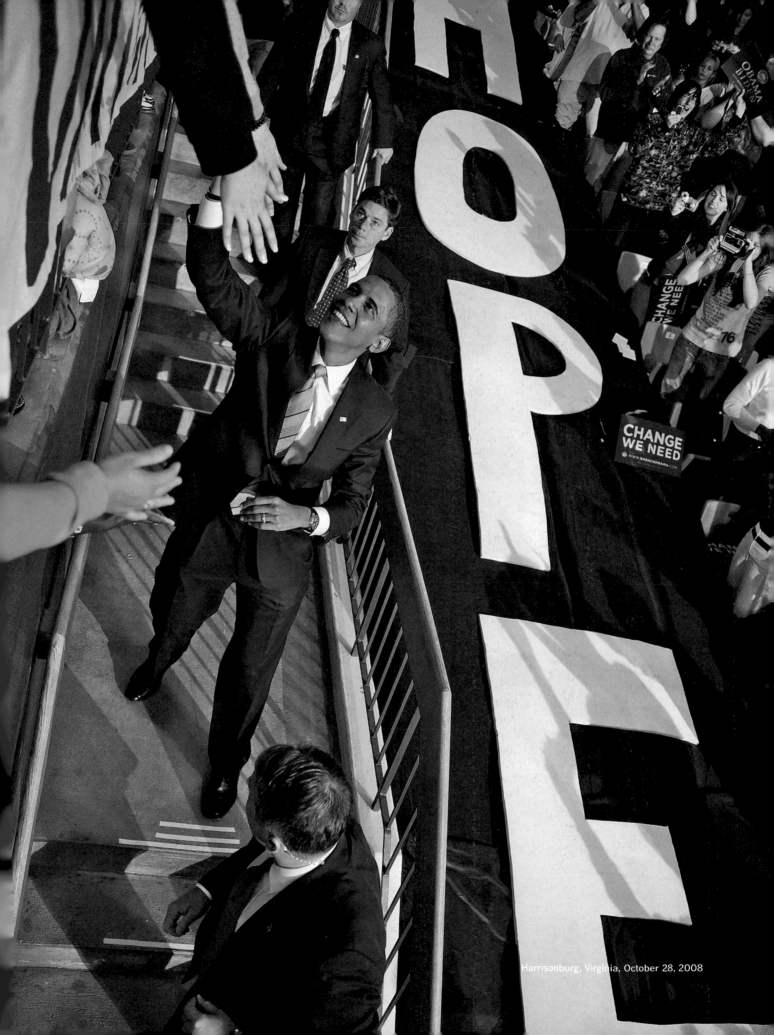

Harrisonburg, Virginia, October 28, 2008

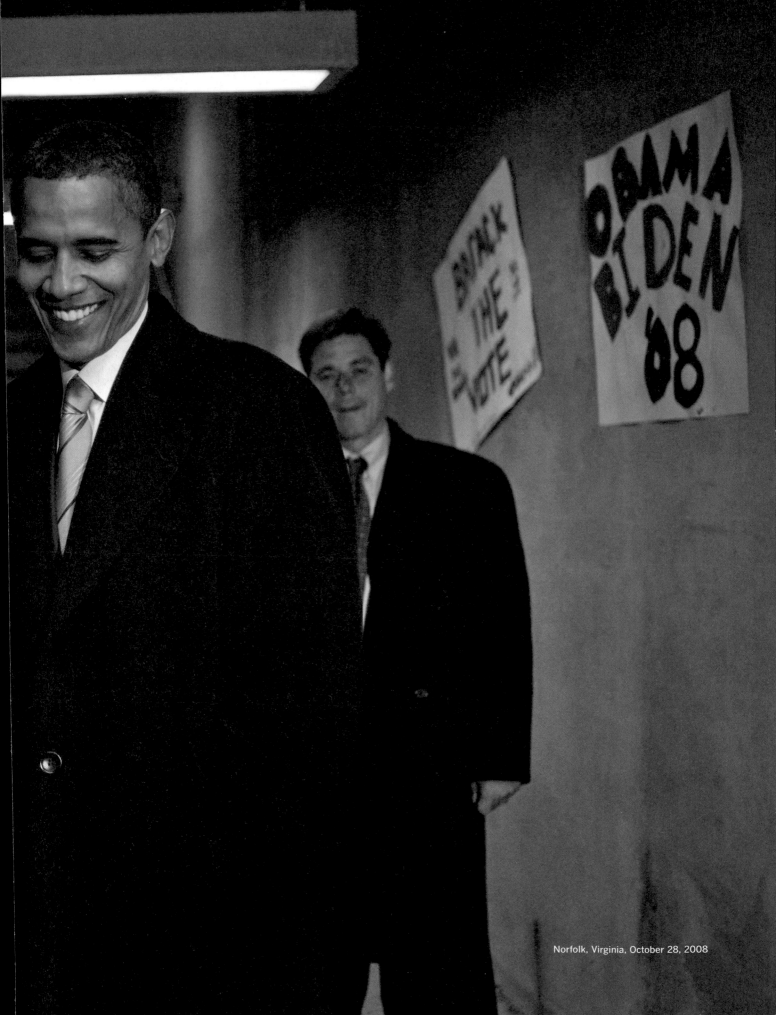

Norfolk, Virginia, October 28, 2008

You and I know that it is time to come together and change this country. Some of you may be cynical and fed up with politics. You have every right to be. But despite all of this, I ask of you what has been asked of Americans throughout our history.

I ask you to believe—not just in my ability to bring about change, but in yours.

Des Moines, Iowa, October 31, 2008

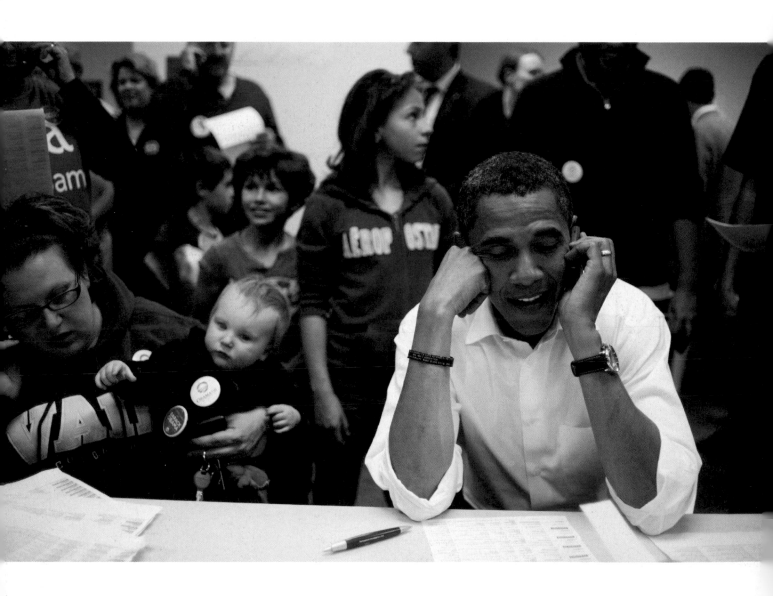

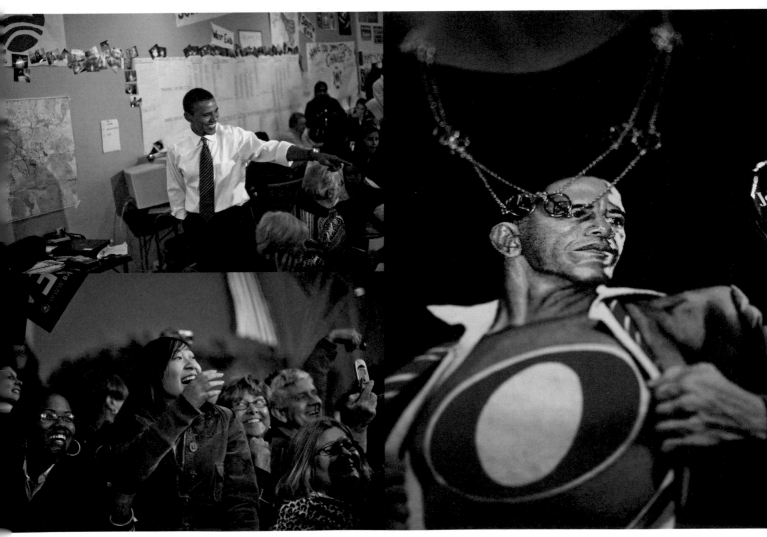

Brighton, Colorado
October 26, 2008

Pittsburgh, Pennsylvania
October 27, 2008

Sunrise, Florida
October 29, 2008

Virginia Beach, Virginia
October 30, 2008

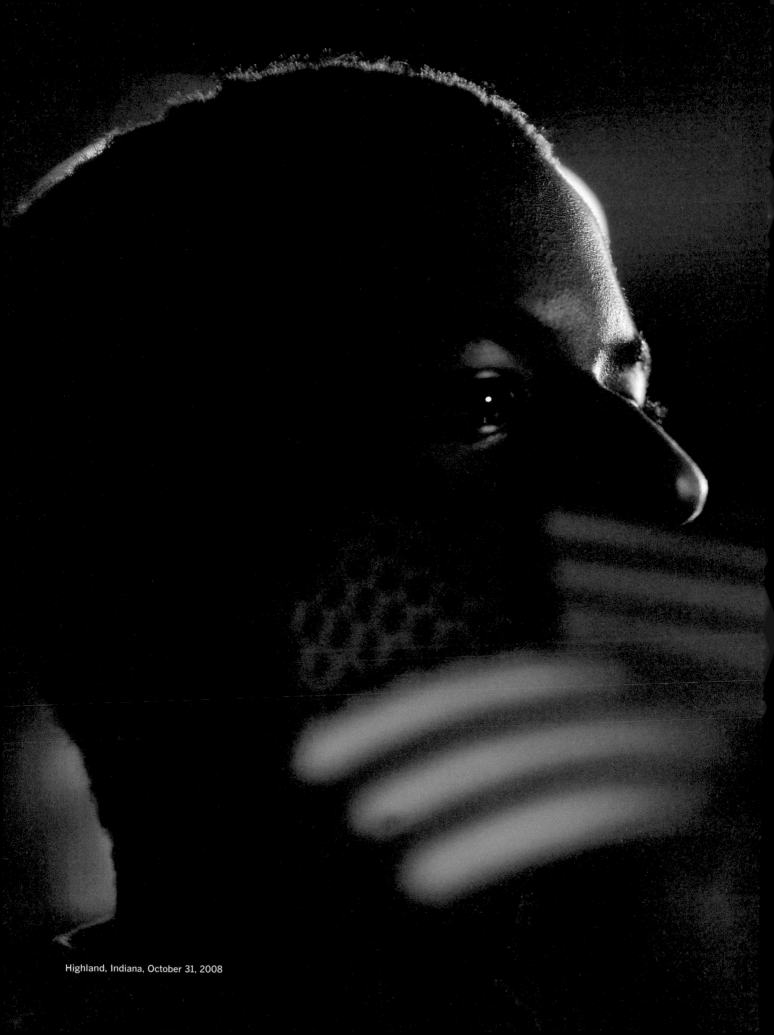

Highland, Indiana, October 31, 2008

I know this change is possible. Because I have seen it over the last twenty-one months. Because in this campaign, I have had the privilege to witness what is best in America. I've seen it in the faces of the men and women I've met at countless rallies and town halls across the country, men and women who speak of their struggles but also of their hopes and dreams.

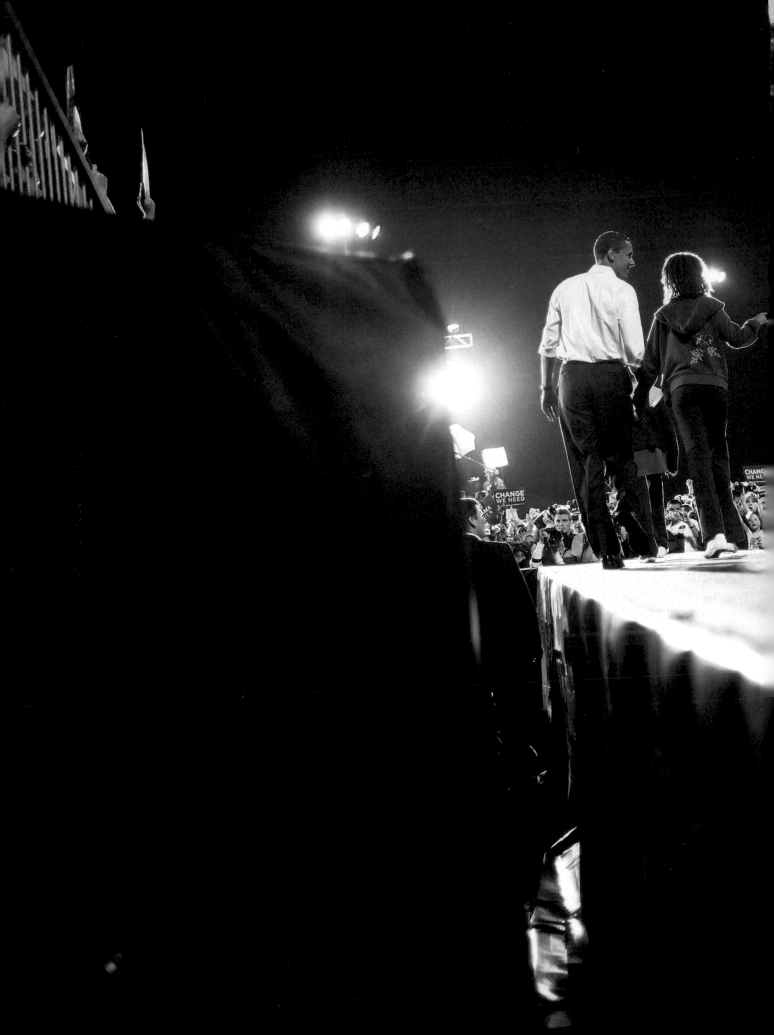

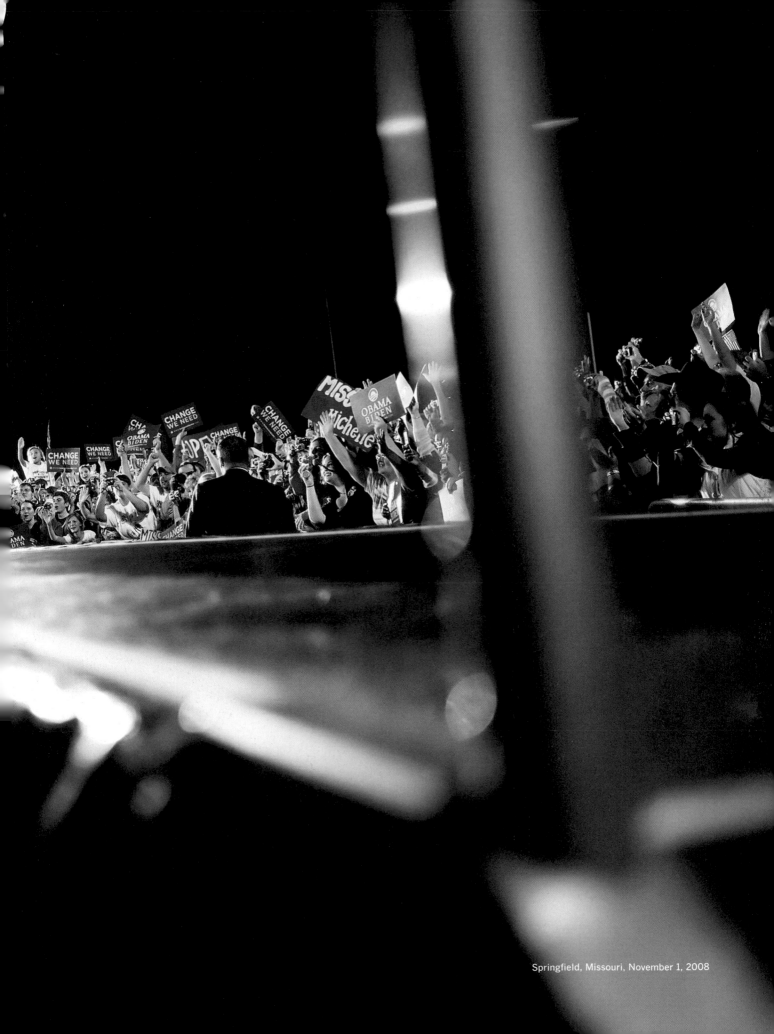

Springfield, Missouri, November 1, 2008

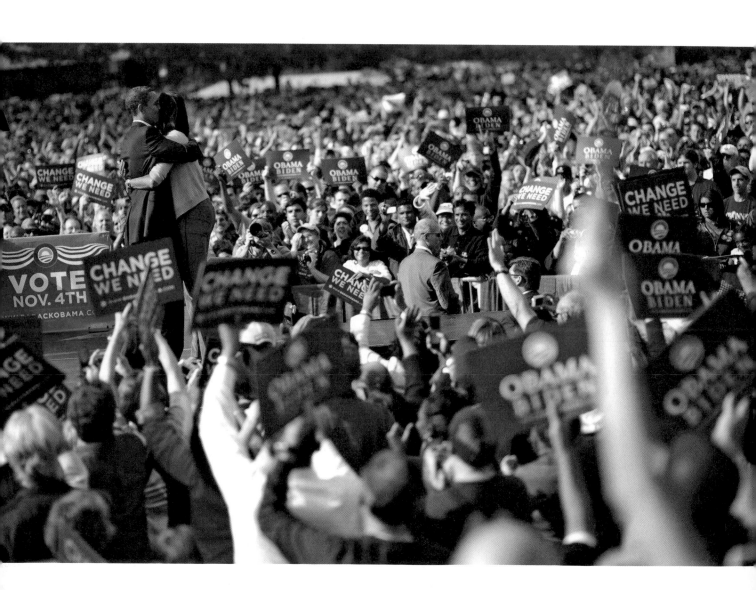

The time for change has come.
We have a righteous wind at our back.

Jacksonville, Florida, November 3, 2008

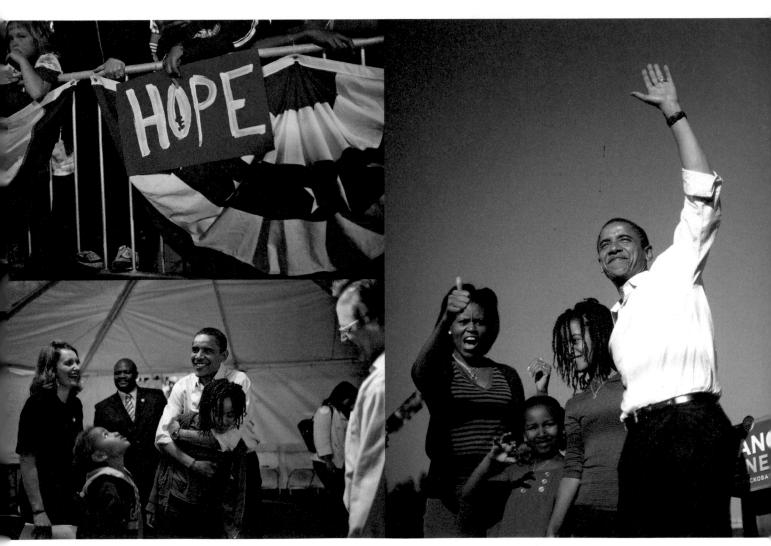

Columbus, Ohio
November 2, 2008

Springfield, Missouri
November 1, 2008

Springfield, Missouri
November 1, 2008

Pueblo, Colorado
November 1, 2008

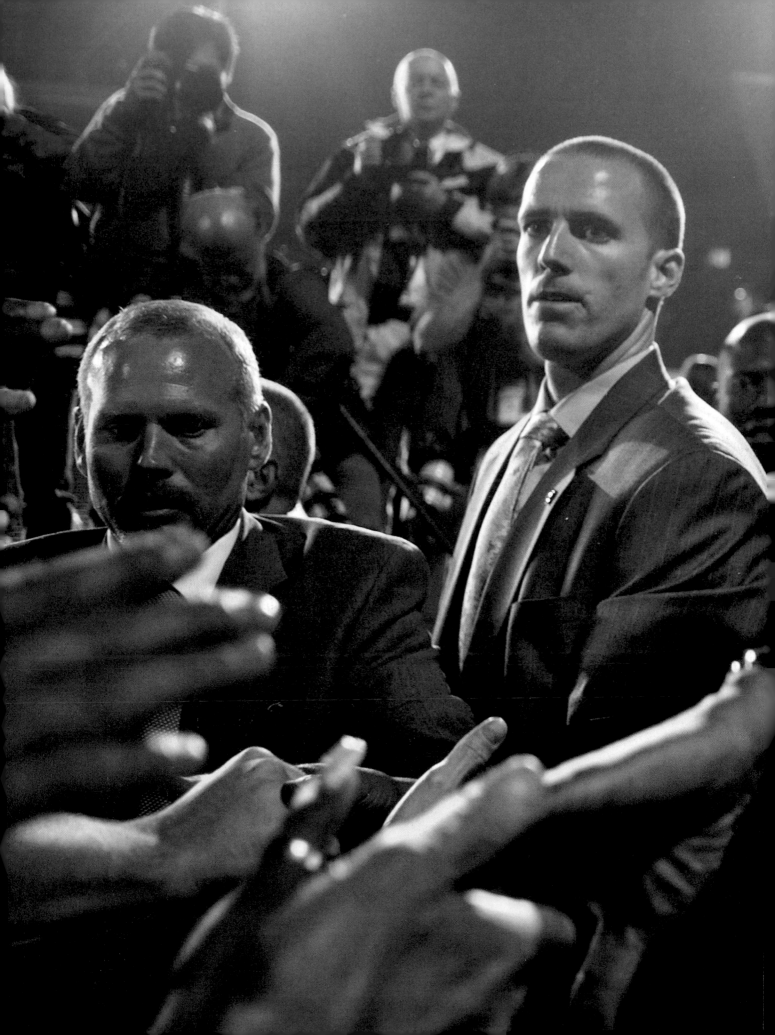

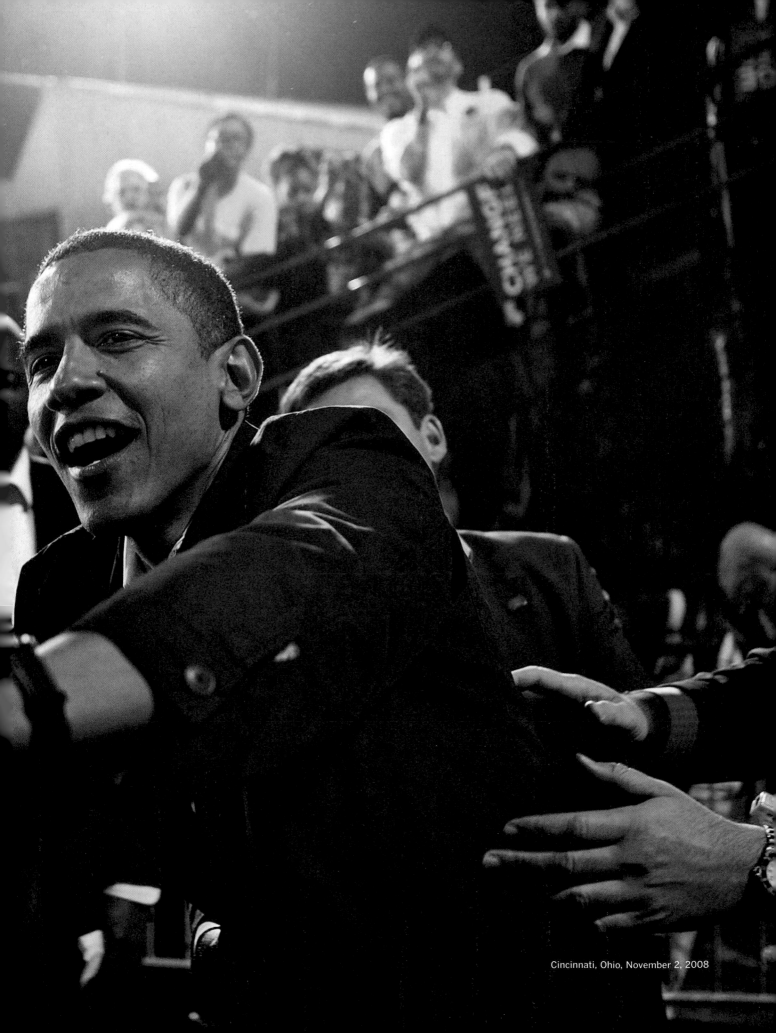

Cincinnati, Ohio, November 2, 2008

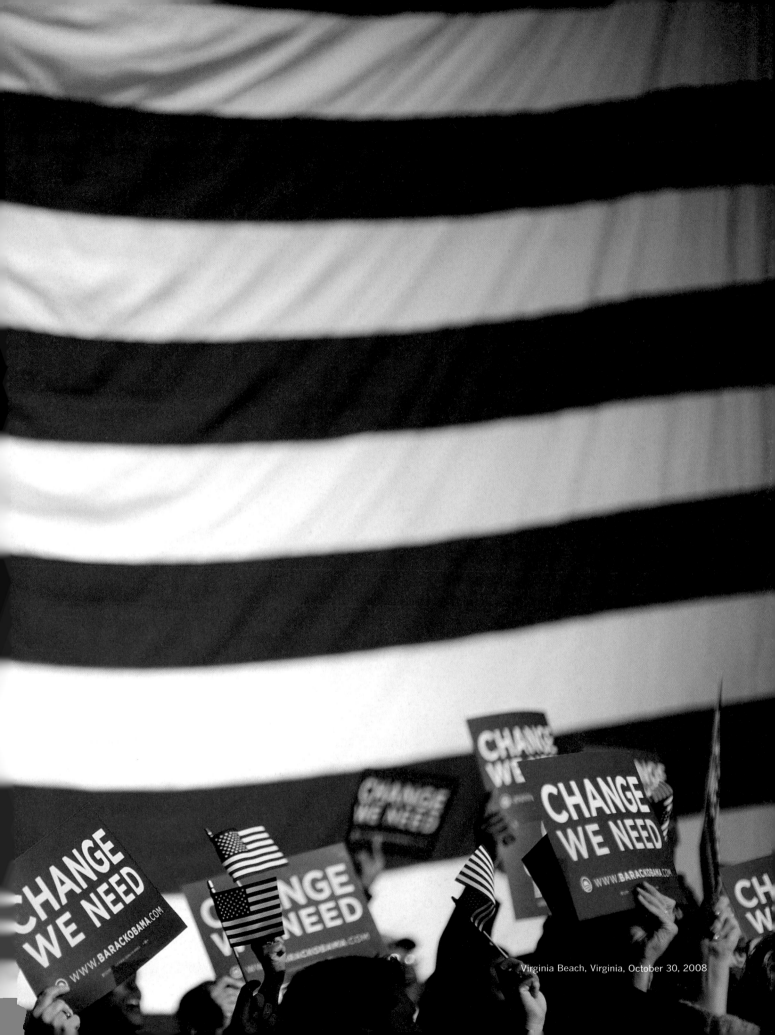

Virginia Beach, Virginia, October 30, 2008

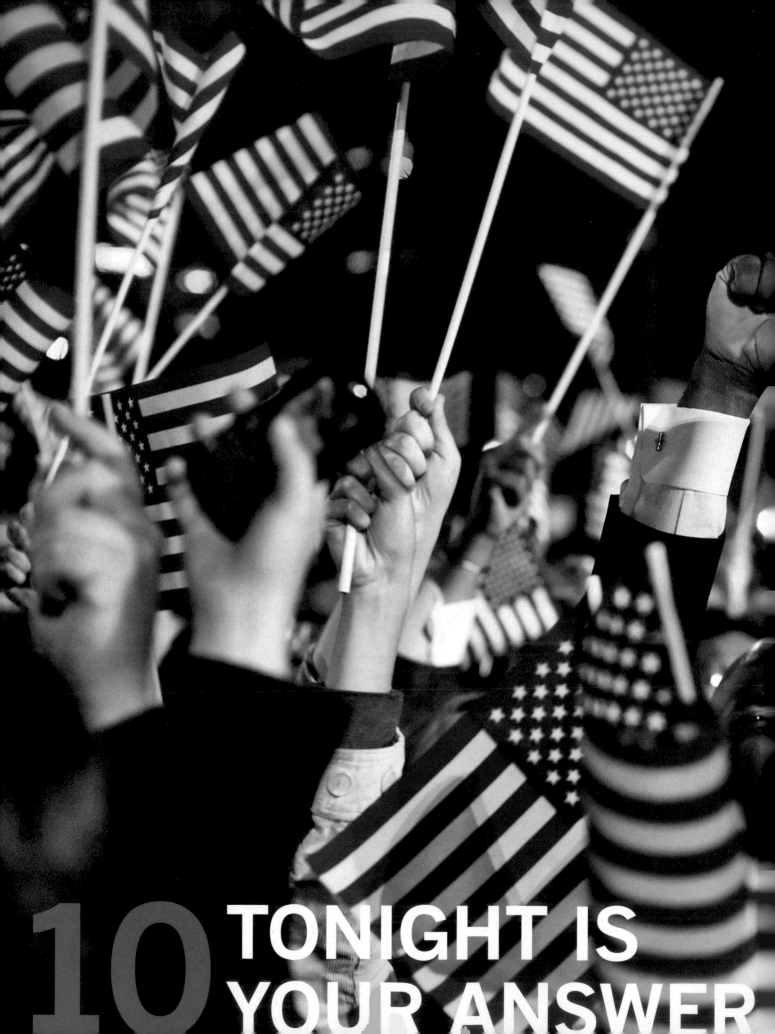

10 TONIGHT IS YOUR ANSWER

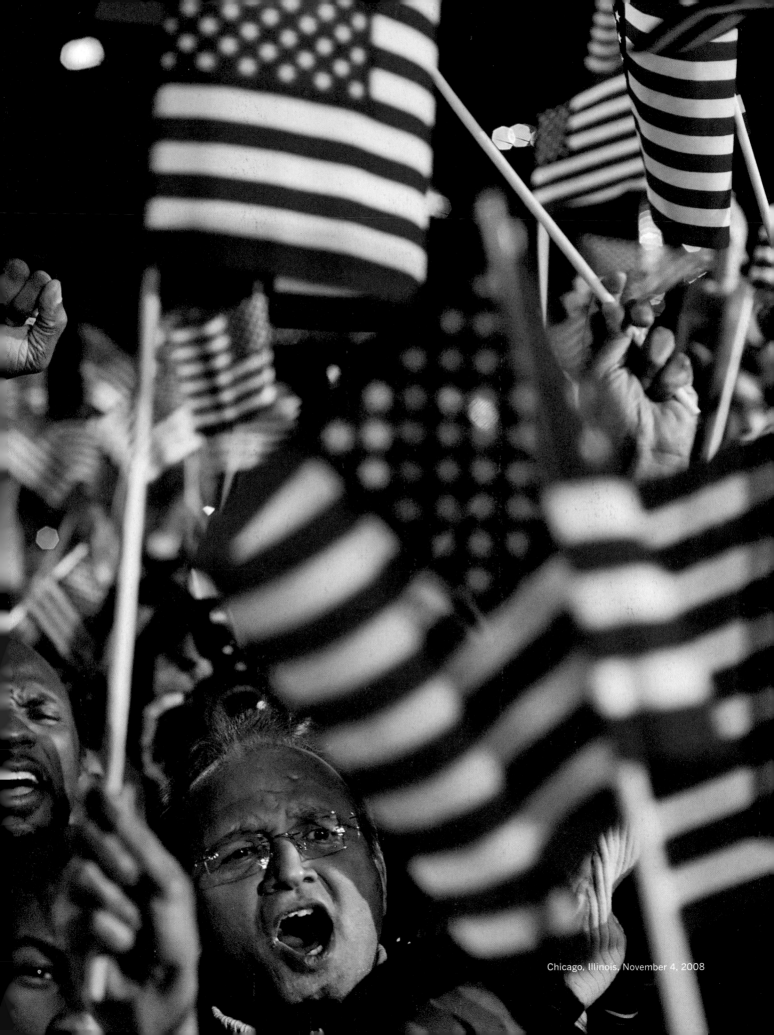

Chicago, Illinois, November 4, 2008

THE PRESIDENT-ELECT

I had my back turned to the screen when the news broke. I had been focusing my lens on someone in Grant Park with a large American flag, when all of a sudden **the crowd, as one, surged up and began screaming in joy**, hands in the air, arms around each other. Even without looking, I knew what had happened. **Barack Obama had just been elected the next President of the United States**.

When the enormity of what our country had just done began to hit, we realized that not only were we in a new world, but that we had come full circle: from the evils of slavery to electing a black man to the highest office in the land. People began to weep in each other's arms, sobbing through a national anthem that had never felt so inclusive and **pledging their allegiance to a changed country**.

ANSWER

Chicago, Illinois
November 4, 2008

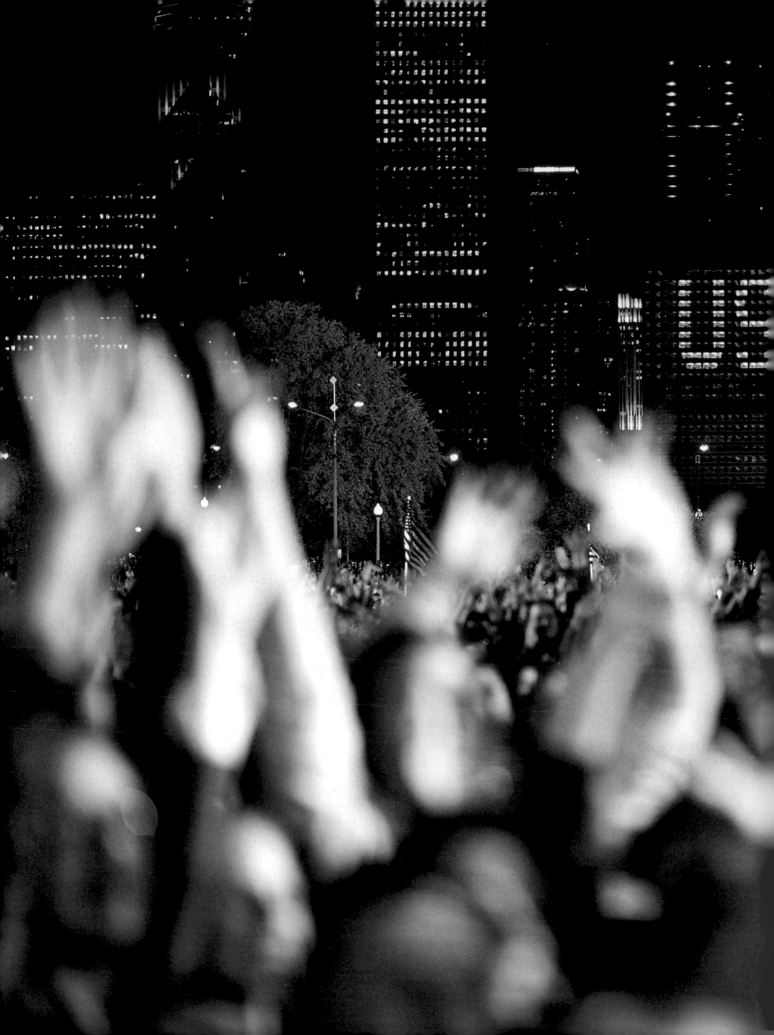

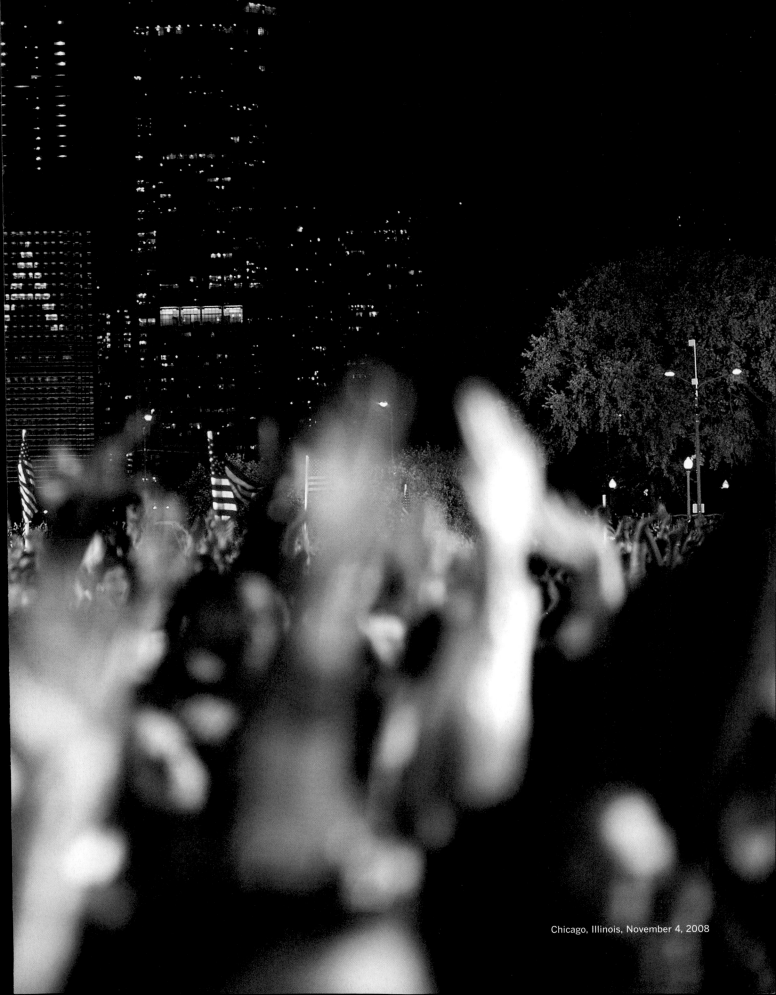

Chicago, Illinois, November 4, 2008

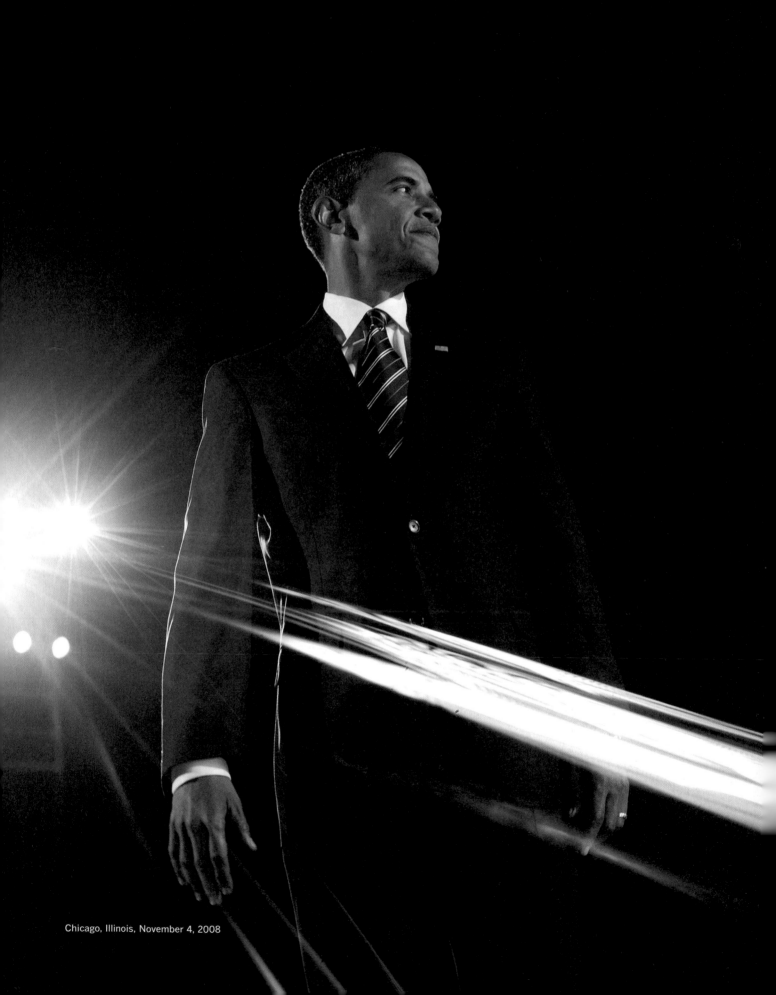

Chicago, Illinois, November 4, 2008

I will always be honest with you about the challenges we face. I will listen to you, especially when we disagree. And above all, I will ask you join in the work of remaking this nation the only way it's been done in America for two hundred and twenty-one years—block by block, brick by brick, calloused hand by calloused hand.

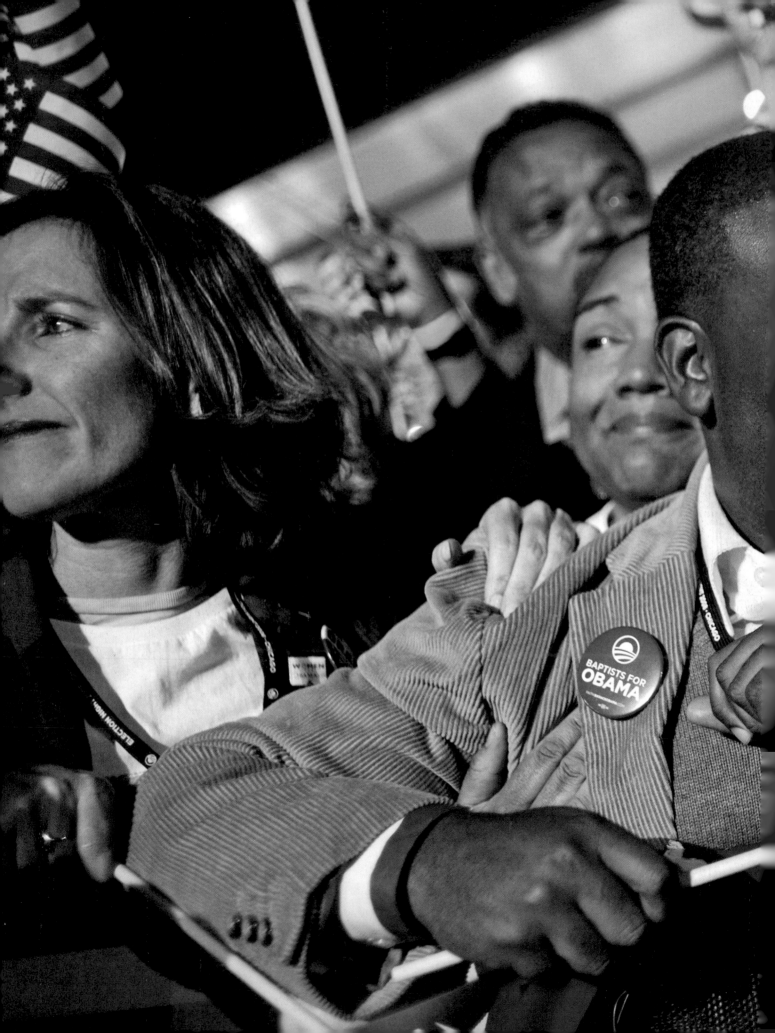

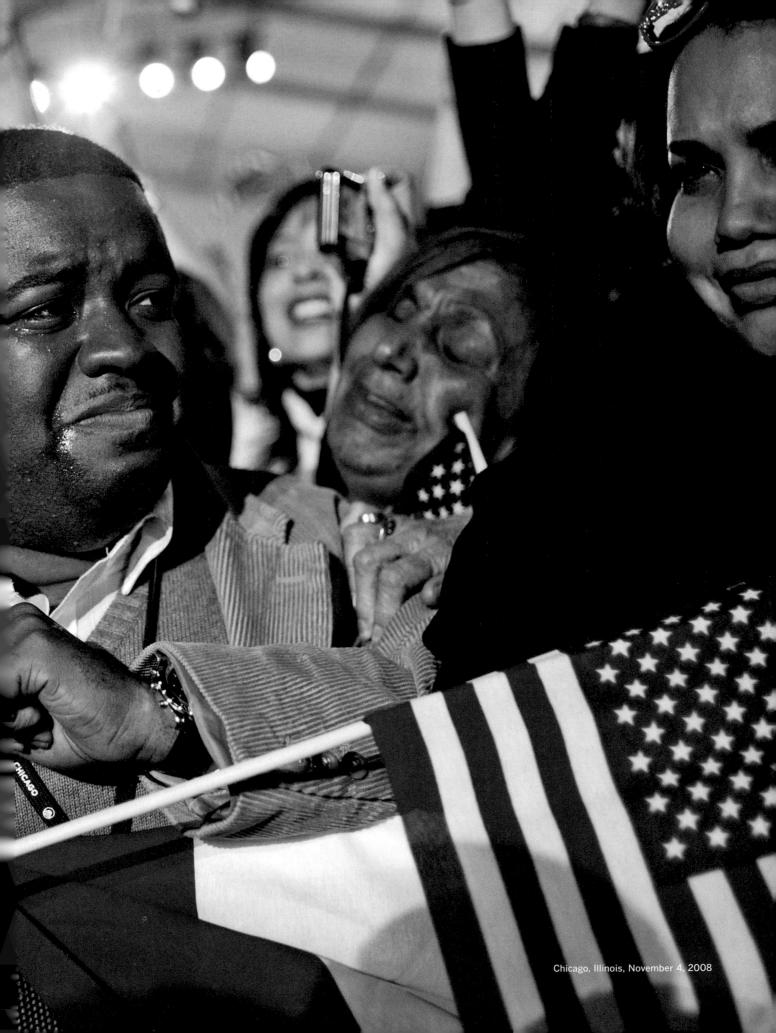

Chicago, Illinois, November 4, 2008

This is our time—to put our people back to work and open doors of opportunity for our kids; to restore prosperity and promote the cause of peace; to reclaim the American Dream and reaffirm that fundamental truth—that out of many, we are one; that while we breathe, we hope, and where we are met with cynicism, and doubt, and those who tell us that we can't, we will respond with that timeless creed that sums up the spirit of a people:

Yes We Can.

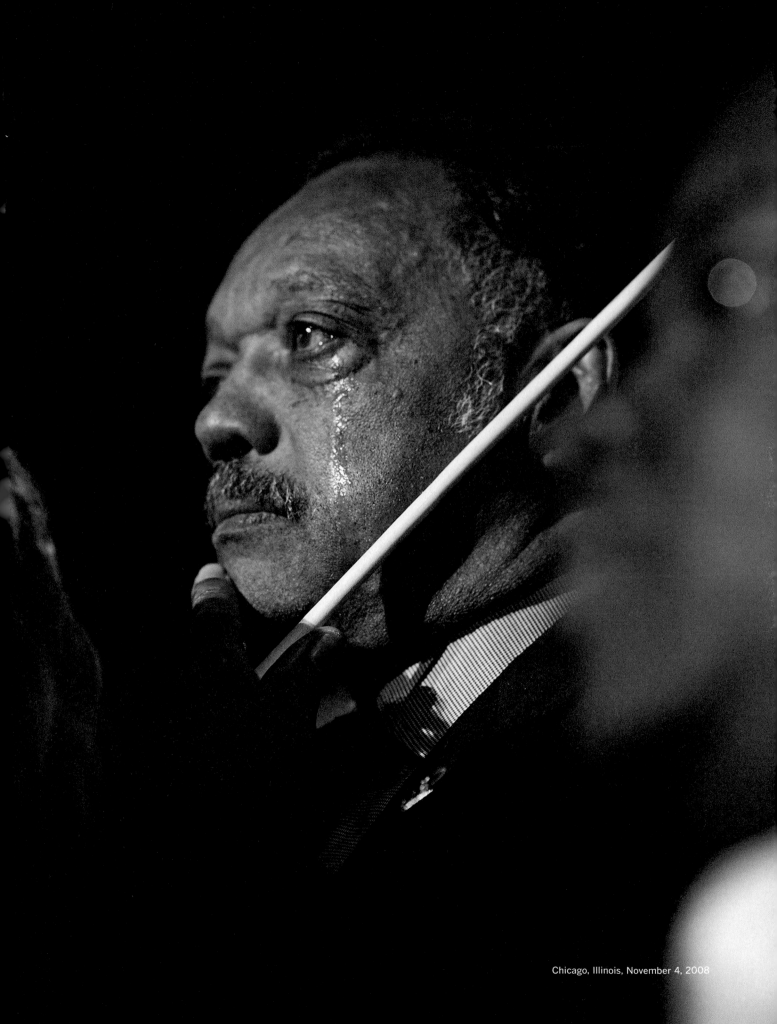

Chicago, Illinois, November 4, 2008

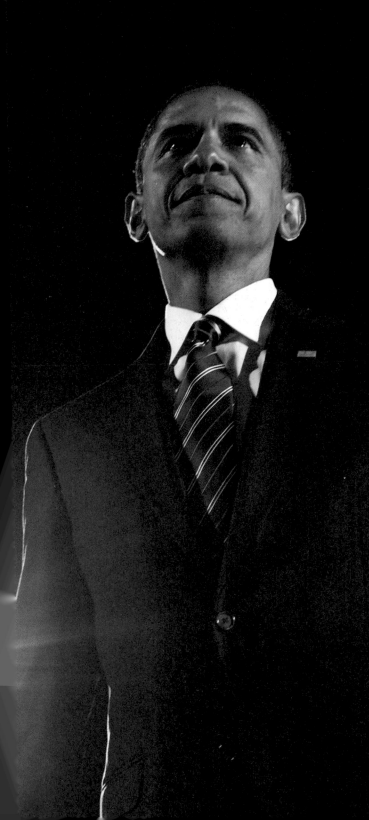

Chicago, Illinois, November 4, 2008

ACKNOWLEDGMENTS

This project has been a huge undertaking, and there are many people without whom I would have been left stranded at the side of the proverbial road. I would first of all like to thank my agency, Polaris Images, especially Kelly, for believing in this project from the beginning, and JP, for helping me to fund it when my credit cards were all maxed out. To Laurie Fox, Linda Chester, and Charles Melcher, for seeing a book in my pictures and making it happen, and to all the editors who have supported me, especially Michelle Molloy at *Newsweek*, without whom I never could have begun this project let alone finished it—I cannot even begin to appropriately express my thanks. To everyone at *Essence*, especially Deb Boardley and Angela Burt-Murray—thank you for your amazing generosity and encouragement. I never would have been able to finish this story without you. David Brown—thank you so much for working with me at an insane pace and tolerating both my physical absence and my distraction as we put together an edit during the final weeks of the campaign. And to everyone at powerHouse Books—I am so thrilled to be working with you! Thank you.

I am also eternally grateful to the entire Obama campaign staff, especially the wonderful (and endlessly patient) Katie Lillie and Sam Tubman, along with Jen Psaki, Robert Gibbs, David Axelrod, Marvin Nicholson, and Reggie Love. In addition, there are far too many members of the advance staff to name, but all of you are "owsome." I do, however, want to single out Peter Weeks, who started on the same day I did back in December 2006, for being a deeply professional and friendly face during the very early stages of this campaign. And, of course, I would like to thank the entire Obama family for their grace and tolerance.

Perhaps most important, I can't imagine having done this without my new family in what could occasionally seem like a traveling circus. To Bonney Kapp, Sunlen Miller, Maria Gavrilovic, Chris Welch, Aswini Anburajan, and Athena Jones, who can beat any boy band any day; Bruce and Raul for making the plane a home and showing a new kid how to both work hard and have a great time; all of my photog buddies for being a constant inspiration; 4A, 4B, and 4C (past and present) for being the big brothers (and sisters) I never wanted; Daren Briscoe for being a font of advice about everything except basketball; Amy Rice for her near-psychic foresight, her great stories, and being the best person ever to sit beside while editing pictures; the Dez Moinez Boys for letting me live on the couch; and to everyone else—I can't name all of you, but from

the AmericINN and the Continental to Club C, from Mineral Wells, West Virginia, to Berlin beach parties, you have made these two of the best years of my life.

This project never would have gotten the attention that it has without the fabulous designers at Neonsky, who developed my website, and it would not have looked as good if Nikon hadn't developed the D3 at the exact right moment. Thanks to the folks at Nikon Professional Services for shipping me equipment at a moment's notice.

I also need to offer my friends in Brooklyn my apologies for virtually disappearing for the past two years, and my gratitude that they seem to remember who I am. In addition, I am incredibly grateful for the generosity and kindness of the Schenkkan family. Finally, although they would probably be happier if I had enrolled in law school, my parents have been endlessly supportive of my choices and patient with my prolonged absences and unreturned phone calls. I can't thank you guys enough.

And most of all . . . to Nate and the good people of Iowa.

Scout Tufankjian

Melcher Media would like to thank Linda Chester and Laurie Fox at the Linda Chester Agency, Craig Cohen and Daniel Power at powerHouse, Lori Baker, Daniel del Valle, Max Dickstein, Coco Joly, Lauren Nathan, Lia Ronnen, Holly Rothman, Jessi Rymill, Alex Tart, Shoshana Thaler, and Megan Worman.

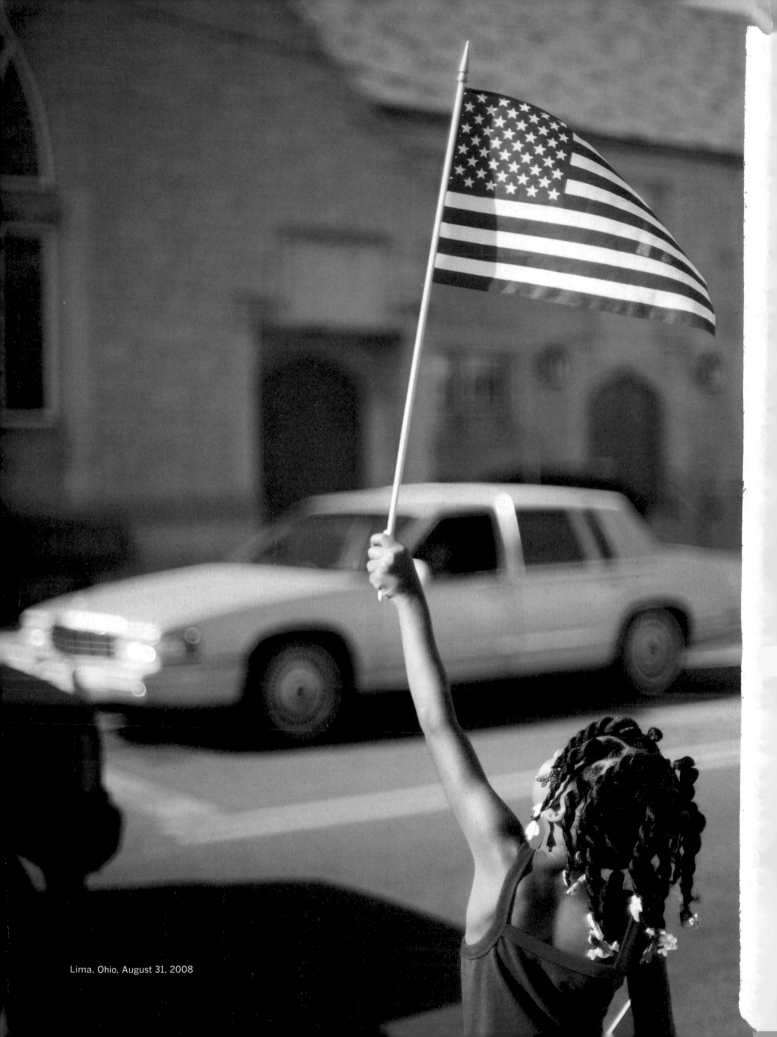

Lima, Ohio, August 31, 2008